THE DIGITAL PHOTOGRAPHER'S GUIDE TO

FILTERS

THE COMPLETE GUIDE TO HARDWARE AND SOFTWARE FILTRATION

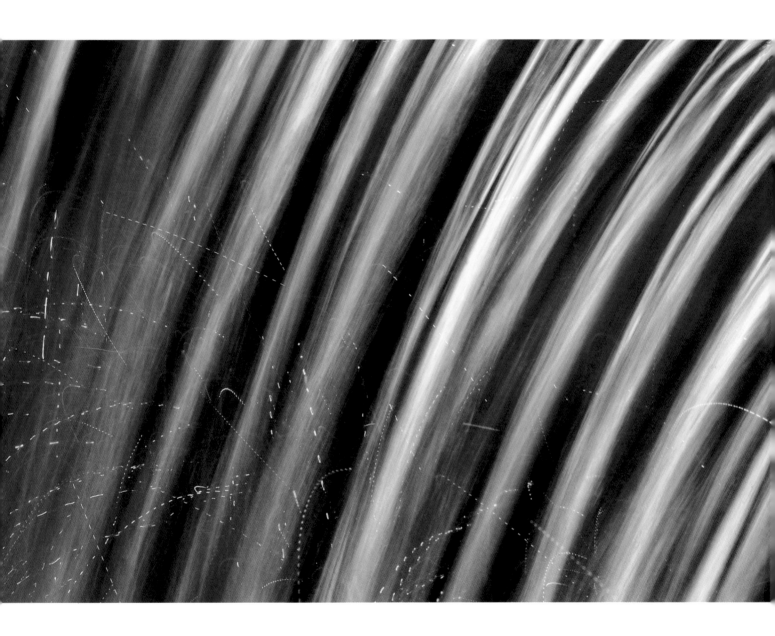

THE DIGITAL PHOTOGRAPHER'S GUIDE TO

FILTERS

THE COMPLETE GUIDE TO HARDWARE AND SOFTWARE FILTRATION ROSS HODDINOTT

D&C
David and Charles

A DAVID & CHARLES BOOK
Copyright © David & Charles Limited 2007

David & Charles is an F+W Publications Inc. company
4700 East Galbraith Road
Cincinnati, OH 45236

First published in the UK in 2007
First US paperback edition 2007

Text copyright © Ross Hoddinott
Images copyright © Ross Hoddinott and Rod Edwards

ISBN-13: 978-0-7153-2654-1 hardback
ISBN-10: 0-7153-2654-6
ISBN-13: 978-0-7153-2669-5 paperback
ISBN-10: 0-7153-2669-4

Printed in China by SNP Leefung
for David & Charles
Brunel House, Newton Abbot, Devon

Commissioning Editor: Freya Dangerfield
Project Editor: Ame Verso
Assistant Editor: Demelza Hookway
Art Editor: Marieclare Mayne
Production Controller: Beverley Richardson

Visit our website at www.davidandcharles.co.uk

David & Charles books are available from all good bookshops; alternatively
you can contact our Orderline on 0870 9908222 or write to us at FREEPOST
EX2 110, D&C Direct, Newton Abbot, TQ12 4ZZ (no stamp required UK only);
US customers call 800-289-0963 and Canadian customers call 800-840-5220.

PICTURE CREDITS

All images taken by the author except:
p25 Greek church, pp40–41 WB comparison sequence, p44 Doorway and
blurred buttercups, p45 Windmill, p55 Castle silhouette, p56 Morning mist,
p63 Sheep, p63 Gondolas, p76 Outdoor portrait, p82 Indoor portrait,
p84 Beach huts, p85 Windmill, p102 Family portrait, p109 Mono portrait,
p112 Abandoned car, p123 Contemporary portrait and subsequent filtered
versions, p126 Mill sails, p129 Cyclist, p132 Changing faces
copyright © Rod Edwards – www.rodedwards.co.uk
p134 Let there be Light! (Light!) , p135 Practical plug-ins (EZ Mask),
images courtesy of Digital Film Tools www.digitalfilmtools.com
copyright © Thinkstock LLC – www.thinkstock.com

[PAGE 2] WEIR SPRAY
When I photographed this small, fast-flowing
weir, I noticed that gusts of wind were creating
a fine spray, which was being backlit by the early
morning sun. With the aid of an ND filter, I was
able to select a shutter speed slow enough to
blur the rapid movement of the water.
*Nikon D70, 100–300mm lens (at 270mm), ISO 200,
1sec at f/32, 0.6 ND filter, tripod.*

[OPPOSITE] TREE SILHOUETTE
The low, evening sunlight cast this tree into inky
silhouette. I positioned myself carefully so that
the sun's rays were filtered by the tree's branches
– thus avoiding the problem of flare. A WB setting
of 'Cloudy' created a warm, orangey cast to
enhance the sunset.
*Nikon D70, 18–70mm lens (at 50mm), ISO 200,
1/300sec at f/11, tripod.*

CONTENTS

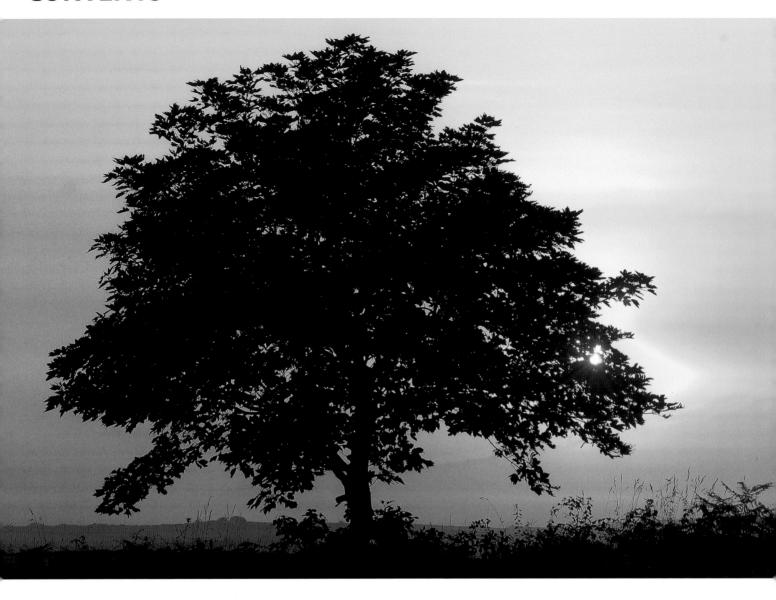

INTRODUCTION

Ever since I first began taking pictures seriously, as an enthusiastic teenager, filters have played an integral role in my photography. Then, I was using an old Zenit SLR, a fully manual and robust Russian camera that my parents had given me. It was an extremely basic SLR, especially compared to the present crop of sophisticated digital models, but it was ideally suited to a beginner. It wasn't long before I bought my first filters. I wanted to dabble in close-up photography, but being a youngster on a very limited budget, I certainly couldn't afford a specific macro lens. A set of close-up filters provided a cheap alternative and soon I was snapping the fascinating miniature world beneath my feet. In fact, it was a photograph of pairing dragonflies, taken using a +4 dioptre, that won me my first photography award; encouraging me to pursue a career in photography.

Soon, I was well and truly hooked. I began taking pictures of the stunning scenery near where I live in Cornwall, England, but the results were disappointing; lacking impact, saturation and suffering from either washed-out skies or dark, underexposed foregrounds. Up to this point, I hadn't fully recognized the importance of using filters; in fact I thought the majority were gimmicky and designed to create an artificial look of some sort. I was wrong. Soon after, I read a magazine article about using filters and learnt that many were designed to enhance reality, not alter it. Shortly afterwards, I went out and

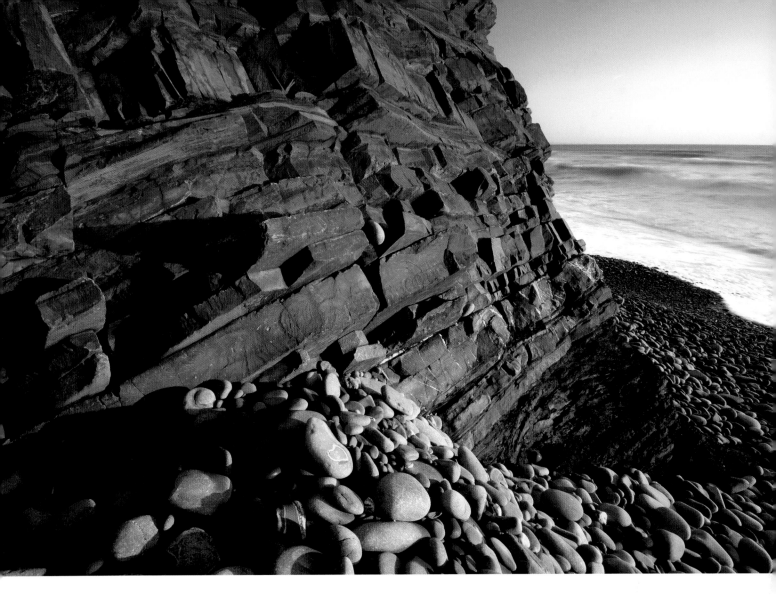

SHORELINE
Don't feel obliged to add filters to every shot you take. There will be times when the light and conditions are so good that you shouldn't meddle – simply arrange your composition and shoot.
Nikon D200, 10–20mm lens (at 11mm), ISO 100, 1/4sec at f/22, tripod.

RED DAHLIA
Without a close-up attachment, I wouldn't have been able to capture this frame-filling image. The subtle lighting helped saturate colour and, to maximize the available depth of field, I carefully positioned the camera's sensor plane so it was parallel with the flower head. I cropped the image into a square format post-capture to emphasize the natural symmetry of the subject.
Nikon D70, 50mm lens, ISO 200, 1/30sec at f/11, +4 dioptre, tripod.

bought a Cokin filter holder, a polarizer, a set of graduated neutral density (ND) filters and a couple of warm-ups; the quality of my photography quickly improved. I marvelled at how, simply by rotating the filter in its mount, I could use a polarizer to saturate colour and deepen blue skies, and was grateful that, by carefully positioning a graduated ND filter, I could balance awkward, uneven exposures. I couldn't get enough of filters.

However, like many photographers, I soon found myself getting carried away. I made the mistake of going from one extreme to the other, relying on filters too heavily and using them in the wrong situations or when they weren't really needed. Naturally, this had a detrimental effect on my shots. I quickly learnt that I had to match the right filters to the subject matter – and that, on occasions, it is best not to attach a filter at all. It is important to remember that, while they are capable of producing great results, filters cannot miraculously transform a bad image into a good one; the light, composition and conditions need to be suitable in the first place. I learnt the hard way, but looking back it was an important learning curve, which in the long term has benefited my photography.

DIGITAL FILTRATION

Digital capture has revolutionized photography. By its nature, digital encourages photographers to be more creative and experimental in their approach. When using film, the effect of some filters was not truly apparent until the picture was returned from the lab. Now, it is possible to review images immediately after releasing the shutter, via image playback. This gives you the luxury to make changes, or subtle adjustments, to filtration when required. Although filters continue to play a vital role in my

photography, it is now possible to mimic the effect of some filters by using image-editing software on a computer. Thanks to post-processing, it is also possible to create a variety of new effects. Digital filters can be applied with greater precision and control than if done in-camera, and they negate the need to buy and carry a large variety of different filters. In addition to this, a digital camera's white balance (WB) setting can be employed to either correct or emphasize the light's colour temperature. But while image-editing software and your camera's WB facility might render some traditional filters redundant, it is simply not true that digital photographers have no need for them at all. Traditional filters continue to be essential accessories and, combined with post-processing techniques, it is possible to create better imagery than ever before.

Personally, I find filters beneficial in a wide variety of shooting situations and this book will dispel the widespread myth that they are chiefly aimed at and suited to scenic photography. By sharing my knowledge, I hope I can help you to sidestep some of the mistakes I've made along the way. *The Digital Photographer's Guide to Filters* begins by looking at the different filter systems available and then, chapter by chapter, the effects of polarizers, white balance, neutral density filters, graduated filters, soft-focus filters and supplementary close-up dioptres. Using friendly, informative writing and comparison pictures, I illustrate their individual usefulness. If you're new to photography, this should help you decide which filters to go out and buy; if you already have filters of your own, this book will help you get the most from your existing system. Having examined the various types of in-camera filtration, the book progresses to post-processing techniques, illustrating ways to correct, enhance and apply special effects to your images. By using easy-to-follow steps, I make it straightforward for you to replicate the effects on your home computer using your own images.

I hope that, after reading this book, you will feel encouraged and inspired to explore the fascinating and vast creative possibilities of using filters – both traditional and digital – and use them wisely to capture even better pictures.

MISTY LAKE
Filters cannot miraculously transform a bad shot into a good one; the light, composition and conditions need to be suitable first. I woke early to arrive at this reservoir to capture the morning mist rising above the water. The conditions were ideal for photography, but a combination of a polarizer and a graduated ND filter enhanced the scene further.
Nikon D70, 18–70mm lens (at 24mm), ISO 200, 1/13sec at f/18, polarizer, 0.6 ND grad, tripod.

MOORHEN
It's a common myth that filters are aimed solely at scenic photography. In reality, they can be useful to enhance almost any subject. When I photographed this moorhen, I altered the camera's WB setting to 'Cloudy'. This has given the image an attractive warm colour cast – replicating the effect of a traditional 81C warm-up filter.
Nikon D70, 100–300mm lens (at 300mm) with 1.4x converter, ISO 200, 1/300sec at f/7.1, tripod.

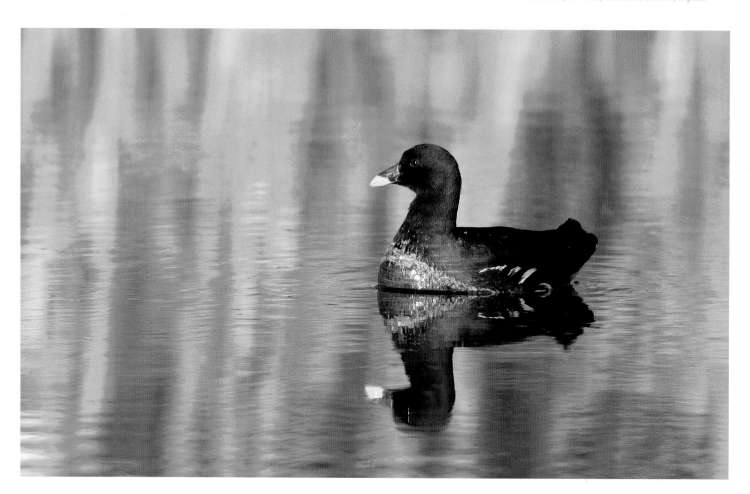

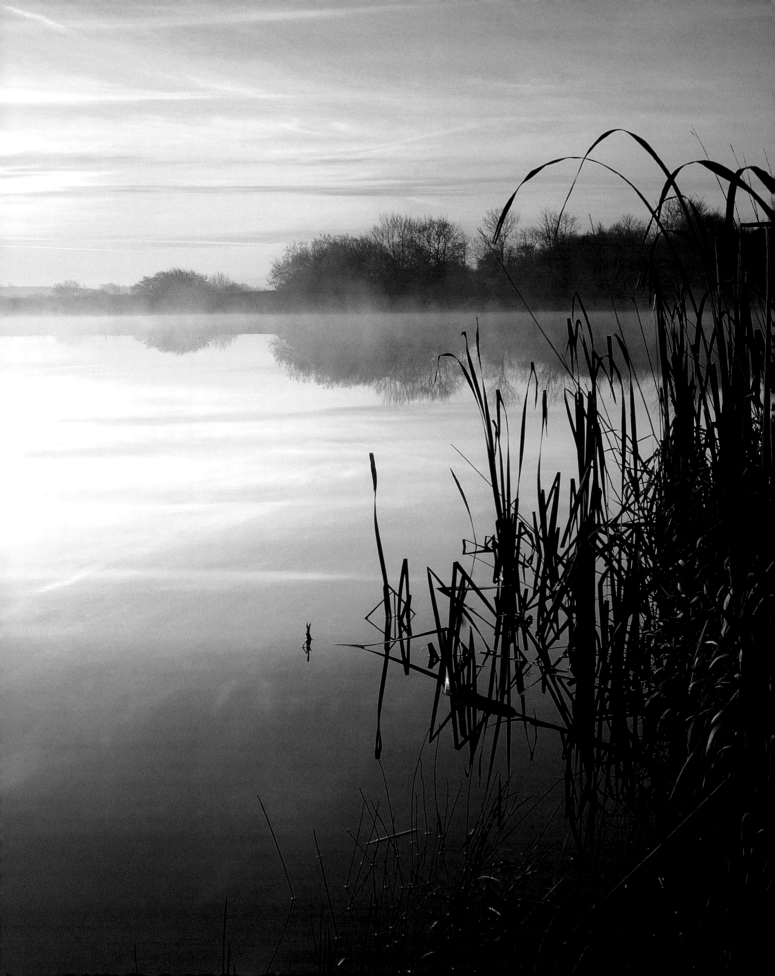

PART ONE: IN-CAMERA FILTRATION

Digital capture has transformed picture-taking. It has inspired a fresh generation of photographers, while re-igniting the passion of the more experienced. By its nature, digital photography promotes creativity and experimentation, but traditional filters have been doing this for years. Filters are designed to enhance a scene or subject and, used correctly, they will greatly improve your photography. Admittedly, digital capture gives photographers the freedom and luxury to add or mimic some filter effects at the post-processing stage. However, there are many advantages to filtering the light before it passes through the lens. There also remains something very magical and rewarding about creating an image at the moment of exposure.

CHAPTER ONE:
CHOOSING A FILTER SYSTEM

As a filter user, one of the biggest decisions you will have to make is which type of system to buy. Pop into your local camera store – or shop online – and you will be greeted with a huge choice of filter systems, types, sizes and brands. It can seem a daunting task deciding exactly what to buy. The cost can vary considerably, but sometimes spending more in the first instance can save you money in the long term. By arming you with the relevant information, the following pages will help you to make the right decisions, ensuring you invest in a system that will suit your personal filter requirements.

SLOT-IN OR SCREW-IN?

There are two distinct types of filter: slot-in or screw-in. Slot-in filters are square pieces of glass or optical resin, designed to slot into a specific filter holder, attached to the lens. Screw-in filters, as their name implies, are circular in design, so they attach directly to the front of your lens, via the filter thread.

Photographers often assume that you either opt for a traditional set of round screw-in filters or a modular slot-in system, but in reality it is not this straightforward. Both types have benefits and drawbacks. The screw-in varieties are handy for filters that you use regularly and for filters that protect the front element of the lens (page 47). However, for versatility and general use, a slot-in system is more practical, user-friendly and cost-effective in the long term. Like many photographers, I employ a hybrid system, using both types to suit different shooting situations.

SLOT-IN FILTERS

The main advantage of using a slot-in system is that you can use the same filters and holder on all of the lenses in your existing set-up. This is possible via adaptor rings, which are available to fit different thread sizes. The adaptor ring fits on to the filter holder, but the holder can be quickly released and coupled with a different ring. This is useful when you want to swap filters from one lens to another. Also, due to a holder's size and design, it is possible to use two or three filters together without the risk of vignetting (page 20). Holders are normally designed with three filter slots, making it possible to combine technical and creative filters to achieve different effects.

Despite the initial outlay, a slot-in system is the most cost-effective, compatible and hassle-free way to apply in-camera filtration, now and long into the future.

COMBINING FILTERS
I used a combination of filters to capture this atmospheric image: a polarizer, neutral density (ND) and graduated ND. Using three filters together without vignetting occurring was only possible due to a filter holder. I later cropped the image into a panoramic format, to suit the shape of the coastline.
Nikon D200, 10–20mm lens (at 13mm), ISO 100, 10sec at f/22, polarizer, 0.9 ND filter, 0.6 ND grad, tripod.

SCREW-IN FILTERS

Traditional circular screw-in filters are produced in specific thread sizes – for example, 52mm, 58mm and 77mm are all common fits. Therefore, it is important to buy filters that match the filter thread of your lens. Unfortunately, it is highly unlikely that one size will suit all the focal lengths in your current set-up and presuming that you have two or three different fits in your collection, you will have a compatibility problem.

It wouldn't be economical or practical to go out and buy a set of screw-in filters for each different thread size. Instead, step-down rings provide a simple solution. They are designed to adapt a lens's thread size, allowing larger filters to fit optics with a smaller diameter. However, if you are going to do this, remember it will be necessary to buy a set of filters that fit the largest diameter lens in your current system. Potentially, this could result in you having to invest in filters up to 77mm or 82mm in size. Not only will the initial outlay prove costly, but filters of this diameter will prove bulky and weighty in your camera bag. Also, while graduated screw-in filters are available, their design isn't suited to this filter type. Unlike the slot-in variety, where the filter can be slid up or down into the position of your choosing, graduated circular filters are inflexible. As a result, the fixed graduation zone will greatly dictate your composition, limiting your creativity.

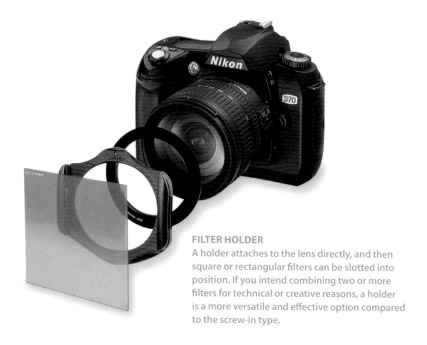

FILTER HOLDER
A holder attaches to the lens directly, and then square or rectangular filters can be slotted into position. If you intend combining two or more filters for technical or creative reasons, a holder is a more versatile and effective option compared to the screw-in type.

STEPPING RINGS

Stepping rings are designed to adapt a filter to a lens, when the two have differing filter thread diameters. For example, let's say you own a 77mm filter, but wish to use it in combination with a 67mm thread fit lens; a suitable step-down ring would allow you to do this. They are made from either metal or plastic, are relatively cheap and available in a wide range of sizes. There are two types of step rings: step-up and step-down. Step-down rings are used for attaching larger filters to smaller thread fit lenses. Step-up rings are used for attaching smaller filters to larger diameter lenses.

While step-down rings are a cost-effective way to expand the compatibility and usefulness of larger filters, step-up rings are less practical. Due to their nature, they greatly increase the likelihood of vignetting (page 20) – particularly when using a wide focal length lens.

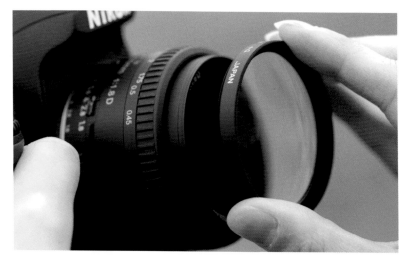

CIRCULAR FILTERS
Circular screw-in type filters can prove fiddly to attach and remove, but they are often the best choice for optical quality.

DOES SIZE MATTER?

Although certain types of screw-in filter – such as UV, close-up and polarizing – will always warrant a place in your camera bag, a slot-in system will prove the best long-term investment. Square filter systems are ideal for those who wish to invest in an expandable system, which can be attached to lenses designed with a different filter thread. Not only are slot-in filters generally less costly, but they can be attached and removed quickly, and are a much more convenient and practical way to use a combination of filters.

Slot-in systems are available in progressive sizes, designed to suit varying budgets and capabilities. There are three popular systems that are aimed at 35mm-equivalent digital photography: 67mm, 84/85mm and 100mm.

BUDGET SYSTEM – 67MM

This is an entry-level system, designed to work with lenses that have a filter thread no larger then 62mm in diameter. To prevent vignetting (page 20), a system of this size is only recommended for focal lengths of over 35mm. However, it won't be long before you will want to combine filters with shorter focal lengths and lenses with a larger diameter. Therefore, in the long run, its size will limit its usefulness.

Advantages – A good introduction to using a slot-in system. Low cost.

Disadvantages – Non-compatibility with short focal lengths will ultimately prove restrictive. Small size can make filters fiddly to handle and position.

ENTHUSIAST SYSTEM – 84/85MM

The next step up is the perfect compromise between cost and versatility, making it a popular choice with both amateurs and professionals.

Due to its larger dimensions, this system is compatible with wider focal lengths. Adaptor rings are available up to a filter thread fit of 82mm; this is more than adequate to cope with the majority of today's large-diameter, wide-

tip

If you are having problems with vignetting, consider adapting plastic Cokin P system holders by cutting off the front slot with a hacksaw. This might sound drastic, but it is not difficult to do. The maximum number of slots you should ever need is three, whereas the P holder is designed with four. The holders are relatively cheap, so some photographers invest in a couple, modifying them so they have two- and three-slot versions to suit different focal lengths.

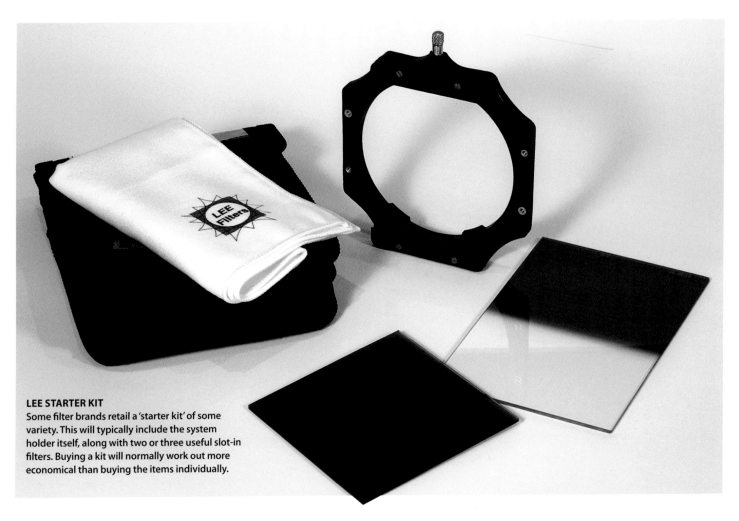

LEE STARTER KIT
Some filter brands retail a 'starter kit' of some variety. This will typically include the system holder itself, along with two or three useful slot-in filters. Buying a kit will normally work out more economical than buying the items individually.

COKIN P HOLDER

The Cokin P holder is at the hub of one of the most popular and widely used slot-in systems. Adaptor rings are available in a variety of sizes and there is a huge range of 84/85mm filters designed to fit this holder – produced not only by Cokin, but also by other filter brands.

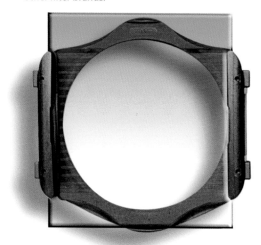

angle lenses. The larger size of both filter and holder alleviates the risk of vignetting.

Although the Cokin P and Hitech 85 holders are the most popular, other brands, such as Jessops and SRB in the UK, and Tiffen and Singh-Ray in the US, also produce compatible filters.

To help overcome the headache of using a polarizing filter in tandem with slot-in filters, many brackets are designed so a polarizer can be attached directly to the holder instead of the lens. This is possible via either an adaptor ring on the front of the holder or a slot at the rear of the bracket. This makes it straightforward to combine a polarizer and, say, a graduated filter, while still being able to control the position of both.

Thanks to the popularity of this size, there is a vast range of filters to choose from. If you are on a tight budget, opt for a less expensive brand. However, if money is less of an issue, it is worth investing the extra cash in a higher-quality filter.

Advantages – Large range of filters and brands to choose from. Cost still relatively low.

Disadvantages – Vignetting may still occur on super wide-angle lenses. Lower-quality filters are easily scratched.

PROFESSIONAL SYSTEM – 100MM

Systems of this size are primarily aimed at the semi-pro and professional end of the market. There are a number of different systems, and

adaptor rings usually go up to 105mm, allowing filters to be combined with large-diameter optics.

A 100mm system is the preferred choice for many professional scenic and travel photographers, including me. Cromatek, Cokin and Hitech are among the brands producing systems of this size. Lee markets one of the most popular 100mm systems currently available. Its bracket can be customized to suit your personal requirements. The filter slots can be adjusted to fit both 2- and 4mm-thick filters and it is also possible to remove or add slots – up to a maximum of four.

Although vignetting is unlikely when using a system of this size, specific wide-angle adaptor rings are also available, designed with a recessed

thread. This allows the holder to sit further back on the lens, preventing vignetting even at extremely wide focal lengths.

The vast majority of systems this size will accommodate a polarizer, either by design or via an optional adaptor ring; however one the size required to fit a 100mm bracket – typically 105mm in diameter – will prove costly. Despite this, if your budget allows, a 100mm filter system is the most flexible on offer to digital SLR (DSLR) users – not just now, but long into the future.

Advantages – More versatile. Large choice of compatible high-quality resin and glass filters. Little or no risk of vignetting.

Disadvantages – Cost of holder and compatible filters are increasingly expensive.

Filters for compact cameras

Today's breed of compact, high-resolution digital cameras are more than capable of producing quality results, almost comparable with a DSLR. However, the majority of digital compacts are not designed with a filter thread, which can prove frustrating. Although it is possible to manually hold a filter in front of a compact's lens, or stick it in position using temporary adhesive, this can prove fiddly and you also risk scratching the filter. Thankfully, there is a better solution. Cokin and Tiffen have designed specific filter holders, which attach to the camera via the tripod screw thread.

DIGI-HOLDER

Cokin's G350 Digi-Holder accepts 67mm A-series filters, housing a maximum of four at one time. The holder is constructed with a flexible rail, so the user can align the holder centrally over the camera lens.

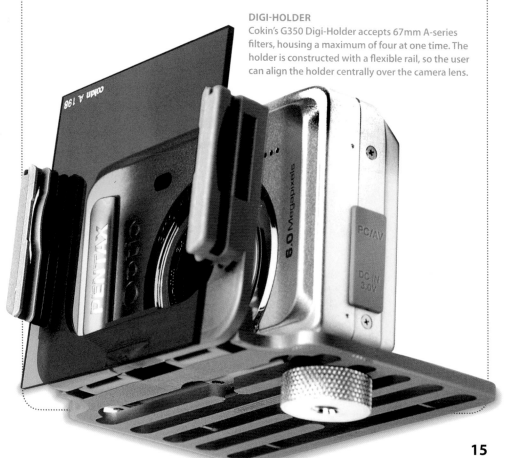

FILTER BRANDS

There are a variety of filter manufacturers worldwide, vying for your business. Some produce both screw-in and slot-in filters, while others specialize in just one type. With such a healthy choice of filters, systems and brands, it can prove a little daunting knowing 'who's who'. To help you, here is a brief overview of the most popular filter brands available, both in the shops and online.

B+W

B+W is a German manufacturer, who many consider produces some of the finest-quality glass filters. Its filters are diamond-cut from Schott optical glass, precision ground, and then polished to ensure flatness on both surfaces and uniform thickness throughout. B+W offers a range of screw-in type filters and their optical quality justifies their higher price tag.

COKIN

Cokin filters are the original square filters. French photographer, Jean Coquin, invented the concept of creative filter photography, designing a system that was simple, versatile and user-friendly. Today Cokin is one of the most widely used brands, producing a comprehensive range. Its most popular systems are the 67mm A (Amateur) series, 84mm P (Professional) series and 100mm Z-Pro series. Cokin also retails filter brackets to fit compact cameras (page 15).

CROMATEK

A British brand with a unique box-shaped 75mm filter holder. This acts as a lens hood, shading the front of the lens and any filters in use, which helps maximize colour saturation and contrast. The interior of the flip-open matte box has slots for filters and gels. Cromatek square filters have protective black rims with finger tabs for easy handling. A further slot on the front of the matte box enables the use of graduated filters in any intermediate position. The system also accepts an adjustable ProShade bellows lens hood. Cromatek also produces a cross-compatible 100mm holder and a range of technical filters.

HELIOPAN

Heliopan filters are produced from high-quality Schott glass – made by the German Zeiss group. Heliopan specializes in screw-in type filters, up to 105mm. They are constructed with a black anodized brass mount to eliminate binding or cross threading. In terms of quality and performance, Heliopan is one of the leading filter brands.

HITECH/FORMATT

The Hitech filter system is manufactured by Formatt filters and is British made. Hitech markets three different sized filter brackets. The 67mm system is an injection-moulded three-slot holder,

> ## tip
>
> *The majority of slot-in holders are cross-compatible, and this is a key consideration when buying a system. While some photographers prefer to stay loyal to one brand, most will base their filter choice on a mixture of cost and quality – not simply the make. For example, the Cokin P and Hitech 85 holders will accept filters from the other's range. Therefore, you might decide to buy Cokin's inexpensive P holder and adaptor rings, but invest in Hitech filters. The choice is yours.*

CROMATEK HOLDER
The Cromatek box-shaped filter holder is unique. It acts like a lens hood, by shading the front of the lens and any filters in use.

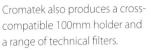

HOYA
Hoya is one of the leading manufacturers of optical glass and has a wide variety of circular, screw-in filters in its range.

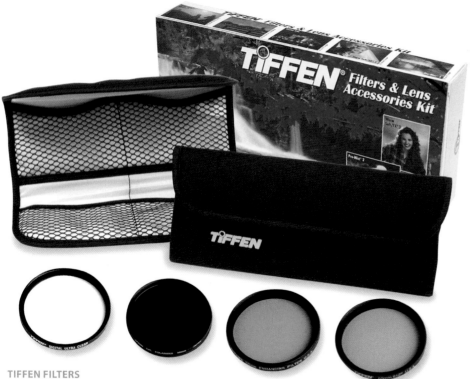

TIFFEN FILTERS
Tiffen is one of the leading filter brands, used by still photographers and Hollywood moviemakers alike.

while the 85mm and 100mm filter brackets are of an aluminium construction. The 100mm holder boasts a 105mm threaded front mounting ring – to accept a large polarizer or compatible lens hood – while the 85mm holder is designed with a 95mm accessory ring. Formatt offers a large range of cross-compatible glass and resin filters.

HOYA

Hoya is one of the largest producers of optical glass; an estimated 60 per cent of worldwide demand is met by this Japanese manufacturer. Hoya offers a wide variety of good-quality, affordable screw-in filters for use in all imaging applications. Its range of Digital Multi Coated (DMC) filters are designed to minimize lens flare and ghosting. Hoya also markets Low Profile Filters (LPF), constructed with slim mounts to help avoid vignetting when combined with wide-angle lenses. Hoya's black rimmed glass (BRG) filters incorporate glass designed to reduce the chance of light reflecting from the edge. Their knurling edge frame (KEF) filters are designed for non-slip, easy attachment and removal.

KOOD

Kood markets a large range of filters to fit 67mm, 84mm and 100mm filter brackets, fully compatible with other systems. Despite a budget price, Kood filters are durable and reliable, as they are made from the finest CR39 optical resin.

SRB-GRITURN

In addition to supplying standard filters, in both mounted and square formats, SRB-Griturn is a specialist manufacturer of adaptors and filter mounts. It is able to source filter materials covering a large range of unusual applications. The company's ability to manufacture bespoke mounts and attachments, in virtually any size or fitting, means it provides an unrivalled service to photographers – especially those whose equipment lacks the facility to take standard fittings, or who need a filter not normally available on the high street.

LEE

Lee is a UK manufacturer with a system developed with the professional photographer in mind. At the hub of the Lee system is its versatile 100mm holder. The unit is supplied in component form. This allows you to construct

a system tailored to your individual needs, capable of holding up to four filters. Lee markets a comprehensive range of quality 100mm technical and creative filters and accessories.

SIGMA

Sigma is best known as a high-quality independent lens manufacturer. However, it also produces screw-in UV and circular polarizing filters, ranging from 52mm to 105mm. Sigma's EX DG filters are digital-specific, benefiting from a multi-layer lens coating developed to counteract the reflective characteristic of image sensors. In addition, Sigma filters are designed to ensure an optimum, neutral colour balance, increasing the white balance accuracy of your digital camera.

TIFFEN

Tiffen is a renowned and long-established American award-winning filter brand, marketing a large and comprehensive range of filters. Its precision-made filters are sold with ten-year warranty against manufacturing defects. Unlike ordinary batch-dyed glass filters, in which colour can be uneven, Tiffen's ColorCore™ technology process allows complete control over colour and density. Tiffen's products are not only used by still photographers, but also by many Hollywood filmmakers.

LEE HOLDER
The Lee system is supplied in component form. You can then customize the holder by selecting and fitting the required filter guides with the screwdriver provided.

STORAGE AND CARE

Filters, regardless of their type, size, make and cost, should be looked after with great care. Neglect will result in scratches, minor dents or damage that will ultimately degrade image quality and enhance the risk of flare. Filters are optical accessories and should be treated with the same care and respect you would give a lens. By handling and storing your filters with consideration you will not only maximize their performance, but also their working life.

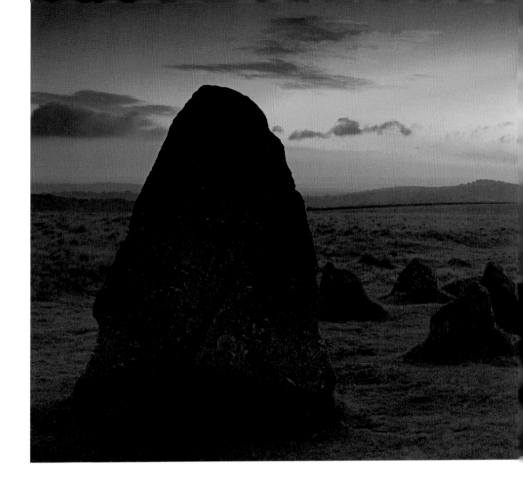

FILTER WALLET
Lee produces a specific, zip-around filter wallet, designed to hold up to ten square or rectangular filters safely. A zippered soft case, designed for CDs, can also be used for filter storage.

STORING

A protective box or wallet is normally provided when you buy individual filters, and these offer adequate protection while the filter is not in use. This method of storage is fine for screw-in filters, but it can prove bulky and fiddly if you own a number of the slot-in type. It is far more convenient to store them all together in one specific pouch, designed with individual pockets. Housing them together in this way will make it easier for you to access the filters you require quickly. There are a variety of storage wallets available that will store ten or more filters. Alternatively, consider buying a small, zippered soft wallet manufactured for CDs. Most have a minimum of 12 pockets and are large enough to be suitable for 67mm and 84/85mm slot-in filters. They tend to cost less than purpose-made filter wallets, yet offer similar protection. To help keep your system well organized, write on the front of each pocket which filter is inside.

CLEANING AND CARE

Regardless of how carefully you store and handle your filters, inevitably they will become dirty or smudged with greasy fingerprints over time. They are important optical accessories, so filters should receive the same care and attention you would give to the front element of a camera lens. Therefore, before cleaning, use a blast of pressurized air (available in aerosol cans) to remove any dust or debris. Only clean your filters using cleaning fluids specifically designed for this purpose, along with a lens tissue or a micro-fibre lens cloth. Personally, I find the best way to

tip

It is easy to over-tighten a screw-in filter or filter ring, resulting in it becoming jammed. Although this is frustrating, try not to exert too much pressure in your attempt to release it, as this can distort or damage the filter. Instead, invest in a filter wrench. They don't cost much, but are designed to apply even pressure around the filter to loosen it.

remove greasy marks, or salty sea spray, safely is first to breath on the filter and then wipe the surface gently with a lens cloth.

Although it is important to keep filters dirt free, only clean them when it is essential. Repeated cleaning will put fine scratches on the filter's surface. This is unavoidable. As a result, flare will become harder to avoid in bright sunlight, or worse, points of light – resembling stars – may appear when you peer through the filter. Should this happen, there is no alternative but to replace the filter. Thankfully, with good care, this shouldn't be necessary for many years.

FLARE
Due to regular use and repeated cleaning, your filters are bound to suffer from fine scratches and minor damage. Filters that have become badly scratched over time will need replacing, otherwise image quality will be affected and flare – clearly apparent in this image – will become progressively more difficult to avoid.
Nikon D70, 18–70mm lens (at 28mm), ISO 200, 1/4sec at f/16, 0.9 ND grad, tripod.

POLYESTER FILTERS
Polyester gels can produce great results, but will not last if used regularly.

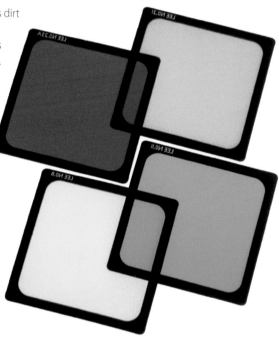

FILTER MATERIALS

The material used to manufacture the filter will, to a point, dictate its quality and lifespan. Polarizers, and many screw-in filters, are normally fashioned from optical glass, while the majority of slot-in filters will be made from rigid optical resin plastic known as CR39. Some brands also market polyester filters, commonly referred to as 'gels'.

Glass filters offer better optical quality and are also more resistant to becoming scratched or damaged through repeated cleaning. However, they are more costly, weighty and fragile; if you drop a glass filter, there is a good chance it will shatter.

Typically, slot-in filters are made from resin. Although they are easier to scuff or scratch, they are tough and don't break easily. Handled with care, resin filters will have a long working life, while producing high optical quality.

Polyester gels are normally mounted in a plastic frame so that they can be used in a conventional holder. Despite being thin, flexible and inexpensive, they are capable of excellent results. However, they are delicate and easily damaged, so they will not withstand regular use.

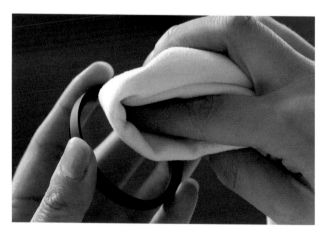

CLEANING
With repeated use, filters will inevitably get dirty. They need to be cleaned with care. First, remove dust and debris using a blast of pressurized air and then gently clean using a purpose-made lens cleaning cloth.

VIGNETTING

Presuming that you store and handle your filters carefully, and clean them when necessary, problems with your filters should be rare. However, the one major reoccurring trouble with using filters is vignetting. This is a term used to describe the darkening of an image's corners and one that you will come across frequently in this book.

CAUSE AND EFFECT

Vignetting is caused by the filter(s) – or holder – obstructing the light reaching the corners of the frame. Most commonly, vignetting is the result of stacking two or more screw-in filters together in combination with a short focal length lens. It can also occur if a filter holder is positioned at an angle, instead of straight. By their very nature, super wide-angle digital lenses are increasingly prone to this problem. Focal lengths of 10–18mm will almost certainly suffer from vignetting, unless a 100mm system holder is used with a specific recessed wide-angle adaptor ring. You might imagine that its effects would be immediately obvious when you peer through the camera's viewfinder, but it can easily go undetected due to the fact that, typically, the viewfinder of a DSLR camera displays only around 88–97 per cent of the total image area. Consequently, vignetting is often only obvious when you view the resulting image on screen.

PREVENTION IS BETTER THAN CURE

The simple answer to overcoming vignetting is to remove one of the attached filters, but this can prove frustrating, as the filter will have been attached for a reason. Instead, try increasing the focal length slightly. It is often a fine line whether vignetting will occur or not. For instance, when using my 10–20mm super wide-angle combined with a filter, I've found that darkening of the image's corners occurs at its widest setting, but not at 12mm. Such a slight adjustment is well worth making.

If you need to employ multiple filters, it is far safer to use slot-in filters in a holder. Vignetting is still possible, but less likely. It is a good idea to rotate the holder while looking through the viewfinder, to see if vignetting is caused. This can be a problem with some holders, but it is easily avoided by keeping the filter slots square.

Vignetting can also be corrected post-capture by using the Clone Tool in Photoshop. This is simple enough if the affected area is of single, regular tone, such as sky or clouds. However, if vignetting is affecting an area of detail, the result of cloning adjacent pixels may be difficult to disguise.

VIGNETTING
The effects of vignetting, caused by a circular polarizer, are obvious in the top corners of this photograph. Although in this instance it would be simple enough to remove the dark corners – using the Clone Tool in Photoshop – it is far better to avoid the problem in the first place.
Nikon D200, 10–20mm lens (at 10mm), ISO 100, 1/8sec at f/22, polarizer, tripod.

FILTERS AND EXPOSURE

A large percentage of filters reduce the amount of light entering the camera and reaching the image sensor. A standardized measurement, known as the 'filter factor' is used to indicate exactly how much light will be lost. The higher the filter factor the greater the light loss.

For example a filter with a factor of 2x would require an exposure increase of 1 stop, 4x 2 stops, 8x 3 stops and so on. To prevent images coming out too dark (underexposed), the exposure needs to be adjusted accordingly.

Thanks to the accuracy and reliability of modern through-the-lens (TTL) metering, photographers do not need to worry about recalculating the length of exposure themselves. Presuming that you meter with the filter in place, the camera will automatically compensate for the loss of light induced by the filter. However, it is still helpful to be aware of the effect a filter is having on exposure time.

Filter factor

A filter's factor should be printed either on its mount, box or on the filter itself. Although your digital camera's TTL metering will take into account the factor of the filter attached, this table lists the exposure compensation necessary for a selection of popular filter types.

Filter type	Filter factor	Exposure increase
Polarizer	4x	2 stops
0.1 ND	1.3x	1/3 stop
0.3 ND	2x	1 stop
0.6 ND	4x	2 stops
0.9 ND	8x	3 stops
ND graduates	1x	None
Skylight	1x	None
UV	1x	None
Soft-focus	1x	None
Close-up	1x	None

EXPOSURE COMPENSATION

UNFILTERED: No filtration was used for this frame.

FILTERED WITHOUT COMPENSATION: I attached a polarizer to saturate colour and a 0.9 ND grad to emphasize the dark, stormy sky, but didn't adjust for the polarizer's 2-stop filter factor. The result is grossly underexposed.

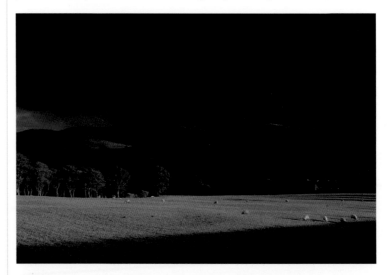

FILTERED AND COMPENSATED: For this image, I adjusted the exposure settings accordingly. The result is perfectly exposed and far more dramatic then the original unfiltered image.

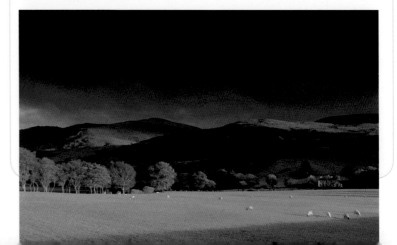

CHAPTER TWO:
POLARIZING FILTERS

Without doubt, the most useful and important filter available to buy – and the one that will spend most time attached to your camera lens – is a polarizer. It has a unique mechanism that enables it to absorb polarized light, reducing glare and reflections and enhancing colour saturation. Unlike other filters, it has a rotating outer ring, which, when turned, varies the polarizing effect. Although best known for its ability to saturate clear blue skies, a polarizer's usefulness extends far beyond this, as this chapter will reveal. If you only ever buy one filter, make it a polarizer – it will transform your photography.

HOW POLARIZING FILTERS WORK

A polarizer is like no other filter. By simply rotating it in its mount you can bring your images to life, by eliminating glare, reducing reflections and enhancing saturation – effects that are impossible to replicate on a computer. To understand how this is possible, you first need to understand and appreciate the way light travels.

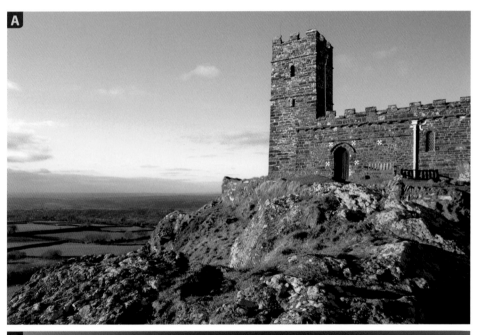

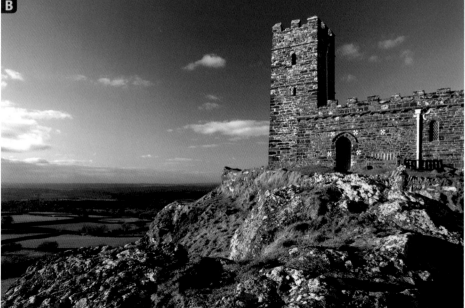

UNDERSTANDING LIGHT AND ITS EFFECT ON COLOUR

Light is transmitted in wavelengths. Light travels in straight lines, vibrating as waves in all directions – side to side, up and down and at all other possible angles. When light strikes a surface, a portion of the wavelengths are reflected and others are absorbed. It is the reflected wavelengths of light that define the colour of the surface it is striking. For example, a red-coloured object will reflect red wavelengths of light while absorbing all others. Similarly, green foliage absorbs all wavelengths of light other than those that form the green part of the visible spectrum, which it reflects.

POLARIZED LIGHT

Polarized light is different. It occurs either due to the reflection or scattering of light waves and travels in only one direction. It is these wavelengths that create glare and reflections, reducing the intensity of a surface's colour.

CHURCH VIEW

These two images were taken just a few moments apart, but are radically different. Image (A) was taken without any filtration. You can see that the colours are dull and the image is lifeless. The photo is little more than a snap. I took image (B) using a polarizing filter. The effect on the sky and landscape are obvious. The sky is a deep blue, the clouds are more defined and the colour of the landscape is saturated, illustrating the positive effect that a polarizing filter can have on your photography. *Nikon D200, 18–70mm lens (at 18mm), ISO 100, 1/15sec at f/14 (A), 1/4sec at f/14 (B), polarizer (B only), tripod.*

GERBERA
Polarizers are best known for saturating skies and colour within a landscape, but by reducing glare and reflections, they are equally useful for shooting flowers and foliage.
Nikon D70, 105mm lens, ISO 200, 1/15sec at f/2.8, polarizer, tripod.

A polarizing filter is designed to block out polarized light, therefore restoring contrast and colour saturation.

A polarizing filter is made from a thin sheet of polarizing material, which is sandwiched between two circular pieces of glass. The front of the filter's mount can be rotated, affecting the angle of polarization and therefore altering the amount of polarized light that can pass through the lens to the image sensor. So, simply by rotating the filter, you can achieve precisely the degree of polarization you desire.

Although the direction that wavelengths of polarized light travel in is inconsistent, the point of optimal contrast can soon be found. This is best determined by looking through the camera's

Linear or Circular?

There are two varieties of polarizing filter available to buy – Linear and Circular. Knowing which type to buy has created some confusion among photographers in the past, but the answer is actually simple; only the Circular type will work properly in combination with your digital camera. Although both varieties are physically circular in shape and similar in appearance, the design of the Linear type will affect the metering accuracy of your digital camera. This is because modern autofocus cameras polarize some light inside the camera. If this light has already been polarized by a filter, a false meter reading is given. Circular polarizers are constructed with a wave-retardation plate, one-quarter of a wavelength thick, allowing the light waves passing through to rotate and appear unpolarized to the camera's metering system. Should you ever use a Linear filter with a digital camera, take a light meter reading before attaching the filter and then increase exposure time by 2 stops.

CIRCULAR NOT LINEAR
There are two types of polarizing filter, but only the Circular type will work properly with your digital camera.

To create eye-catching images with strong, vibrant colours, a polarizer is a must-have. In this instance, I rotated the filter until the clear, blue sky was fully saturated. This contrasted perfectly with the unusual, colourful geology.
Nikon D200, 10–20mm lens (at 11mm), ISO 100, 2sec at f/25, polarizer, tripod.

viewfinder while slowly twisting the filter in its mount. As you do this, you will notice reflections come and go and the intensity of colour strengthens and then fades.

WHEN AND WHEN NOT TO USE A POLARIZER

Polarizing filters are best known for their ability to darken the colour of a clear blue sky, although the strength of this effect varies depending on the angle of the camera in relation to the sun (pages 26–27). Some surfaces remain unaffected by the polarizing effect. For example, metallic objects do not reflect polarized light patterns, so there is little point in using a polarizing filter in combination with these subjects.

The amount of polarization is at the discretion of the photographer. The most flattering, natural results will not always be achieved at full polarization and the effect of the filter can sometimes be too strong (page 33). Also remember that the effect of the filter will depend on its exact rotation; if you adjust the focusing of the lens, either manually or through autofocus, you also alter the degree of polarization.

ADAPTOR RING
Polarizers are produced in a range of filter threads, so it is important to buy one that will fit your lens. However, it is unlikely that all the lenses you own will share the same filter thread – so you will need to invest in several sized polarizers, which can prove costly. Thankfully, larger systems allow you to attach a polarizer to the front of the holder – normally 105mm in diameter – meaning that only an adaptor ring is needed to swap the filter between optics with differing threads.

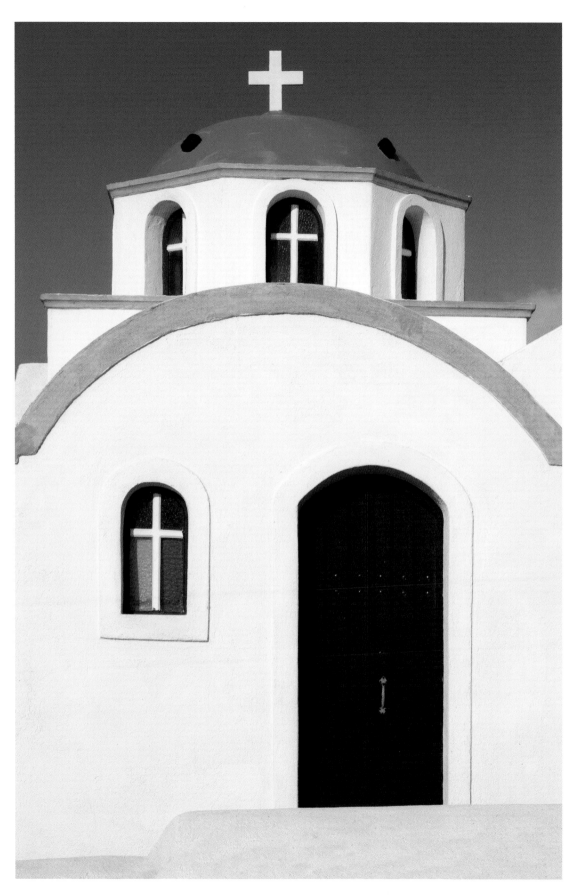

GREEK CHURCH
A clear, blue sky will benefit from being polarized, even when it isn't a prominent part of the image. While the church rightly dominates the frame, the sky still plays a significant role – acting as a complementary backdrop.
Nikon D2x, 28–105mm lens (at 55mm), ISO 100, 1/80sec at f/11, polarizer, tripod.

tip

For most photographers, a polarizer is the single most important filter you will ever buy. Therefore, it is wise to opt for the best quality glass you can afford. For example, German optical glass is renowned for its high quality. While you might spend more initially, as long as you take proper care of your filter (pages 18–19), it will prove a good, long-term investment.

BLUE SKIES

Once you begin to recognize the benefits of using a polarizer, you will find that it spends more time attached to your lens than any other filter. Polarizers are best known – and most commonly used – for their ability to strengthen the intensity of blue skies, but there are also other benefits.

When using a polarizer, clouds will stand out boldly against their deep blue background and, on bright days, this effect can look stunning. Other subjects captured against a polarized sky will also look more dramatic – trees, birds and buildings, for example. This is not simply due to the darker sky making light, contrasting subjects appear more prominent, but also because the filter helps to cut through haze, improving clarity and subject definition.

WHY IS THE SKY BLUE?

It is useful to understand why a polarizing filter has such a dramatic effect on blue skies. In basic terms, a polarizer works by reducing the light reflecting off the particles in the atmosphere, allowing us to view the sky as a deeper shade of blue. The atmosphere contains both air molecules and tiny suspended particles – smaller than a wavelength of light – both of which scatter light. This is known as Rayleigh scattering, named after British physicist Lord Rayleigh. This scattered light is polarized, which is why polarizing filters work so effectively to deepen the colour of skies. This scattering effect has a greater influence on shorter wavelengths of light. Short light wavelengths are blue-violet in colour, which is a major contributing factor to why the sky appears blue. Skies at high altitudes tend to be naturally darker as there is less Rayleigh scattering. This is also why our moon's sky is black, since there is practically no atmosphere and therefore no scattering of light.

SATURATING BLUE SKIES

The effect of a polarizer on the sky will vary greatly depending on the angle of the camera in relation to the sun. The angle that produces the strongest level of polarization is known as Brewster's angle, and can be found by keeping

TREE
Clear, saturated skies are an ideal backdrop for a wide variety of subjects. The stark, white trunk and branches of this tree contrast perfectly with the deep blue sky behind.
Nikon D200, 18–70mm lens (at 18mm), ISO 100, 1/50sec at f/7.1, polarizer, handheld.

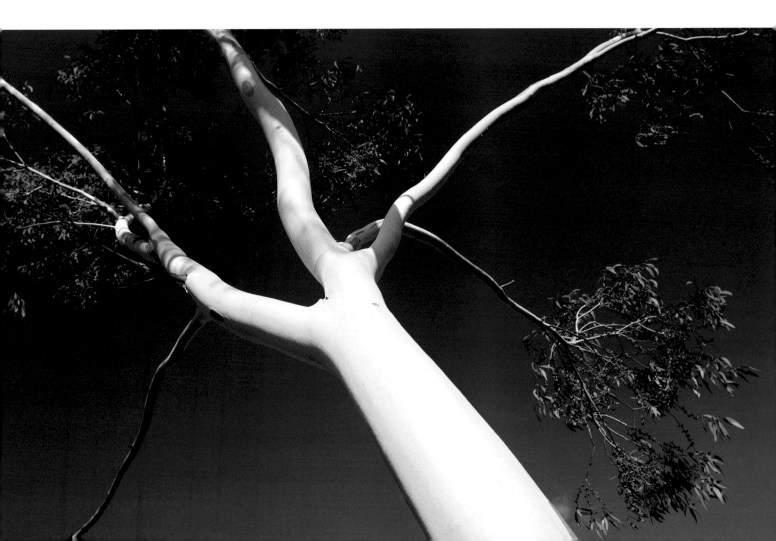

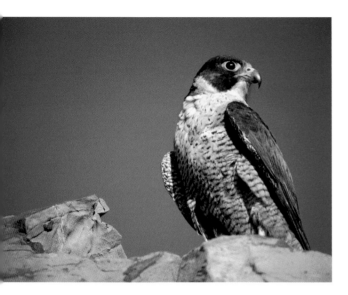

FALCON
When I photographed this peregrine falcon, I deliberately selected a low viewpoint to contrast the bird against a polarized sky. Due to the bright, sunny conditions, the filter's 2-stop filter factor didn't make the shutter speed impractically slow.
Nikon D70, 300mm lens, ISO 200, 1/180sec at f/8, polarizer, tripod.

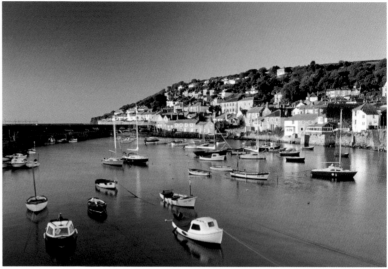

FISHING HARBOUR
One of the key ingredients to creating a successful image is colour. There is no comparison between a polarized and non-polarized shot. In this image of a quaint fishing village, the intense colours of the sky are a sure giveaway to the use of a polarizer.
Nikon D70, 18–70mm lens (at 18mm), ISO 200, 1sec at f/22, polarizer, tripod.

the sun at right angles to the camera. This is because the sun contains most polarized light in the areas that are at 90 degrees to the sun. The polarizing effect will appear more pronounced during morning or afternoon, when the sun is lower in the sky, but less evident when the sun is overhead during the middle of the day. A polarizing filter has little or no effect on hazy, cloudy skies.

BLUE SKIES DON'T JUST SUIT LANDSCAPES

Although polarizers are most commonly used to shoot landscapes, they are ideal for architecture, especially when photographing modern buildings or bridges from low, interesting viewpoints. Equally, a blue sky provides a colourful and complementary background for trees and flowers, particularly those boasting strong colours of their own. For example, a bright yellow sunflower or red poppies will stand out boldly against a deep, polarized sky, producing an image bursting with impact. Birds and wildlife also look good posed against a blue backdrop. However, polarizing filters designed to fit large-diameter telephoto lenses can prove costly. Also, the loss of light induced by its filter factor (page 21) can make these impractical should you wish to capture flight or movement.

WARM POLARIZING FILTERS

Polarizing filters can induce a slight bluish cast, cooling down the colour temperature of the prevailing light. To combat this, some filter brands, such as B+W and Tiffen, market a warm polarizing filter. Hoya also produces a version called 'Moose's filter', a warm-tone screw-in polarizer made to the specification of American wildlife photographer 'Moose' Peterson. They combine the effects of a polarizer with an 81A warm-up filter in a standard 8mm depth mount. The 81A glass creates a more pleasing and 'warm' colour balance to the entire scene. It also restores any deficiencies in the light's colour temperature without the aid of another filter. However, digital photographers can just as easily mimic the effects of a warm-tone polarizer by adjusting their WB setting by +200–300k (page 34).

tip

The polarizing effect is greatest at 90 degrees to the sun. An easy way to find this angle is to make a 'gun' with your forefinger and thumb. Point it at the sun and then rotate your thumb 90 degrees either side. In either of these directions, the polarizer will have its greatest effect.

FOLIAGE

Many photographers invest in a polarizer for its ability to deepen blue skies, not realizing that it has many uses besides. For example, by reducing the glare reflecting from foliage, it is able to intensify its colour. Glare is created by polarized light. This often appears as a reflective sheen, especially when a reflective surface, such as foliage, is viewed in bright, sunny conditions. This glare significantly reduces colour saturation, weakening the impact of the resulting images. By aligning the filter's polarizing foil so that it blocks the polarized light, you can restore colour intensity.

It is important to remember that eliminating this type of glare can only be achieved effectively in-camera at the point of releasing the shutter – no post-capture technique will have the same dramatic effect as using a polarizer.

FLOWERS AND LEAVES

A polarizing filter will make a huge difference to your woodland and garden images. Colours that appear dull, flat and washed-out will be transformed, looking crisp and vibrant. You will notice the biggest difference when photographing foliage that is damp, perhaps after a recent downpour. Wet leaves tend to

reflect even more stray light, reducing the apparent saturation. Peer through the viewfinder while rotating the polarizer within its mount, and watch the colours transform and intensify – there really is no comparison between a polarized and non-polarized shot.

When photographing woodland, or even garden images for that matter, I almost always attach a polarizer. I find it especially useful when I'm capturing fresh spring growth or rich, golden autumnal foliage. To saturate the warm colours even further, you can combine your polarizer with a red-enhancing filter (see box opposite) – the results can be stunning.

WOODLAND RIVER
You don't need to include blue sky in your images to enjoy the benefits of using a polarizer. I photographed this woodland scene following a night of heavy rain. The reflective glare from the damp moss, rocks and leaves greatly reduces colour saturation in the non-polarized shot (A). For image (B), I attached a polarizer, and the effect is dramatic. The green foliage and moss now look naturally fresh and vibrant.
Nikon D200, 10–20mm lens (at 12mm), ISO 100, 20sec at f/22, polarizer (B only), 0.6 ND filter, tripod.

tip
When rotating a polarizer – especially an ageing, well-used filter – it can be easy to loosen or inadvertently unscrew the filter on the lens. If you are not careful, this can result in the filter actually falling off. This can prove a costly error, so it is worth bearing in mind.

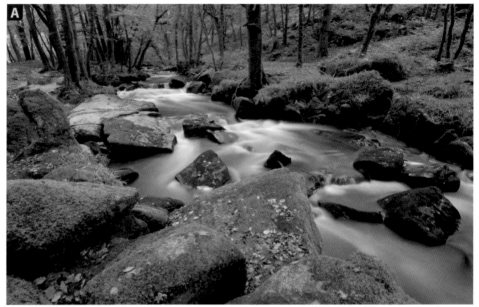

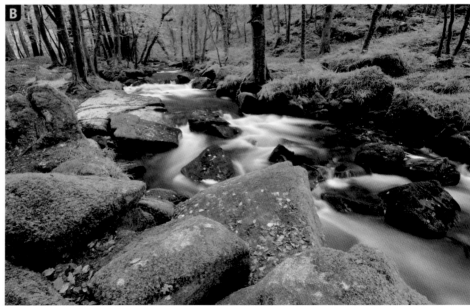

RED-ENHANCING FILTERS

Red is the most powerful colour of the spectrum and our eyes are naturally drawn towards it – even if it only occupies a small part of the frame. By reducing or eliminating glare, polarizers help saturate colour and emphasize warm tones, but they are not able to enhance red in the way specific enhancing filters do.

Enhancers work by deepening colours at the warmer end of the visible spectrum, in particular red, but other colours are intensified too; orange goes deeper, with a slight shift towards red, while yellows appear more golden. However, enhancing filters have a magenta colouring, so any light or neutral shades will adopt this hue. This can give white clouds an unnatural look. Also, shades of green will be weakened.

Red enhancers work well in combination with a polarizing filter. Digital photographers can also enhance the reds within their images by adjusting Hue and Saturation at the post-processing stage (page 92).

AUTUMN LEAVES
An enhancer will give warm colours added punch. I arranged these colourful leaves on the ground, composed my shot and attached a polarizer to reduce glare from their wet surface (A). To enrich colour further, I attached a red-enhancing filter (B). *Nikon D70, 105mm lens, ISO 100, 1/8 at f11, polarizer, red-enhancing filter (B only), tripod.*

FLORAL CLOSE-UPS

By removing glare radiating from the surface of foliage, polarizers are a must-have filter for photographers wishing to capture vibrant floral close-ups. That said, some macro photographers overlook polarizers, wrongly assuming that their usefulness only extends to skies and scenics.

By cutting through reflective glare, a polarizer is able to reveal a flower's true colour and beauty. Strong, saturated colours will help your images stand out. By controlling reflections, you can add apparent depth and texture to your subject and/or background. If you don't own a macro lens, it is fine to couple a polarizer with a close-up filter (page 64). Stacking the two filters together shouldn't cause vignetting, as it is likely you will be using a focal length upwards of 50mm. Of more concern is freezing any subject movement. Polarizing filters have a 2-stop filter factor, so shutter speeds slow as a result of using one. This isn't a concern when shooting indoors or on a still day. However, if it is breezy, the resulting loss of light may make your shutter speed too slow to record your subject acceptably sharp – thus making the use of a polarizer impractical.

SPRING GARDEN
When I took this shot, I employed a polarizer to saturate the fresh, vibrant foliage and colourful spring flowers growing in this quaint, country garden. *Nikon D70, 18–70mm lens (at 28mm), ISO 200, 1/20sec at f/20, polarizer, tripod.*

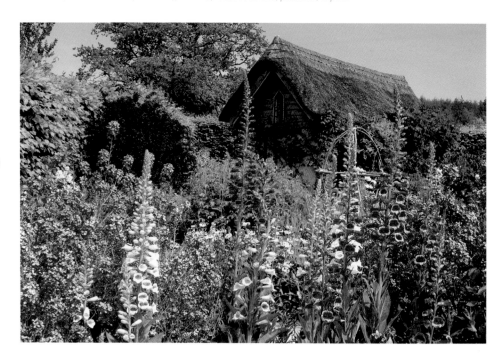

REFLECTIONS

Reflections can be either a good or a bad thing. A photograph of rolling hills or range of mountain peaks will be enhanced if they are also perfectly mirrored in a still, reflective body of water. In contrast, the light and glare reflecting from shiny surfaces can be ugly and distracting – for example, when you are photographing a modern glass building. By attaching a polarizer, you can carefully regulate the effect you desire; rotating the filter to either emphasize the reflections or eliminate them altogether.

WATER

Whether it is running water, delicate dewdrops or crashing waves, water is irresistible to photograph. Still, reflective water has even greater appeal. On still days a reservoir, lake, loch, canal or even a puddle will perfectly mirror its surroundings. In situations like this, centred horizons and symmetrical compositions often work well. With the reflection being a key ingredient to the image's success, you need to take care if using a polarizer to strengthen colour and deepen blue skies. Due to the filter's ability to cut through reflections, it can have a negative effect in situations like this. You may have to decide what is of higher priority – saturated colours and a deep blue sky, but poor reflections; or good, vivid reflections, but sky and colours that are weaker. If you are lucky, you won't need to compromise – the angle between the reflection and lens axis may be such that the reflection will remain unaltered. In fact, a polarizer can actually intensify reflections by removing the sheen from the surface of the water. Therefore, carefully regulate its effect on the reflections by peering through the viewfinder as you rotate the filter.

While reflections can benefit your images, they can sometimes prove undesirable. In situations like this, a polarizer should be attached to eliminate them altogether. For instance, Mediterranean seas will look transparent when polarized, revealing fish and coral that would otherwise remain hidden. If you wish to eliminate glare and reflections, the lens axis needs to be at a 30–45-degree angle to the surface. Sometimes, you will achieve the maximum effect – or near to it – through the way you would naturally compose your picture, but equally you may need to adjust your shooting position to get the effect you desire. Therefore, you need to weigh up what is more beneficial to the resulting image: removing the reflections, but possibly compromising the best composition; or prioritizing composition, but only partly removing the reflections. If unsure, it is best to take both for later comparison.

ABSTRACT REFLECTIONS

Polarizing filters can enhance reflections as well as diminish them. I attached a polarizing filter when I took this abstract image of a colourful fishing boat reflected in the water, rotating the filter until the sheen on the water's surface vanished – thus saturating colour further.
Nikon D50, 300mm lens, ISO 200, 1/180sec at f/11, polarizer, tripod.

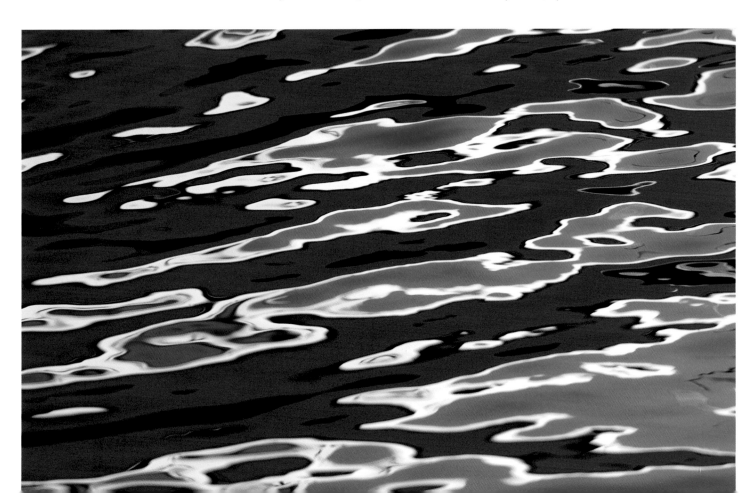

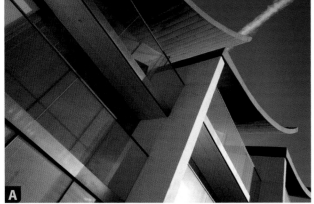

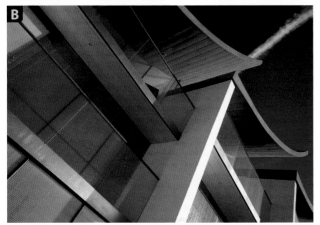

GLASS AND REFLECTIVE SURFACES

A polarizer is an essential tool if you enjoy shooting architecture and urban landscapes. The glare and reflections emitted from shiny surfaces can greatly degrade the look of the final image. Reflected light from any surface is polarized to some extent, with the degree of polarization related to the angle of incidence of light and the refractive indices of the two materials. Therefore, a polarizing filter will either tame or completely eliminate the reflections visible. However, the strength of the effect will depend on the camera angle in relation to the reflective surface – with the maximum effect achievable at an angle of 30–45 degrees. Say you wish to take an image through a glass window. Position yourself straight on at a 180-degree angle without a polarizer attached – you will see a reflection. Now, attach a polarizer and you will notice that, even when you rotate the filter, the reflection remains unaltered. However, adjust your shooting position so the camera is at a 30–45-degree angle to the glass. The reflected light is now 100 per cent polarized. Try rotating the filter again and the reflections will diminish or even disappear completely. Metal surfaces have only a very slight polarizing effect on light; consequently it isn't possible to achieve a significant reduction in glare or reflections.

◀ **APARTMENT BLOCK**
By shooting from a low angle, I was able to photograph this block of apartments contrasted against a clear blue sky. However, the glare and reflections radiating from the windows proved ugly and distracting (A). By using a polarizer, I was able to tame the reflections and restore colour saturation – producing a far stronger result (B).
Nikon D200, 10–20mm lens (at 17mm), ISO 100, 1/80 at f/11, polarizer (B only), handheld.

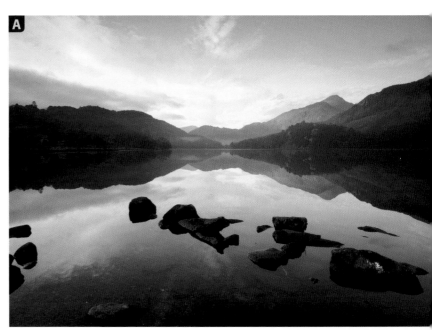

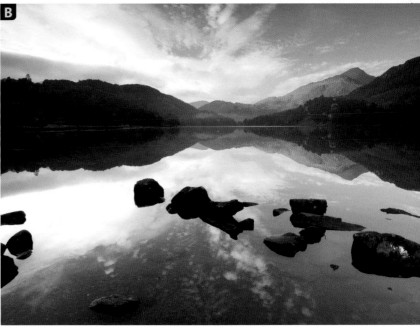

LAKE AND REFLECTION
Morning is often the best time of day to photograph still water. Check the weather forecast the night before and, if a still morning is predicted, set your alarm early. Due to a polarizer's ability to diminish reflections, it is often overlooked when shooting this type of scene (A). However, used correctly, it can actually enhance reflections (B).
Nikon D200, 10–20mm lens (at 16mm), ISO 100, 1sec at f/29, polarizer (B), 0.6 ND grad, tripod.

CROSS-POLARIZATION

In stark contrast to their traditional role, two polarizers can be combined together to create a surreal effect known as cross-polarization. By photographing a backlit transparent plastic object between polarizing materials, it is possible to create a kaleidoscope of colour. The abstract-looking results can prove particularly striking in close-up.

This isn't a technique that will be to everyone's taste, and probably not an effect that you will find useful very often. However, even if you only ever try cross-polarization once, you will have fun experimenting with the colourful, bizarre results it can create.

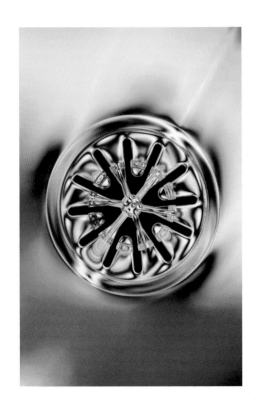

HOW TO CROSS-POLARIZE

Due to the way it is produced, plastic is generated with stresses. Although these aren't visible to the naked eye, through cross-polarized light the points of stress are revealed, appearing multicoloured. This strange, rainbow effect is the result of diffraction of white light into parts of the spectrum – with the most dramatic colours occurring at areas under most stress. Clear plastic geometry sets, cutlery and CD cases are among the objects that photograph well when shot through cross-polarized light.

To produce the cross-polarized effect, you need a light source and two polarizers. A lightbox is ideally suited to backlighting your object, as it can be positioned on the floor or a table, allowing you to easily set up your tripod and shoot from directly overhead. You now need to place a polarizer over the light source. A large-diameter polarizing filter can be employed to do this or, alternatively, buy a sheet of polarizing gel – available from craft or camera shops. Place your transparent plastic object on top of it, so the foil acts as a backdrop. Crop in tight to your subject for maximum impact, using either a macro lens or close-up filter (page 64) and compose your shot. Finally, attach a polarizing filter to your camera lens. With the plastic object sandwiched between the two polarizers, its appearance will completely change. Rotate the polarizer to intensify or weaken the effect, until you achieve the look you desire. Visible areas of the polarizer, covering the light source, will appear black if fully polarized, helping the colourful plastic stand out.

Cross-polarization shouldn't fool your camera's sophisticated TTL metering, but you may still find it helpful to bracket your exposure by 1 stop either side of its recommended reading to guarantee a perfectly exposed result.

RAINBOW COLOURS
This is just an example of the type of eye-catching, bizarre results that can be achieved by shooting clear plastic objects through polarized light.
Nikon D200, 105mm lens, ISO 100, 1/2sec at f/14, polarizers, tripod.

tip

Having arranged your set-up and composed your shot, before you begin taking pictures, make sure that you switch off the room lights. Overhead household lights can create distracting catch-lights on the objects and can also interfere with the camera's metering, meaning that you will get an inaccurate reading.

POLARIZING PROBLEMS

Although you shouldn't leave a polarizer on your camera lens at all times, you will almost certainly find it more regularly used than any other filter in your collection. However, there are one or two problems that you may encounter when using one, which can easily be avoided.

tip

If you are taking pictures of the view from an airplane window, do not attach a polarizer. Aircraft windows are birefringent – the amount of polarization depends on the wavelength – and this will create a rainbow of colour if a polarizer is used.

UNEVEN POLARIZATION

Polarization is uneven across the sky. It is at its maximum when facing 90 degrees to the sun and at a minimum at 180 degrees. As a result, when taking pictures at certain angles to the sun, you may find that the colour of the sky will be irregular. For example, you may find that the sky darkens more noticeably in just one area, due to the fact that this region contains more polarized light wavelengths, giving a rather odd effect. Wide focal lengths are the most prone to this problem because they are able to capture a broader expanse of sky – uneven polarization is virtually impossible to avoid when using focal lengths wider than 24mm. To sidestep this problem, select a longer focal length lens or adjust your shooting angle. However, if this just isn't practical, try positioning a graduated ND filter (page 48) at an angle so that it filters the lighter region of the sky. Although this isn't a faultless solution, it can greatly reduce the effect.

OVER-POLARIZATION

A deep blue polarized sky looks attractive, but it is also possible to overdo the effect. You will find that in some situations, a polarizer isn't needed at all as the sky is already saturated. If one is used the effect can be too great, with the sky being rendered almost black, which looks unnatural.

Over-polarization is more likely when photographing a blue sky overhead at high altitudes, because the sky can be almost 100

OVER-POLARIZED
Don't feel you always have to attach a polarizer to saturate blue skies. The undesirable effect of over-polarization is obvious in this image, with the sky looking artificially dark.
Nikon D200, 10–20mm lens (at 20mm), ISO 100, 1/80sec at f/8, polarizer, handheld.

per cent polarized. The effect should be obvious through the viewfinder, but replay your images on the LCD screen to check the sky remains natural-looking.

VIGNETTING

Polarizers are constructed with two pieces of glass. Therefore, the filter mount of some polarizers can prove quite deep, and at focal lengths below 20mm there is a genuine risk of vignetting (page 20) – even when using the filter on its own. Thankfully, many brands, including Hoya and Sigma, market ultra-slim screw-in polarizers aimed for combination with short focal lengths. They cost a little more, but are worth it.

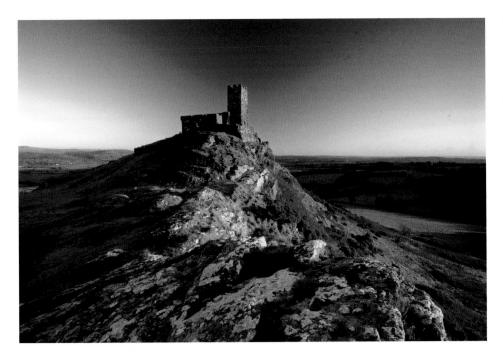

IRREGULAR POLARIZATION
Using a wide focal length enables you to capture large, sweeping views. However, by recording a broad expanse of sky, uneven polarization is likely to result. When I took this image, I used a focal length of just 12mm and you can see that the colour of the sky varies from one side to the other, being at its deepest in the centre.
Nikon D200, 10–20mm lens (at 12mm), ISO 100, 1sec at f/22, polarizer, tripod.

CHAPTER THREE:
WHITE BALANCE

White balance is a new term to photography and unique to digital capture. It is designed to correct undesired colour casts, produced by different temperatures of light. Although digital cameras can be programmed to set the amount of white balance automatically, this will not guarantee the most aesthetically pleasing results. To do this, the photographer should intentionally match – or mismatch – the white balance setting to the light available.

COLOUR TEMPERATURE

Every light source contains a varying level of the three primary colours: red, green and blue (RGB). The temperature of light is measured in degrees Kelvin (k). Lower temperatures have a greater percentage of red light and appear warmer. Higher temperatures have a greater proportion of blue light and appear cooler. At around 5,500k, light is considered neutral – white light.

COLOUR CASTS

If the colour temperature isn't balanced, a colour cast of some variety will be apparent. Our eyes naturally interpret the colour temperature of light – natural or artificial – and correct it so that we perceive it as white or neutral. It is for this reason that we will often find different light types indistinguishable from one another. An image sensor isn't quite as discerning as the human brain, which is why digital cameras have a white balance (WB) setting, programmed with a variety of WB pre-sets designed to suit different lighting conditions. The WB setting can also be set manually for added precision.

CREATIVE USE

Although white balance is primarily designed for correction, it can also be used for creative effect. The WB setting has now assumed the role of a variety of traditional filters, so it is important that digital photographers have a good understanding of how it is best manipulated. Before looking at the role of white balance in more detail, the series of images opposite illustrate how it is possible to radically alter the look and feel of an image by deliberately mismatching the WB setting with the type of light. The term 'white balance' is inherited from professional video. Videographers employ a type of oscilloscope, called a waveform monitor, to match or 'balance' the signals from the camera's red, green and blue channels. This makes whites appear neutral under different sources of light. In photography we depend on light to communicate colour – be it a single band or the entire spectrum. However, in conventional film photography, most photographers would take for granted the colour temperature of the light falling on their subject and how their film might react to and render it. The advent of digital has forced a change in attitudes towards colour temperature. White balance enables photographers to take full control over how the colour of light is captured, giving them more corrective and creative control than previously possible.

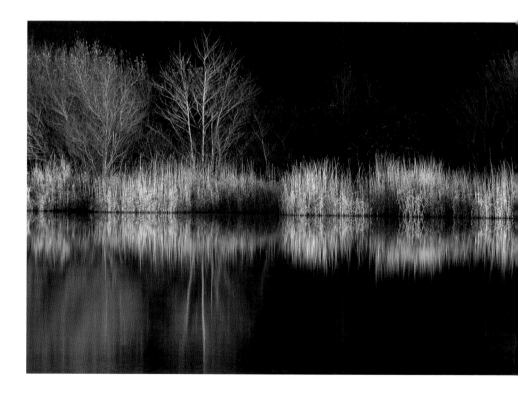

REFLECTED REEDS
It was a still winter's evening when I took this image of reeds reflected in a reservoir. Although the sun radiated a degree of natural warmth, looking at the replayed image in the camera's monitor I could tell that the shot lacked impact. Therefore, I selected a WB pre-set of 'Cloudy' to create a warm, orangey colour cast. This suited the scene far better than the 'correct' setting.
Nikon D70, 100–300mm lens (at 270mm), ISO 200, 1/30sec at f/11, tripod.

WHITE BALANCE PRE-SETS

AUTO: The automatic WB setting is designed with a large and flexible colour temperature range of 3,000–7,000k, making it well suited to the majority of shooting conditions.

DIRECT SUNLIGHT: This setting is designed to replicate the natural temperature of sunlight – assumed at 5,200k. This pre-set is suited to produce natural-looking results when the subject is lit by direct sunlight on a cloudless day.

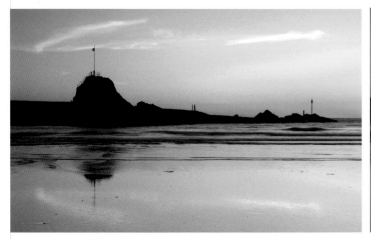

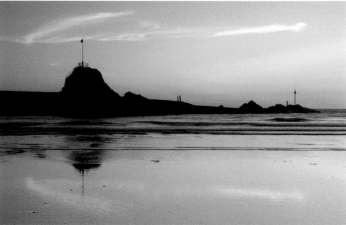

INCANDESCENT: With a colour temperature of 3,000k, this setting is intended for use under incandescent lighting, such as household lamps and street lighting. When used under ordinary lighting conditions, it will create a cold blue cast.

CLOUDY: A cool colour cast, created by overcast conditions, can be balanced by using the 'Cloudy' WB pre-set. With a colour temperature of 6,000k, it can also be used to create an attractive warm hue when applied under normal lighting conditions.

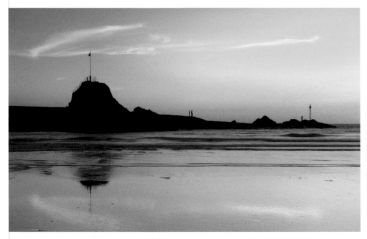

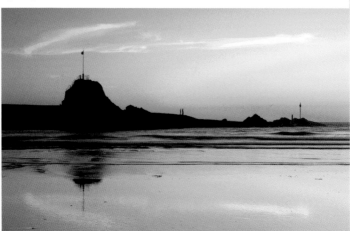

FLUORESCENT: The 'Fluorescent' pre-set is normally 4,000–4,200k. This will correct the warm light cast from stadium or strip lighting. In combination with natural sunlight, it will create a pleasant cool blue hue – subtler than the 'Incandescent' setting.

SHADE: Designed for when photographing subjects in the shade, this WB setting has a colour temperature of around 7,000–8,000k. Other than being useful for colour correction, it will create a strong warm cast, which can be used to enhance a sunset or autumnal colours.

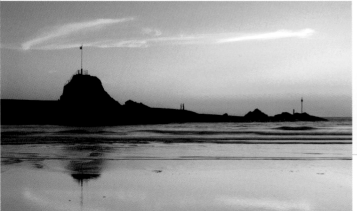

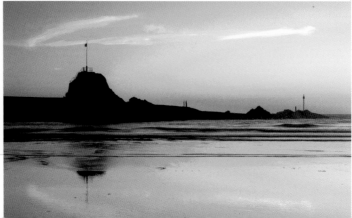

CORRECTION

Although white balance can – and should – be used creatively (page 38), essentially it is designed for correction. The colour temperature of light plays a hugely significant role in photography, greatly influencing the appearance and feel of pictures. If the light's colour temperature isn't correctly balanced, the light will adopt an unnatural colour cast.

ExpoDisc

The ExpoDisc is a WB filter, designed to help you achieve images with balanced colour in-camera, even in challenging lighting conditions. It works by allowing you to customize your camera's WB setting specifically for the light available. This virtually eliminates the need for post-capture colour adjustments. By taking an incident (the light illuminating the subject) light meter reading while the ExpoDisc is attached, you can confidently set your camera's custom WB setting for the ambient light. For the most accurate results, it is best to position the camera in the same lighting as the subject and point the camera back towards the location from where you will be taking the shot.

The ExpoDisc is simpler to use than a grey card, white card or calibration target and consistently produces accurate results in natural, artificial, mixed and studio lighting. There is also a warm balance ExpoDisc filter available, designed to give images a warm feel – ideal for portraits where you want warmer skin tones.

UNDERSTANDING COLOUR TEMPERATURE

It is easy to get confused by colour temperature values, as warm light has a low temperature, while cool light has a high temperature. This is due to it being based on a 'black body radiator' – a theoretical object that re-emits 100 per cent of the energy it absorbs as it is heated. As it grows progressively hotter, its colour changes from black, to red, orange, yellow, through to blue. The spectral output of any light source is said to approximate to a 'black body' at the equivalent temperature. As a result, at low colour temperatures light contains a high proportion of red wavelengths, and at high colour temperatures it contains a high proportion of blue wavelengths. For example, the concentrated light of a candle flame has a value of around

tip

To guarantee you achieve accurate WB, even in the trickiest, mixed lighting conditions, bracket your WB settings. Bracketing is a term given to taking multiple photographs of the same subject using different settings. More commonly, you bracket exposure settings, but the same principle can be applied to WB. Many cameras have a function to do this automatically. If not, manually alter the WB setting for each frame.

1,800k, while shade under a blue sky is equivalent to around 7,500k.

To capture colour authentically, you need to match the colour temperature of the light with a reciprocal WB setting on your camera. The majority of photographers rely heavily on their camera's WB pre-sets, which are designed to

WARM, EARLY MORNING LIGHT
The warm sunlight illuminating the rising mist created a wonderful orange glow. However, my camera's AWB setting tried to compensate for the warm colour temperature and the resulting shot (A) fails to capture the atmospheric conditions I witnessed. To match the prevailing light, I quickly adjusted WB to its 'Sunlight' pre-set, enabling me to record the scene's colour accurately (B).
Nikon D200, 150mm lens, ISO 200, 1/320sec at f/8, tripod.

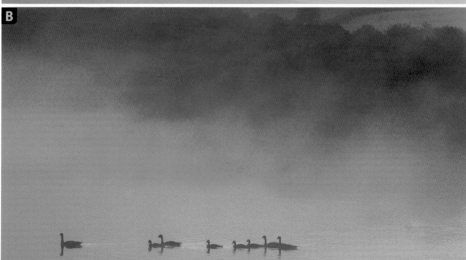

PENCILS

I photographed these colourful pencils under normal room lighting. For image A, I forgot to alter my camera's WB setting and used a colour temperature of 5,500k – balanced for direct sunlight. This created an unsightly orange cast. For image B, I altered the WB setting to a value of 3,200k, to match the colour temperature of the artificial light. This allowed me to record the colours accurately.

Nikon D70, 105mm lens, ISO 200, 1/4sec at f/14, tripod.

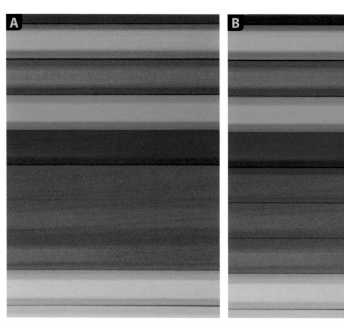

SETTING SUN

Colour temperature values can prove confusing. Although you might automatically assume that the warmth of a setting sun has a high colour temperature, it actually has a low value of around 3,000k.

Nikon D70, 100–300mm lens (at 300mm) with 1.4x converter, ISO 200, 1/800sec at f/11, tripod.

match a variety of common lighting situations. By setting WB to a specific colour temperature, we are telling the camera that the light is that colour. To compensate, it biases the result in the opposite direction. Although the WB pre-sets are unable to guarantee exact colour reproduction, matched correctly with the prevailing light they help get acceptably near to it.

AUTO VS PRE-SET

It is a mistake to leave your camera on its Auto White Balance (AWB) setting at all times. It is designed to adjust WB automatically, often choosing between a large set of values, typically 3,000–7,000k. However, it can be unreliable, failing to differentiate between the colour of light and the intrinsic colours of the subject. AWB may also compensate for lighting conditions that are part of what you're trying to record.

As sophisticated as it is, AWB is only 'guessing' at the setting needed and certain colours are renowned for causing it problems. Some cameras are more prone to error than others and, although AWB can often be relied upon, it is safer to match the prevailing lighting with the corresponding WB pre-set manually.

The colour temperature scale

This chart will help you to compare and understand the way colour temperature changes depending on the light source.

Degrees Kelvin		Light Type
7,000–8,000k	—	Shade
6,000–6,500k	—	Under cloudy sky
5,500k	—	Electronic flash
5,200–5,500k	—	Average direct sunlight
3,500k	—	Early morning/late afternoon
3,400k	—	Tungsten light
3,000k	—	Sunrise/sunset
2,800k	—	Domestic tungsten bulb
2,500k	—	Torch bulb
1,800–2,000k	—	Candle flame

USING WB CREATIVELY

The WB settings on your digital camera can be used creatively by deliberately mismatching the WB setting with the available light. Like many digital photographers, I consider WB a convenient form of in-camera filtration – one that can be easily accessed and altered at the flick of a switch.

WARMING UP

Rather than colour being rendered technically 'correct', photographs often benefit from a little extra 'warmth'. Portraits (page 40), for example, will be improved by selecting a warmer WB setting than the one that actually matches the conditions. To create a warm tone, you simply need to set a higher Kelvin level than the ambient light. For example, mid-day daylight is roughly equivalent to 5,200–5,500k. Instead of setting WB to 'Direct Sunlight' (5,400k), adjust it to 'Cloudy' (6,000k) and your picture will adopt a warm feel – similar to using an 81B colour-balancing filter.

You do not need to rely on your camera's WB pre-set to do this. For greater control

SILHOUETTED CATKINS
By deliberately selecting a high colour temperature, it is possible to exaggerate the warmth of a setting sun in-camera. This can work especially well when combined with a silhouetted subject. When I photographed these catkins, I used my camera's 'Shade' WB pre-set to boost the warmth of the sky behind the subject.
Nikon D70, 100–300mm lens (at 180mm), ISO 200, 1/180sec at f/11, tripod.

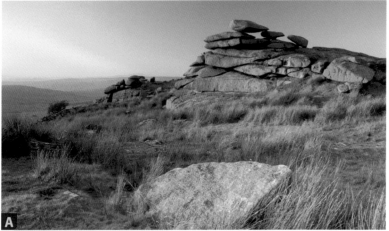

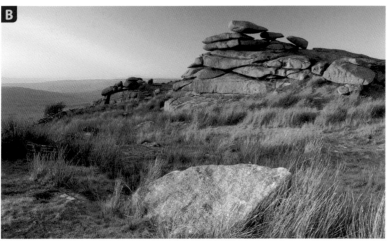

LATE EVENING LIGHT
Creative use of WB usually needs to be subtle and unobtrusive, but I prefer a slightly warm bias to my scenic shots. When I used to shoot film, I relied upon an 81B filter to do this. Now I simply shoot using a WB setting of +300–400k or use the 'Cloudy' pre-set (B). The effect is subtle, but flattering when compared to the original image shot using the 'Daylight' pre-set (A).
Nikon D70, 18–70mm lens (at 18mm), ISO 200, 1/2sec at f/20, polarizer, tripod.

and precision, dial in the colour temperature manually. The majority of DSLRs have a Custom White Balance (CWB) setting where you can adjust the temperature in 100k increments and save your preferred settings for future use.

Creative adjustments to WB will often be subtle to retain a natural feel, but larger shifts in colour temperature can also prove effective. Subjects already boasting warm tones, such as sunsets and autumnal colour, can benefit from the colours being enhanced even further. To do this in direct sunlight, set your WB pre-set to 'Shade', or dial in a colour temperature of 8,000k or greater. This will add an orange cast, roughly equivalent to an 81EF filter.

Although experience will tell you when to manipulate WB creatively, experimentation is important. RAW users have the added advantage of being able to alter the WB applied to their images post-capture (page 80).

COOLING DOWN

A blue colour cast can convey a sense of coolness and mystery. To do this, you need to employ a lower colour temperature setting than the available light source would otherwise permit. In normal daylight, a custom WB setting of 3,200–4,200k would be needed. Alternatively – although less flexible – the camera's 'Fluorescent' (4,200k) or 'Incandescent' (3,000k) settings can be used. A setting close to 3,000k is designed to correct for the orange warmth of tungsten light, therefore it will create a deep blue cast – not dissimilar to a blue 80A colour-conversion filter. A more moderate setting of around 4,000k will normally prove more practical, but, as ever, it will depend on the type and strength of effect you desire.

A wide variety of subjects can benefit from a cooler approach. However, most commonly it will be used to enhance the blue cast you would get in misty or wintry conditions, moonlight, in pre-dawn light before sunrise or in bad weather.

ST MICHAEL'S MOUNT
A blue hue will not suit every subject, but it can prove very effective when combined with the right scene or light. In this instance, I dialled in a WB setting of 4,400k to create a cool, blue cast. This 'wrong' WB setting created a more atmospheric result than if I had remained faithful to the scene's true colour temperature.
Nikon D200, 10–20mm lens (at 10mm), ISO 100, 5sec at f/20, polarizer, tripod.

COLOUR-BALANCING AND COLOUR-CONVERSION FILTERS

Daylight-balanced colour slide film is intolerant to shifts in the colour temperature of light. As a result, there are two popular ranges of filters aimed at correcting colour imbalances – warming-up and cooling-down filters.

The most widely used are the amber-coloured 81 series, available in six strengths. They are intended to correct minor blue deficiencies in the light, for example when taking pictures in dull light or shade.

The 82 series of cooling-down filters work in reverse to warm-ups. They are produced in progressive shades of blue and are designed to correct slight warm deficiencies in the light, with four strengths available. Although not as handy on a day-to-day basis as warming-up filters, they are useful for reducing the warmth of subjects shot outside in warm light where accurate colour rendition is a priority.

There are also two groups of colour-conversion filters available, designed to balance much larger colour shifts in light temperature. The blue 80 series range of filters is primarily aimed to correct for tungsten lighting and other similarly warm light sources. The orange 85 series are essentially strong warm-up filters, useful when the light is excessively cold.

For digital photographers, the convenience and speed of using WB has effectively made colour-balancing and colour-conversion filters redundant. You may still wish to use them, but if you do, remember not to employ your camera's AWB setting. AWB will attempt to compensate for the filter's hue – partly or totally negating its effect.

PORTRAITS

With control over lighting, composition and the subject, you might think that people photography would be simple. Wrong. Capturing consistently good portraits is a genuine skill and entire books are dedicated to the art. Achieving natural-looking results is far from easy. To capture eye-catching, contemporary portraits, you should challenge existing ideas and try breaking the compositional rules; only by doing this will you achieve fresh, modern-looking portraits. One of the key ingredients to portrait photography is light; not just the quality and direction of it, but also its colour temperature.

PORTRAITS AND WB

While there is no denying that composition and pose are key to a portrait's success, light is the vital ingredient – giving an image its feel and mood. The colour temperature of light is of huge significance to portrait photographers. 'Pure' white light is the result of an equally balanced mixture of the three primary colours; red, green, and blue. However, in different lighting conditions – natural or artificial – the proportions and mix of each colour will vary. While our brain automatically adjusts for the changes in colour temperature, the camera's sensor has to be 'told' via its WB setting. If the WB setting isn't correctly matched to the prevailing light, a colour cast will result and this can have a dramatic effect on the resulting image, especially on skin tone.

Unless you have access to a studio set-up, it is likely that you will be shooting your portrait images relying predominantly on natural lighting – possibly supplemented with a burst of fill flash

tip

To add further mood and atmosphere to your portrait shots, attach a soft-focus filter (page 58). This will help disguise spots or imperfections in your sitter's complexion, while also softening hard edges. Combined with a 'Warm' WB setting, the results will be attractive and flattering.

or redirected light from a reflector. Sunlight is the best form of illumination if you wish to capture natural-looking portraits, although strong, dramatic directional lighting isn't always best. A bright, overcast day is excellent for outdoor portraits, with the cloud acting like a giant diffuser, softening the sunlight. However, when it is overcast, remember to adjust WB accordingly. A 'Daylight' WB setting in cloudy conditions will cool down the image, adding a faint blue tint to skin tone. Generally speaking, this is an undesirable side effect. Therefore, remember to

THE EFFECT OF WB ON PORTRAITS

To help illustrate the way a digital camera's WB settings can dramatically alter the look and feel of your portrait images, this sequence shows the same image, but with varying WB settings applied.

Obviously, the effect of your chosen setting will vary depending on the light's colour temperature. In this instance, the image was shot under studio lighting – aimed to approximate the temperature of natural light.

AS SHOT: The original Kelvin setting gives authentic colouring. *Kodak DSLR, 200mm lens, ISO 160, 1/125 at f/4.8, tripod.*

TUNGSTEN: Skin adopts an ugly cold, blue colouring at this setting.

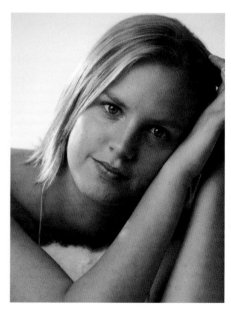

FLUORESCENT: This is slightly warmer, but a cool blue hue is still apparent.

adjust your WB setting to closely replicate the conditions – don't simply rely on the camera's AWB setting.

You may not always be able to rely on your camera's WB pre-sets to achieve faithful colour rendition. Instead, you may need to manually dial in the colour temperature – in degrees Kelvin – that you require, remembering that lower values will cool down the shot, while higher ones will add warmth.

Of course, WB doesn't need to be employed purely to produce accurate-looking results. Just as with other subjects, WB can be employed creatively as a form of in-camera filtration. A colour temperature of 3,000–4,200k – which you would typically use to balance the warmth of artificial lighting – can also be used to cool down portraits when used under normal conditions. However, it is more likely you will wish to warm up your portraits. A higher WB setting will add a subtle orange cast to your shots, adding pleasing warmth to skin tone – mimicking the effect of an 81B or 81C filter. More often than not, this effect is flattering and beneficial to your portraits.

If you are shooting in RAW, you can always experiment with the effects of different WB settings post capture (page 80). This way, your concentration won't be diverted from composition and posing your sitter while actually taking pictures, allowing you to capture a better image in-camera, then tweaking colour later.

Taking great portrait photographs

There is no shortage of books dedicated entirely to people photography, so should you wish to improve your portrait photography, these titles will help you to hone your technique. However, there are a few general tips and hints that you may find helpful.

- A flattering focal length for portrait photography is 80–150mm, condensing perspective slightly.
- Always focus on your subject's eyes.
- Keep your subject's backdrop simple, complementary and free of anything distracting.
- Often, the best family portraits aren't posed. To capture natural, informal shots, take pictures when the subject is unaware of you and/or your camera.
- Ask your sitter to hold a reflector – or sheet of white card – on their lap, angled to reflect light upwards. This will lift any harsh, unflattering shadows underneath their eyes or nose.

DAYLIGHT: A 'Daylight' setting gives added warmth, flattering to skin tone.

CLOUDY: The result is still acceptable, but the warm colour cast is unnatural.

SHADE: At this setting, the orangey colour hue is too obvious and unattractive.

CHAPTER FOUR:
NEUTRAL DENSITY FILTERS

Although neutral density (ND) filters are essential tools for professional photographers, they possibly remain less appreciated among amateurs. The reason for this is that their purpose is often misunderstood or overlooked, which is understandable, as at first glance their appeal isn't immediately obvious. They are not tinted with colour or graduated, but simply plain, grey filters. They are designed to reduce the light entering the camera, which at first does not sound useful or appealing. However, ND filters have two key roles. They can either be employed to lengthen shutter speeds in order to emphasize movement, or be used to allow the use of a wider aperture to reduce depth of field.

DENSITIES

ND filters are available in progressive strengths. The darker their shade of grey, the greater their absorption of light. A density of 0.1 represents a light loss of 1/3 of a stop. Therefore, a 0.3 ND will be equivalent to 1 stop of light.

Unless you will be using them on a regular basis, I wouldn't suggest you invest in a full set. Instead, buy one or two filters of more moderate densities, which can then be combined to achieve a greater light loss. Many photographers will find a 0.6 ND adequate in most situations.

The reliable and advanced TTL light metering systems of today's DSLR cameras automatically compensate for the filter factor of an attached ND filter. Therefore, achieving correctly exposed images shouldn't present any problem.

HOW NEUTRAL DENSITY FILTERS WORK

ND filters are neutral grey. When used, they do not create a colour cast of any kind – they alter only the brightness of light, not its colour. This is possible due to the way they absorb all the colours in the visible spectrum in equal amounts. The aim of using an ND filter is to limit the amount of light passing through the lens. Therefore, if after attaching the filter the shutter speed is maintained, a larger aperture must be employed to achieve a correctly exposed image. If the aperture is kept the same after adding an ND filter, a slower shutter speed must be selected to obtain the right exposure.

FLOWER
ND filters allow the use of a wider f/stop; this is helpful in shooting situations where the light levels are so high that you would otherwise be limited to using a smaller aperture. This is handy when you wish to creatively utilize a shallow depth of field. When I photographed this flower, a 0.3 ND was attached, forcing the camera to set a wider aperture in order to get enough light to the sensor.
Nikon D200, 150mm lens, ISO 100, 1/4000sec at f/2.8, 0.3 ND filter, tripod.

TOO MUCH LIGHT

ND filters are most commonly used to lengthen shutter time to emphasize movement (page 44), but they can also be used to compensate for too much light. An ND filter is handy in situations where you would like to increase the aperture more than the light or camera capabilities permit. For example, if you were shooting in very bright, sunny conditions you may find that the f/stop the camera is recommending is too small and the resulting picture has too much front-to-back sharpness. Too much depth of field can be a problem with portraiture or flower photography, when a distracting background can potentially ruin the aesthetics of the image. By attaching an ND filter, a photographer is able to open up the lens and create a shallower depth of field.

Filter factor and exposure increases

ND filters are available in different densities, which reduce the ambient light by a specific and accurate level. The most popular and widely used ND values are listed below.

ND filter density	Filter factor	Exposure increase (light loss) in stops
0.1	x1.25	1/3
0.2	x1.5	2/3
0.3	x2	1
0.6	x4	2
0.9	x8	3
1.2	x16	4

PEBBLES

It was a bright day when I photographed these pebbles. I wanted to blur the water to create an ethereal feel, but the slowest exposure the prevailing light would allow was 1/30sec. This wasn't sufficiently slow to create the effect I wanted (A). I attached a 0.6 ND filter and the resulting 1/2sec exposure created a far more pleasing result (B). *Nikon D70, 100–300mm lens (at 280mm), ISO 200, 1/30sec (A) 1/2sec (B) at f/14, 0.6 ND filter (B only), tripod.*

tip

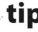

A polarizer has a filter factor of x4, or 2 stops of light. This is equivalent to a 0.6 ND. Although not all polarizing filters are totally neutral, they can be employed – and are useful – as a makeshift neutral density filter.

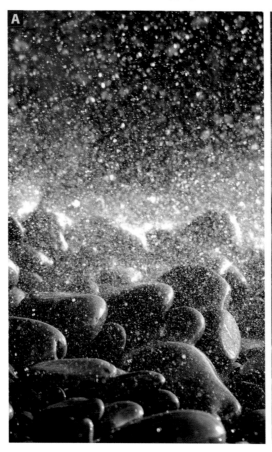

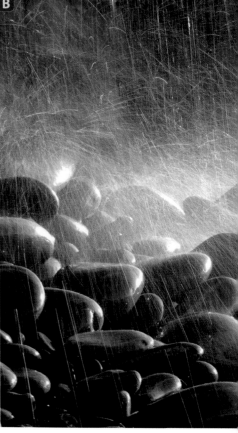

EMPHASIZING MOVEMENT

One of the first things you learn as a photographer is that it is important to freeze subject movement and achieve pin-sharp images. While this is often true, sometimes a degree of blur will create a feeling of motion, speed or mood. However, if the light levels are high, your camera often won't allow you to set a shutter speed long enough. This is why ND filters are such a useful aid, as they are designed to reduce the light reaching the image sensor.

DOORWAY AND BLURRED BUTTERCUPS
ND filters are most commonly employed to blur running water. However, don't overlook other moving subjects. People jostling along a busy high street can look striking blurred, or possibly crops or flowers being blown in the wind. In this instance, an ND filter was used to blur the swaying buttercups growing in front of this rustic old barn.
Canon 5D, 70–200mm lens (at 180mm), ISO 100, 1sec at f/22, 0.6 ND filter, tripod.

Using a long shutter speed to blur movement can prove a powerful visual tool, although it should be used selectively. The key is to match the technique carefully to an appropriate scene or subject – running water, a bustling street of people, swaying grass or a running animal are just a few examples.

An ND filter is also useful for creating a shutter speed slow enough to pan. Panning is a technique where you follow a moving subject with your camera during exposure, so that the main subject will be sharp against a blurred background. It is a technique that takes practice to perfect, but can create striking results.

HOW LONG?

When it comes to long exposure, achieving just the right effect is tricky. While the camera's shutter is open, all subject movement within that time will be recorded. Too much motion and detail can grow indistinguishable; too little and it will not look intentional. It is a balancing act and it will vary greatly depending on the subject. For fast-moving subjects, a shutter speed of 1/10sec may prove sufficient. On the other hand, you may need to employ an exposure of several seconds or longer to create the effect you desire. Use image playback to regulate the results and adjust the shutter speed if the effect is not what

you intended. It is important that you do not add your own movement to that of the subject, so using a tripod is essential.

WATER

ND filters are most popularly used to blur moving water. A shutter speed exceeding 1sec will reduce a gushing waterfall or crashing waves to a milky blur. Normally, an ND filter is the only way to obtain a long shutter speed in average lighting conditions, but with overcast light it will create even longer exposures, possibly exceeding 10sec if a small aperture is also employed. Presuming that the camera is well supported, this isn't a problem and can often – although not always – create a more dramatic result. However, shutter speeds of this length greatly enhance the risk of noise and reciprocity law failure. This is when the reciprocal relationship between aperture and shutter speed begins to break down, and a level of compensation is required to achieve the correct exposure. You can check the accuracy of your camera's metering by replaying the image.

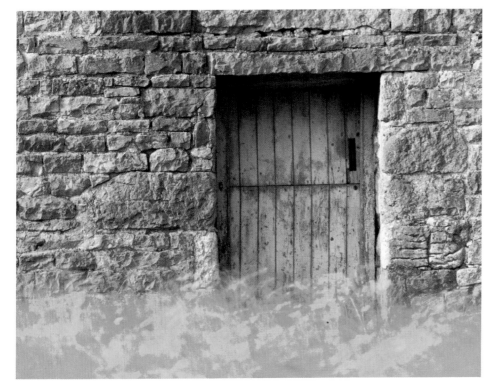

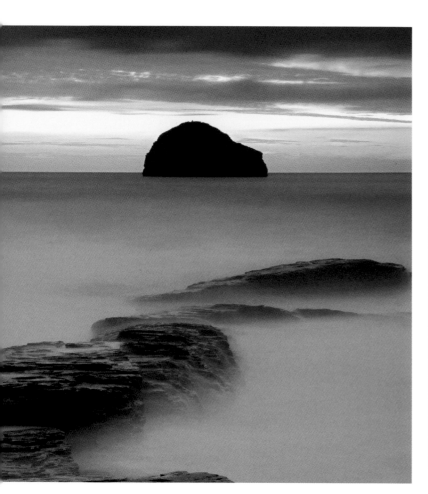

STORMY SEA
The sun had already dipped below the horizon, so the light levels were low, but to achieve the 30sec exposure I desired, I attached a 0.9 ND filter. This reduced the rising tide to an atmospheric mist. The cool, blue hue only adds to the image's mood.
Nikon D80, 18–70mm lens (at 40mm), ISO 100, 30sec at f/20, 0.9 ND filter, tripod.

Long Exposure Noise Reduction

Noise – randomly spaced, brightly coloured pixels – will be more obvious in images taken at higher ISO sensitivities, and is also more likely in pictures taken using a long exposure. Because of this, the majority of DSLR cameras are designed with a Long Exposure Noise Reduction (Long Exp. NR) function. This can normally be accessed via one of the camera's set-up menus and is designed for when shutter speeds exceed 4sec. When it is switched on, images will be processed in-camera to reduce the undesirable effects of noise. Although burst speed, and the number of images that can be stored in the camera's buffer, is greatly reduced, Long Exp. NR is a helpful feature and should be utilized when you are using ND filters.

WINDMILL
In this shot, the impression of movement has been created by a slow shutter speed. This wouldn't have been possible without an ND filter as it was a bright, sunny day and there was ample light. Therefore, if the filter hadn't been attached, the faster shutter speed would have frozen the mill's sails. The shot would have looked static and its impact would have been greatly diminished.
Nikon D2x, 35mm lens, ISO 100, 1/5sec at f/20, polarizer, tripod.

tip

ND filters with a density greater than 0.6 ND significantly darken the camera's viewfinder. This can make composition and focusing difficult – if not impossible. Therefore, only attach the filter after you have set up your shot, remembering to adjust the exposure settings before releasing the shutter.

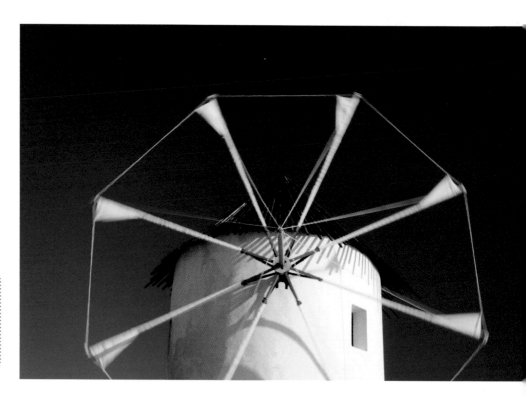

UV AND SKYLIGHT FILTERS

When you peer through your camera's viewfinder, the effect of the filter attached is normally quite obvious. However, this isn't so with a UV or skylight filter. Their effect is far subtler, but this isn't to say that they don't still play a significant role.

If you hold a skylight or UV filter up to your eye, they appear completely transparent, but they work by absorbing the image-degrading effects of ultraviolet (UV) light. Although this type of light is mostly invisible to our sensory system, it creates a reduction in contrast – characterized as slight haze in distant landscapes. Not only are UV and skylight filters useful to combat the effects of haze, but they can also be utilized to protect the front element of your valuable optics.

HAZE

Pollution, heat, dust and moisture particles in the atmosphere scatter wavelengths of light passing through them. The result is haze, which reduces clarity, visibility, colour saturation and definition on distant objects. It can also add a bluish cast to images, due to the fact that it grows more obvious at the blue end of the colour spectrum. Sometimes it can work to a photographer's advantage, but normally it is undesirable. The effects of haze are often exaggerated by longer focal lengths, and although the multi-coatings applied to the front element of modern lenses are designed to help reduce rays of UV light, they do not eliminate them entirely. This is why a specific UV filter is required.

DIGITAL UV AND SKYLIGHT FILTERING

Although they are different, UV and skylight filters are essentially designed to do the same job. Digital image sensors are capable of recording UV light that our eyes are unable

JUVENILE SWALLOW
A UV or skylight filter is an inexpensive method of protecting the front element of valuable optics. I leave a UV filter on my longest telephoto lens at all times. This prevents it from getting scratched or being damaged accidentally.
Nikon D200, 100–300mm lens (at 300mm), 1.4x tele-converter, ISO 200, 1/400sec at f/5.6, UV filter, tripod.

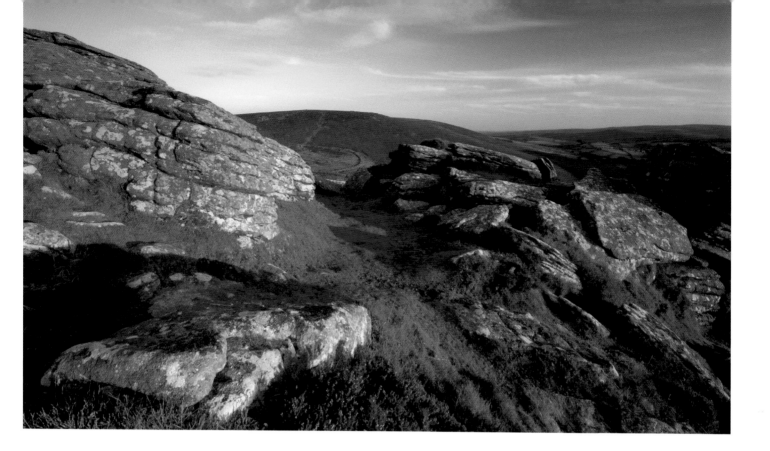

to detect, but UV and skylight filters work by blocking UV wavelengths. They are circular, screw-in filters that attach directly to the lens.

UV and skylight filters should always be used when taking pictures at altitude, even if visibility is crystal-clear. They filter out the greater concentration of UV light wavelengths found at height, which, otherwise, would create an artificial cool blue cast. They are also useful for taking pictures during winter, when the atmosphere is cooler. Snow is renowned for reflecting UV light, so attach a UV or skylight filter to negate its effects.

UV FILTER
Hoya's Super HMC PRO-1 UV and skylight filters boast 12 layers of super multi-coating to increase resistance to flare and maximize image quality.

Because they are clear, UV and skylight filters do not induce a loss of light. Therefore they have a 1x filter factor (page 21), which requires no exposure compensation.

Although they share the same purpose, a skylight filter is also tinted with a very weak pink colouring. This adds slight warmth to shadows that suffer from a pale bluish hue caused by reflected skylight. They are often available in two strengths, 1A or 1B – 1B being the warmer of the two.

UV and skylight filters are designed specifically to eliminate haze; they do not work in other atmospheric conditions, for example mist or fog.

PROTECTION
It is common practice to use a UV or skylight filter to protect the front element of your lens, as they are clear – or almost, in the case of the skylight – and relatively inexpensive to buy, and so are ideally suited to this purpose. They protect the lens from dust, dirt, sand, moisture, greasy fingerprints and scratches – all of which are potentially damaging to the optics and can degrade picture quality. It is much safer to clean a filter on a regular basis, than the delicate multi-coated front element of a valuable lens. It is also much cheaper to replace a scratched or

MOORLAND VIEW
A UV or skylight filter is ideal for reducing atmospheric haze and improving image quality, especially in the distant landscape. A UV filter proved useful when I shot this far-reaching moorland landscape.
Nikon D200, 18–70mm lens (at 18mm), ISO 200, 1/5sec at f/18, UV filter, tripod.

damaged filter than a lens, which is why many photographers leave a UV filter permanently screwed on to every lens in their system. However, this is a controversial practice. Some believe that the extra layer of glass will increase the likelihood of flare and can also degrade image quality. In truth the quality of modern filters from the reputable brands is so high that there shouldn't be a problem.

If you do decide to employ UV filters on a permanent basis to protect your optics, you will need to consider the depth of the filter mount. If you wish to attach additional filters – or a holder – you must remember that they will be projected further away from the lens. With wide focal lengths, this will greatly enhance the risk of vignetting (page 20). The simple and obvious solution is to remove any protective filters prior to attaching corrective or creative ones.

CHAPTER FIVE:
GRADUATED FILTERS

For landscape photographers in particular, graduated filters are not simply accessories, but essential aids. Graduates are designed to equal the contrast in light between land and sky and, although there are ways to do this during post processing (page 86), many photographers prefer to achieve a beautiful, perfectly exposed result in-camera. While neutral density (ND) grads are designed so they do not alter the natural colour of the sky, graduated colour filters are intended to add a splash of colour to otherwise dull, boring skies. They are available in a wide variety of natural and artificial-looking colours and matched to the right scene or subject, can help bring your images to life.

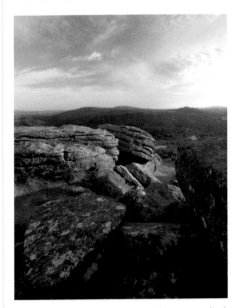

UNFILTERED ORIGINAL – no graduation applied.

GRADUATED ND FILTERS

Have your scenic images ever suffered from dark, underexposed foregrounds or overexposed, washed-out skies? This is a familiar problem, caused by the sky being brighter than the ground. When a scene is unevenly lit, it is impossible to achieve a correctly exposed image overall. This is because a camera's sensor is capable of capturing a more limited range of contrast than the human eye. The solution is to balance the contrast in light using filtration.

Graduated ND filters are designed to lower the contrast in bright skies so that they require the same exposure as the image's foreground. ND filters work by reducing all the colours in the spectrum by an equal amount, so that their effect is completely natural. While solid ND filters (page 42) are coated across their entire area – affecting the whole image – ND grads are half-clear, half-coated, with either a soft- or hard-edged transitional zone. The coated area should be carefully positioned so that only the sky portion of the composition is filtered – therefore equalizing brightness evenly across the frame.

DENSITIES
ND grads are available to buy in varying densities, with 0.1 being equivalent to 1/3 of a stop of light. The density of grad you need will vary depending on the contrast of light within the scene. The three most common and popular densities are 0.3, 0.6 and 0.9 – equal to 1, 2 and 3 stops of light. Some filter brands also include 0.45 and 0.75 ND grads in their range, which reduce light by 11/2 and 21/2 stops respectively. If you can only justify buying one filter, opt for a 0.6 ND grad. This strength will often prove to be the best compromise and most useful day-to-day. It provides a 2-stop light reduction in the sky, which in many situations is adequate. However, if you regularly photograph landscapes and want

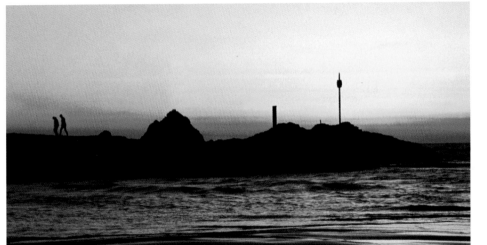

tip

In shooting situations where the average meter readings for the foreground and sky don't equate to full stops of light, it is normally better to opt for the nearest lighter grad rather than the darker one. Photographs often look more natural if the sky is a little lighter than the ground.

SUNSET
Bright skies or sunsets can be toned down using an ND grad, which balances the contrast in light between the sky and ground, producing more natural-looking results.
Nikon D70, 18–70mm lens (at 40mm), ISO 200, 1/10sec at f/16, 0.6 ND grad, tripod.

I captured the first shot in this sequence without filtration, but the sky in the resulting image looked washed-out. Using the same exposure settings, I took subsequent frames using progressively stronger ND grads.

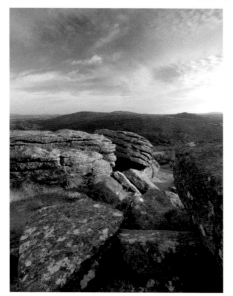

0.3 ND GRAD ATTACHED

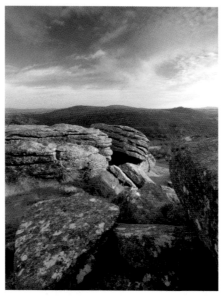

0.6 ND GRAD ATTACHED

0.9 ND GRAD ATTACHED

total control, I recommend you invest in the full set. ND grads can also be combined to create different values, increasing their versatility further.

DECIDING ON DENSITY

The contrast between foreground and sky can vary tremendously, depending on the conditions and time of day. If you are new to using ND grads, you may find it easiest to take a series of images using progressive densities. Not only will this guarantee you a correctly exposed result – similar in principle to bracketing (page 36) – but by comparing the results it will help you to select the correct filtration when presented with similar conditions in the future.

However, it is more efficient to calculate the contrast accurately, by comparing light meter readings from the foreground and brighter sky. To do this, first you need to determine the correct exposure for the foreground – the exposure setting you will use to take the final image. Take a spot reading from a mid-tone in the foreground. If none are immediately obvious, take readings from the brightest and darkest areas, and calculate the average. Now, do the same for the sky. Once you have done this, you can discover the density of the ND grad you need to employ by comparing the results. For example, if the average reading for the ground is 1/8sec at f/22, and the one for the sky is 1/30sec at f/22, the difference is exactly 2 stops. Therefore, you know that using a 0.6 ND grad will achieve a good, balanced exposure. Had the average meter reading for the sky been 1/60sec at f/22, the difference would have been 3 stops, requiring a 0.9 ND grad.

Spot metering

DSLRs boast different forms of metering, designed to suit a variety of lighting conditions. While you will normally want to employ a metering mode that sets exposure based on information from all areas of the frame, there will be times when you wish to meter from a small, specific area. Spot metering is the process of reading reflected light levels from, typically, just 2–3 per cent of the image area. The vast majority of DSLRs are able to spot meter internally. By setting an exposure based on a spot meter reading, it is possible to guarantee this area will be correctly exposed. Your camera's spot meter can be used to take readings from different areas of the frame to achieve an average or to calculate and compare the contrast in light, between the sky and foreground.

You can also purchase external spot meters, which are handheld devices with sights through which you can peer and select the areas you wish to meter from.

ND GRADS
Graduated ND filters are available in progressive densities, allowing you to reduce the brightness levels of the sky by a measured amount. The most common strengths are (from left to right) 0.3, 0.6 and 0.9 – equal to 1, 2 and 3 stops of light respectively. If required, they can be combined to create stronger values.

OTHER CONSIDERATIONS WITH ND GRADS

Calculating the density of the filter isn't the only consideration when using an ND grad. Each picture-taking situation will pose different questions. For instance, should you attach a soft or hard grad? How do you best align the filter? Do any key features, such as a building or a tree, break the skyline and if so, will they be badly affected by the filter's graduation? You need to know the answers to ensure you produce natural-looking results when using ND grads.

SOFT OR HARD GRADS?

Graduated ND filters are not only available in varying densities, but also in soft- or hard-edged transitions. A 'soft' ND is designed with a feathered edge, providing a gentle change from the ND portion of the filter to the clear area. A 'hard' ND has a more sudden transition.

Deciding which type to buy will partly depend on your level of expertise. If you are relatively inexperienced, soft grads will prove easier to use. Due to their design, there is greater leeway for error. Should you slide the filter too far down in the holder – so that the graduation begins to overlap with the ground – it shouldn't be too

COASTLINE
Selecting the correct exposure is really quite straightforward when using ND grads. In this instance, I decided to take a spot meter reading from the grassy cliff top – which I considered a suitable mid-tone. I then added a 0.6 ND grad to balance the contrast in light between the sky and coastline, and applied the exposure settings from before the grad was attached.
Nikon D200, 10–20mm lens (at 11mm), ISO 100, 1/2sec at f/20, polarizer, 0.6 ND grad, tripod.

tip
When you have to work quickly due to changing or fading light, you require quick access to the filter(s) you need. Therefore, if you have a collection of soft and hard ND grads housed together in one filter wallet, ensure the sleeves are clearly labelled and the filters always returned correctly. This will save you wasting valuable time looking for the filter type and density you require.

noticeable. However, on the downside, due to their soft graduation, only a third of the filter is coated with the filter's full-specified density before it begins to fade into transparent. This can pose a problem. Often, the brightest part of the sky will be just above the horizon, where a soft grad is at its weakest. Therefore, it has little or no effect on this area, which can result in a bright, overexposed strip of sky just above the horizon. To avoid this, it will often be necessary to align the filter lower than you would ideally like, resulting in overlap.

In contrast, hard grads are designed so that the full strength of their specified density is spread over a greater proportion of the coated area. This makes them less forgiving should the filter be poorly aligned with the horizon, or if trees or buildings break the horizon line. However, they do allow you to reduce the brightness of the sky with greater accuracy than a soft grad, doing so without having to overlap part of the landscape with the graduated transition.

Both soft- and hard-edged ND grads justify their place in your camera bag, as they are suited to different picture-taking situations. Therefore, if you are using them on a regular, day-to-day basis, it is well worth investing in a set of both.

HEATHER
Positioning a graduated filter is simple when horizons are relatively even. The beginning of the graduated line can be 'hidden' at the point where the sky converges with the landscape. When I took this image, I pushed my 0.3 ND grad down in the holder until the coating met the distant hills.
Nikon D70, 18–70mm lens (at 18mm), ISO 200, 1/5sec at f/20, polarizer, 0.3 ND grad, tripod.

Metering

When using an ND grad, setting the right exposure is surprisingly straightforward. ND grads are designed to tone down the exposure value of the sky, making it equal with the landscape. Therefore, you meter for the foreground, as this is the area of your composition that you want correctly exposed. To do this, you may wish to take a spot meter reading from a mid-tone area of the foreground before you add your ND grad. However, thanks to the technology and sophistication of modern DSLRs' TTL metering, it is possible – and easiest – to meter with your filter already in position.

Modern metering systems take brightness readings from a number of different points, across the entire area of the viewfinder, to determine an accurate exposure. Therefore, if you meter with the grad in position, the readings will be equal as you have already reduced the sky's brightness to match the rest of the scene.

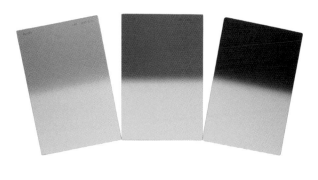

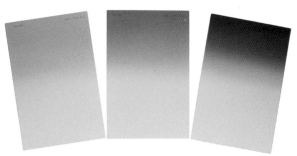

SOFT- AND HARD-EDGED ND GRADS
Graduated ND filters are available in both soft- and hard-edged transitions, designed to suit differing picture-taking scenarios. Both types will prove useful so, if you can justify it, invest in a set of both.

DRIFTWOOD
When I took this image, I had to position the filter holder at an angle instead of square on the lens. Doing this enabled me to align my ND grad so that it matched the slope of the cliffs. If I had placed the filter straight in the holder, it would have artificially darkened the red Triassic stone of the coastline.
Nikon D200, 10–20mm lens (at 12mm), ISO 100, 2sec at f/22, polarizer, 0.3 ND grad, tripod.

CROPPED-TYPE SENSORS

Although full-frame digital cameras are available, the majority of DSLRs are designed with a cropped-type sensor (page 67). Compared to the 24 x 36mm frame – the traditional standard size for a 35mm camera – the CCD or CMOS sensor covers a smaller part of the image area. For this reason, they are actually using a smaller region of the filter attached. When using 'solid' filters, such as polarizing and soft-focus filters, this doesn't have any relevant effect, but when using grads, the graduated part of the filter will effectively span a larger area of your image. This alters its effect. For instance, a hard-edged grad will appear to have a more gradual transition.

ALIGNMENT

To produce a natural-looking effect, careful and accurate alignment of your ND grad is essential. If you push the filter too far down in the holder, the coated area of the grad will stray over the foreground. This will artificially darken the landscape; the effect of this will be especially noticeable if you are using a hard grad.

The easiest way to align your grad precisely is to first mount your camera on a tripod so that it is in a fixed position. Using a grad while shooting handheld is impractical, as even the slightest change to the camera's orientation will alter the alignment of the grad in relation to the sky and ground. Having composed your image, peer through the viewfinder while depressing the depth-of-field preview button – allowing you to view your image at the actual aperture selected. Although this will darken the viewfinder, it makes the transitional line of the grad appear more prominent as you push it down into the holder. This will help you to align the graduated area of the filter so that it only affects the sky.

BROKEN HORIZONS

The line of transition, from the graduated to clear area of an ND grad, cuts horizontally across the middle of the filter. By design, they are best suited to scenes with relatively even horizons, as the natural dividing line it creates is perfectly suited to 'hiding' the edge of the filter's graduation. In reality, though, not every scene you photograph will have a straight horizon. When the horizon is angled, it is often possible to position the filter and holder at an angle to compensate (page 53). However, it is common for hills, buildings, trees or other features to actually break the horizon. In situations where something is intruding on the sky, the edge line will grow visible. This is because anything breaking the horizon will also be darkened by the grad, while parts of the same subject below the graduation line will remain unaltered. There is no easy solution to this unnatural-looking effect. Using a soft grad, designed with a more gentle transition, is one way to disguise the problem. Alternatively, try using a weaker density – although by doing so you will obviously not darken the sky by the level you would otherwise require. Of course, you can simply filter the scene as you would normally, and accept that anything above the skyline will be recorded darker. The effect of this will be more obvious on foreground subjects than on distant ones. It is up to the individual to assess what level of darkening is visually acceptable without it affecting the aesthetics of the final image. The digital solution to this is to take two exposures and merge them later in Photoshop (page 86).

OTHER APPLICATIONS FOR ND GRADS

Although most commonly employed to balance the light difference between sky and ground, graduated ND filters also have other uses.

STORMY SKY

ND grads can be used to darken already dark skies for added drama. When I took this shot, the foreground was brighter than the grey rain clouds, so no filtration was necessary (A). However, I decided to attach a 0.6 ND grad to further emphasize the stormy conditions (B).
Nikon D200, 10–20mm lens (at 10mm), ISO 100, 4sec at f/20, 0.6 ND grad (B only), tripod.

DARKENING SKIES

In my experience, some of the best picture-taking conditions for scenic photography are when there are large, threatening rain clouds looming in the sky. In weather conditions like this, the foreground will, if anything, be lighter than the dark grey storm clouds above. Therefore, theoretically no filtration is needed, as the light is naturally balanced. However, using an ND grad may still prove beneficial to your shot. It can be used to darken the sky artificially, thus emphasizing the stormy weather conditions even further. Dark, dramatic grey clouds can provide the perfect contrast to a beautifully lit foreground – especially when it is early morning or late evening and the light is naturally low and warm.

OTHER USES

Some unevenly lit scenes, especially landscapes boasting hills, cliffs or mountains, will have a horizon that slopes at an angle. In situations like this, it is possible to align the holder at an angle to mimic your subject, instead of overlapping and darkening part of your scene. However, be aware that placing a holder at an angle on the lens, as opposed to straight, can cause vignetting at shorter focal lengths.

The usefulness of ND grads extends beyond darkening the sky in just the upper part of the frame. A grad can be placed at an angle to help correct uneven polarization (page 33). Alternatively, you may be photographing a scene that is well lit one side, but not the other. If so an ND grad can be positioned so its transitional zone runs vertically or diagonally through the composition to match the division between light and shade.

An ND grad is also useful when photographing a landscape along with its reflection mirrored in a large body of still water, such as a lake or reservoir. The reflection will need more exposure than the scene itself, so to create a balanced image, carefully position the filter's graduation line to meet the 'fake' horizon created where the water and landscape meet. In other words, position the ND over the landscape, not the sky.

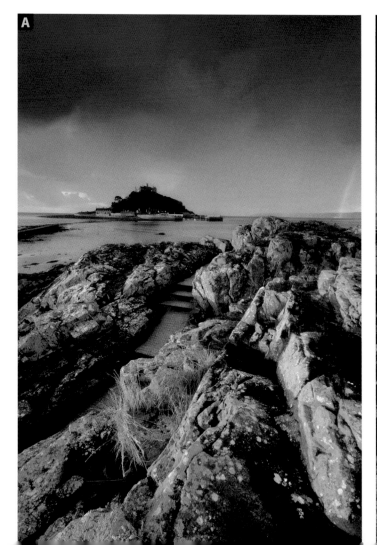

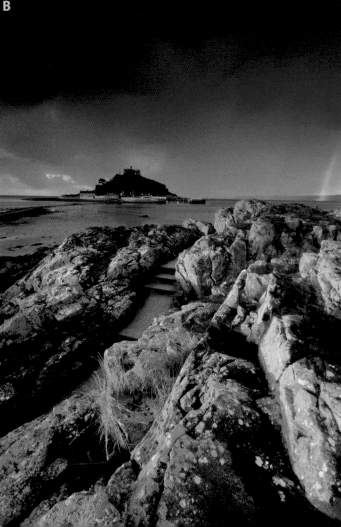

COLOUR-GRADUATED FILTERS

Rather than having the practical role of an ND grad, colour-graduated filters are designed purely for creative effect. By causing a light reduction, they will also lower contrast between the sky and foreground, but their main purpose is to add colour and interest to otherwise dull, nondescript skies.

There are a wide variety of different colours available, from subtle-looking shades of blue, coral and orange, to the dramatic, artificial look of red, pink and tobacco graduated filters. The effect of using a colour grad may not be for purists, but combined with a suitable scene or subject, they can produce eye-catching results. However, they should be used with care. Only employ a colour grad when its effect genuinely enhances the image – if you have any doubts, remember to also take an unfiltered image.

WHICH COLOURS SHOULD I BUY?

Every filter user will have their opinion on which colours they feel will enhance their images. Personally, I mostly prefer to capture natural-looking results and therefore employ colour grads sparingly. However, I recognize their role and keep several in my camera bag. I have used coral, blue and mahogany grads to good effect, although some of the brighter, more artificial colours available are not to my taste. However, one of the joys of photography is that it is totally subjective, so while I might give these particular filters a wide berth, you may enthusiastically embrace their strong visual effect. Experiment with different types until you learn which effects you do and don't like.

NATURAL SHADINGS

The colour grads that are generally considered to be the most useful are those boasting subtle shadings that exist naturally. For example, a graduated blue filter can be used to liven up insipid, white skies.

Grads boasting a warm colouring are among the most useful. They are especially well suited to enhancing pictures taken at dawn or dusk

STONE RUINS
Colour grads have been badly misused over the years, which is why they don't have a good reputation among some photographers. However, as long as they are used carefully and intelligently, they can greatly enhance your images. The most useful are grads boasting natural shadings. In this instance, a coral grad was employed to add warmth to an otherwise ordinary sky.
Nikon D200, 18–70mm lens (at 18mm), ISO 100, 1/2sec at f/22, coral grad, polarizer, tripod.

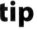
tip

If you're not entirely positive that you will like the effect of a certain colour grad – or just wish to experiment – buy a cheaper brand at first or even opt for a polyester 'gel'. This way, it won't be an expensive mistake if you don't like the results. If you later find yourself using the filter regularly, it might be worth considering buying a better-quality version – if your budget allows.

COLOUR GRADS

There are a wide variety of colour-graduated filters available to buy. They range from subtle, natural-looking shades to garish artificial colours. It is up to personal choice which filters you prefer.

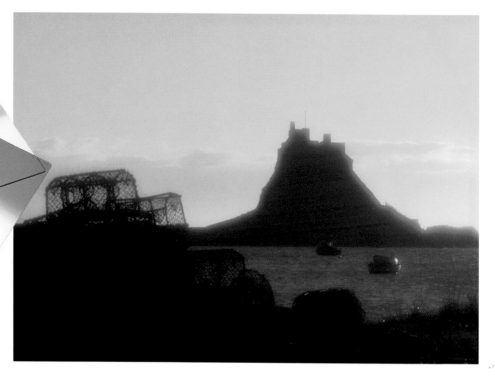

when the light is already warm. Coral, amber, pale orange, autumn and straw are among the names that different brands give their warm-coloured grads. They might each be shaded slightly differently, but all are designed to do a similar job. They are best combined with subdued, pale-looking sunsets and sunrises, giving them added punch and impact. If the sky is already very warm, your grad is probably best left in your camera bag. At this time of day, the light's colour temperature (page 37) is already low and your images will appear warm. Therefore, the addition of a warm-colour grad may well create a result that is over the top. Warm-colour grads will also boost the colour of autumnal woodland, or can be positioned upside down in the holder to add warmth to a sandy beach or dunes.

The key when using a colour grad is to match the filter sensitively with the scene. Don't add a chocolate-colour grad to a warm, orange sunset, as the resulting shot will look neither one thing nor the other. Also, however much you enjoy using colour grads, if the sky is already colourful and interesting, opt for an ND grad instead and simply emphasize the sky's natural beauty.

CASTLE SILHOUETTE
A plain white sky will ruin an otherwise good shot. A suitable colour grad will restore the impact. In this instance, a graduated filter was attached to add a strong wash of colour to the blank evening sky.
Nikon D2x, 70–200mm lens (at 150mm), ISO 100, 1/30sec at f/16, sunset grad, tripod.

ALIGNMENT

While it is important to position an ND grad carefully (page 52), correct alignment of a colour-graduated filter is even more crucial – unless you are shooting a silhouette. ND grads – especially those with a soft-edged transition – are relatively forgiving should you position them too low or too high in the filter bracket. Colour grads, on the other hand, are not. Positioning one too high in the holder will result in a strip of unfiltered sky just above the horizon. Align one too low and the colour graduation will bleed beneath the horizon into the landscape. Both effects look equally odd and bring attention to the use of a grad. Therefore, it is extremely important never to get complacent or lazy when applying graduated filtration.

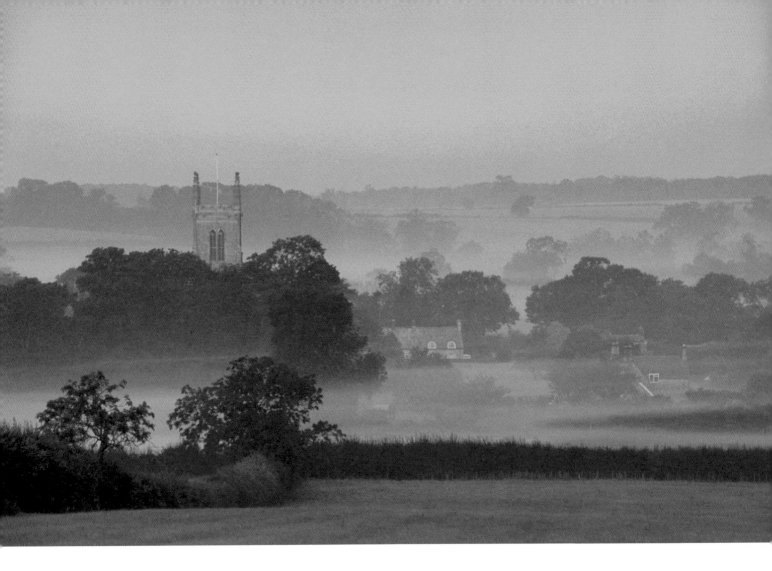

MORNING MIST
Although the effect of many colour-graduated filters will be obvious – producing an artificial look – combined with the right subject and conditions they can greatly enhance a photograph. In this instance, the warmth of the attached colour grad works well in combination with the atmospheric morning mist.
Nikon D2x, 300mm lens, ISO 100, 1sec at f/16, sunset grad, tripod.

BAD REPUTATION

Photographers today tend to be quite wary of colour-graduated filters. These filters have been badly abused in the past and the poor results have put many photographers off from experimenting or benefiting from their effect. This is a shame. Despite their reputation, when used correctly they will enhance your images. Even artificial shadings, like tobacco and sepia, have a role to play if used intelligently and sensitively – moderation is the key. Too often in the past, photographers have only reached for a colour grad whenever confronted with a boring image, in the vain hope that the filter would bring the shot to life. It won't. The resulting picture will still look boring, only now it will also boast a colourful sky.

Remember, just like any other filter, a colour grad is only capable of enhancing a shot – it cannot miraculously transform a poor image into a good one. Instead, colour grads are a good,

creative tool and their effect can complement a wide variety of subjects and shooting situations.

LIGHT

Colour grads can be used to add a touch of subtlety or drama, enhance reality or change the specific colour within a scene to help create a desired special effect. However, regardless of your reason for using a colour grad, the light and time of day are important factors. Although they will add a splash of colour to washed-out or hazy skies, their effect looks far more obvious and artificial on blanket cloud than when combined with a clear, or only partly cloudy,

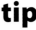

tip

If you don't want to go to the expense of buying a variety of different colour-graduated filters, you can apply similar effects during post-processing (page 98).

sky. If you decide to use a colour grad in dull, overcast weather, the sky is going to stand out against the muted colours of the landscape below. Therefore, try using a bold or colourful subject in the foreground to grab the viewer's attention and create the impact needed.

SILHOUETTES

Brightly coloured skies are the ideal backdrop for shooting silhouetted subjects. Colour grads are the perfect tool for livening up a dull, boring sky. Therefore, they are well suited to situations where you wish to capture a bold, inky outline against a contrasting background.

A silhouette is the most extreme form of backlighting, where the subject is recorded as a black shape against a lighter background. Silhouettes are easier to create at either end of the day, when the sun is lower in the sky. Many subjects look striking in silhouette – people, cityscapes, church steeples or windswept trees are good examples. However, it is important to choose a subject with a strong, recognizable outline.

In normal lighting conditions, shooting a subject that is breaking the skyline – while using a graduated filter – would present quite a headache. By aligning the grad correctly with the horizon, you also inadvertently filter anything that is intruding on the sky. This has an unnatural effect, which can potentially ruin the shot. However, this isn't a problem when shooting silhouetted subjects breaking the horizon, as they are pure black in tone and therefore unaffected by the colour of the filter attached. This means you can push the grad fully down in the holder until the coating meets the horizon, without fear of affecting its appearance.

STRIPE FILTERS

Some filter brands produce 'stripe' slot-in type filters. They are related to graduated filters and work using a similar principle. However, whereas grads are coated from the top of the filter to where their graduation finishes at midpoint, stripe filters are designed with just a thin, coated strip placed horizontally across the middle of the filter. The strip measures approximately 2½cm (1in) in depth and is feathered on its top and bottom edges to give a more gradual, subtle appearance. The strip can be positioned anywhere within the frame to add a splash of colour, but it is principally aimed at filtering the lightest part of the skyline – the bright band of sky immediately above the horizon. Stripe filters are available in several different colours, including cyan, pink, coral and straw.

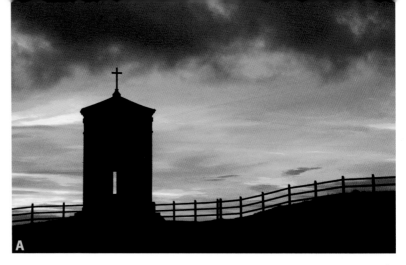

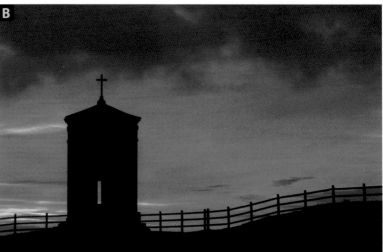

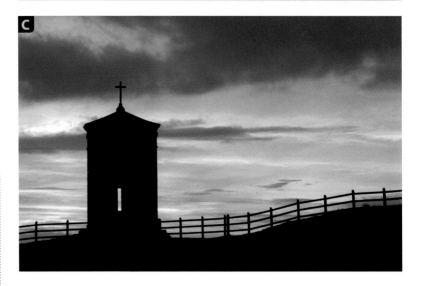

SILHOUETTED FOLLY
In image (A), I metered from the sky and used the camera's recommended settings to cast the building into silhouette. However, although the cloud looked interesting, there was little colour in the sky and the shot lacked impact. A tobacco filter produced a dramatic, eye-catching image (B). A blue grad created a very different result, giving the scene a cold, moody feel (C). Both filtered images are more striking than the unfiltered version.
Nikon D200, 18–70mm lens (at 62mm), ISO 100, 1sec at f/20, tobacco (B), blue (C), tripod.

CHAPTER SIX:
SOFT-FOCUS FILTERS

The idea of a soft-focus filter may, at first, seem like a daft concept. Photographers are forever being taught to discard images that aren't razor-sharp. Digital equipment is designed and optimized to produce bitingly sharp images, so why place a misty piece of plastic or glass in front of the camera lens? The answer is quite simple; mood. Soft-focus filters are designed to add atmosphere and romance to your shots. By disguising hard edges and obscuring fine detail, a soft-focus filter can give the ambient light an attractive, dreamy quality. Although the look of a soft-focus filter can be mimicked at the post-processing stage (page 126), there are advantages of filtering the light at the moment of exposure.

LOCH AND ROWING BOATS
When I took this image of boats moored at the edge of a Scottish loch, I knew I'd need to employ a small aperture to achieve sufficient depth of field to maintain back-to-front sharpness. However, I also knew this would begin to negate the effect of any soft-focus filter I attached. Therefore, I used a stronger grade of filter, to ensure that the effect remained obvious.
Nikon D70, 18–70mm lens (at 20mm), ISO 200, 1sec at f/18, polarizer, 0.6 ND grad, soft-focus filter, tripod.

SOFT FOCUSING

Soft-focus filters are available as both screw-in and slot-in types and also in varying strengths – designed to create just the effect you require. It is also possible to make your own (page 62). A little diffusion can transform a portrait image, producing evocative results, and so this is a popular filter among wedding photographers. But the effect of using a soft-focus filter shouldn't be restricted to portraits. Combined with the right light, scene or subject, they will benefit landscape, architecture and still-life images too.

When a lens is focused correctly, the layout of its elements ensures that the rays of light passing through the camera lens come into sharp focus at the point where they strike the camera's image sensor. If the lens isn't precisely focused, the light rays will either meet in front or behind the sensor plane, resulting in a soft or unsharp image. Soft-focus filters work using a similar principle. Despite using the lens to bring the scene or subject into sharp focus, when a soft-focus filter is attached it causes some of the light rays to refract or bend so they don't combine together on the sensor plane. However, the effect isn't the same as being out of focus and diffusion filters are not designed to degrade image quality, but instead subtly alter their mood.

Soft-focus filters work by obscuring fine detail, while stronger detail, and the subjects overall

LENSBABY

If you like the effect a soft-focus filter has on your images, you may wish to try using a Lensbaby. Lensbabies are rather odd-looking attachments. They are not a filter, but neither are they like a conventional lens. They attach directly to your DSLR body and work by bringing just one area of the photo into sharp focus. The rest of the frame is rendered pleasantly diffused, with glowing highlights – similar to the effect of a soft-spot filter. You can quickly adjust the area in focus to any part of the frame by bending its flexible lens tubing. Lensbabies are designed to promote a creative and fun approach to photography.

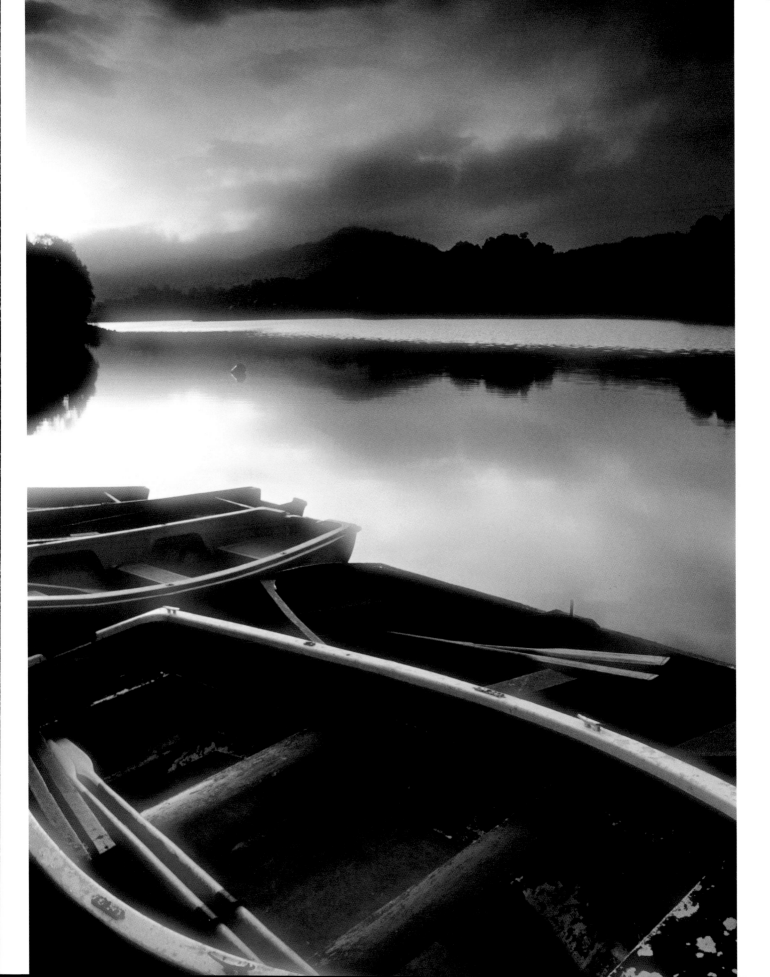

form and outline, remain recognizable. In general, your image will appear to be correctly focused, just overlaid with a gentle and attractive diffusion.

BRAND TYPES

Rather confusingly, filter brands tend to give their soft-focus filters different names. However, regardless of whether they are marketed as a 'soft', 'diffuser', 'mist', 'halo' or 'dream' filter, each type shares the same purpose. That said, the effect they create will vary from one manufacturer to the next and also depends on the way they are produced. Each variety is designed with some means to distort the light and therefore lower image contrast. To achieve this effect, some filters are designed with bubbles, dents, ripples or even fine black mesh – 'net' filters – built into the optic to selectively redirect the light rays.

Soft-focus filters are available in progressive grades, but it is tricky – if not impossible – to recommend a particular type or strength. The effect desired will depend not only on the subject, but also on the style and taste of the individual photographer. It is a very subjective effect and, while some photographers prefer a subtle look, others prefer a much more obvious softening of the image.

There are also fog filters available to buy, aimed at replicating the effects of foggy weather conditions. They are designed to mute colour and reduce contrast to a far greater extent than a soft-focus filter. They do not create the same glowing form of diffusion either. Although generally less

EVIE
Soft-focus filters disguise fine detail and lower image contrast, creating an attractive, ethereal mood. They help conceal minor flaws in complexion and are therefore popular among wedding photographers. They are also ideally suited to taking flattering family portraits. I used a Lee Soft Focus 3 to take this portrait of my baby daughter.
Nikon D200, 105mm lens, ISO 400, 1/640sec at f/2.8, soft-focus filter, handheld.

tip

The soft-focus effect is one that I personally like and utilize whenever the scene or subject is suited to it. However, bear in mind that a soft-focus filter is actually degrading image quality. Therefore, it is worth remembering that you should always be in the habit of taking a subsequent unfiltered image – just in case you later decide you don't like the soft-focus one.

useful on a day-to-day basis, they still have their uses – adding atmosphere to views and some woodland scenes.

Another variation is the soft-spot filter, which is designed with a clear central area, the idea being that the photographer will position their main subject centrally in the composition so that it is unaffected by the filter, while the rest of the frame is diffused.

LIGHT

Light is the key ingredient to successfully using a soft-focus filter to enhance your images. They work by 'bleeding' the highlights of an image into the shadow areas to create the ethereal, atmospheric glow associated with them. This effect can be enhanced if you deliberately place your subject against a dark background, so that it is surrounded by an attractive glow or 'halo'. This can work especially well when shooting portraits outdoors. However, you will need to ensure that the subject's face is well lit, perhaps using a reflector to manipulate the natural sunlight.

This type of effect can also produce stunning results when taking scenic images – especially when combined with soft early morning or late evening light. Although shooting towards the light isn't normally recommended, sunlight filtering through woodland, for instance, will look beautiful when softened via filtration. The light will bleed through the leaves of the trees, creating an attractive, dreamy glow. In situations like this, it is best to meter for the shade within the scene. By doing this, the highlights will overexpose slightly, burn out and begin to merge with the shadows. In fact, when using a soft-

POPPIES
The effect of a soft-focus filter can be enhanced by shooting towards the light, and framing your subject against a darker background. I noticed these poppies growing in the garden of a quaint, thatched cottage. A soft-focus filter helped create a dreamy feel, transforming an otherwise quite ordinary shot.
Nikon D70, 18–70mm lens (at 52mm), ISO 200, 1/100sec at f/8, soft-focus filter, tripod.

focus filter, it is often preferable to err on the side of overexposure – by 1/2 to 1 stop – as this will create a more pleasing high-key effect.

F/STOPS

Not only can you alter the diffusion effect by using different grades of soft-focus filter, but you can also alter the level of softening by simply altering the f/stop. The larger the aperture you select, the stronger the effect will be. Therefore, at wide apertures of f/2.8 or f/4 you will enjoy the full benefit of the filter attached, while the diffusion effect will progressively lessen as you stop down the lens to smaller apertures of f/16 or f/22. Obviously, this is a major factor to take into consideration when you are deciding which filter and aperture combination to use – your decision will greatly influence the success of the final image. If you are shooting portraits, it is likely you will be employing wide apertures to help throw the backdrop out of focus. By doing this, you will enjoy the full effect of the soft-focus filter attached anyway. However, when shooting subjects where you need to select a small aperture to maximize back-to-front sharpness the result of using a mild diffuser may prove too subtle to have any effect. In instances like this, it is best to experiment with different f/stops and/or strengths of filter until you achieve exactly the effect you require.

TIFFEN DIGITAL DIFFUSION/FX
Soft-focus filters vary greatly from one brand to the next. There are a wide variety of competing types and strengths. Tiffen's Digital Diffusion/FX range is designed to create a silky smooth look on textured surfaces, while suppressing facial blemishes and wrinkles in portraits. The Diffusion/FX filters are available in 1/4, 1/2, 1, 2, 3, 4 and 5 densities.

DIY SOFT FOCUS

Due to the way soft-focus filters work, it is actually quite straightforward to mimic their effect. It is possible to create a look of diffusion in various ways, using everyday, household materials. Therefore, if you fancy saving yourself some money, try experimenting with one or two of the following ideas…

tip

Hairspray can be applied to a clear filter to create a greasy film that will produce a soft-focus effect. Spray the filter from a short distance away, so that a mist of spray coats your filter. If after one coat the effect is not strong enough, remove the filter and apply another coating. If it is too strong, wash it in warm water and start again.

BREATHE ON THE LENS

The quickest and most convenient way to soften the appearance of your images is to simply breathe on the front element of the lens – or a clear filter, such as a skylight or UV filter (page 46), placed in front of it. This creates a fine mist of condensation, diffusing the image. Although the effect is normally too strong at first, it will grow softer as the condensation begins to clear.

STOCKINGS

Hollywood film cameramen first devised this technique in the 1940s, using nylon stockings stretched over the lens to help ensure that their leading ladies looked as beautiful as possible in close-up. It works just as well when combined with a stills camera. The stocking can be secured quickly and easily using an elastic band. However, if you like the effect, a more permanent filter can be constructed by stapling the material to a stiff piece of card cut to fit the dimensions and thickness of the filter slots of your chosen holder. You can create different levels of diffusion by using different grades of stocking material – measured in denier. The higher the denier number, the denser the material and, as a result, the stronger the soft-focus effect. Black stockings will produce neutral-looking results, while flesh-coloured stockings will warm up your image as well as softening the shot.

PETROLEUM JELLY

Smearing petroleum jelly (e.g. Vaseline) over a clear filter is probably the best-known way to mimic the soft-focus effect. A tiny blob of jelly – 1–3mm in diameter – will be enough to smear across the filter's surface. Obviously, it is not wise to apply the jelly directly to the front element of your valuable lens. Instead, use an inexpensive clear filter, such as a UV or skylight filter. By covering the filter in a film of jelly, the light passing through it will be diffused. One of the reasons that this technique is so popular is that you can vary the effect easily from one frame to the next by smearing the jelly in a different way, using either a finger or cotton wool bud.

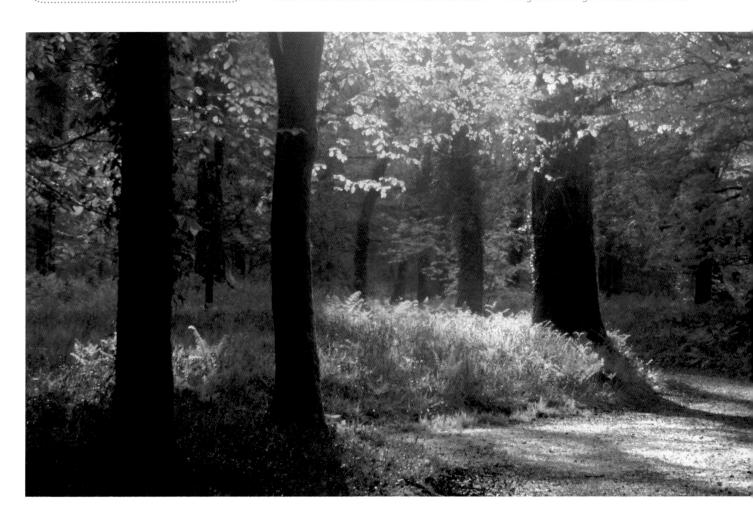

SHEEP
A soft-focus filter doesn't restrict the light entering the lens, so shutter speeds remain unaffected. Their effect will help add a soft, dreamy glow to your images, especially when combined with warm morning or evening sunlight. This diffused effect can suit and enhance all manner of subjects.
Nikon D2x, 70–200mm lens (at 135mm), ISO 100, 1/60sec at f/11, soft-focus filter, tripod.

Apply larger quantities of jelly to create more artistic, ethereal or distorted images. Also, try using your finger to create streaks or circles for bizarre, abstract results.

FOOD WRAP
If you don't have any of the aforementioned materials to hand, try using cling film. Plastic food wrap can be used to produce a subtle form of diffusion. Screw the wrap up into a ball first – the creases will help enhance the effect – and then stretch it over your lens. Add further layers of film to strengthen the effect. You can also spray food wrap with hairspray, or smear petroleum jelly on it, if you don't have an old UV or skylight filter spare to attempt the previous techniques.

◀ **SPRING WOODLAND**
Although this woodland scene already made an attractive image, by breathing on the front element of the lens I was able to mimic the effect of a soft-focus filter. I had to wait several moments until the condensation this created cleared sufficiently to produce the subtle, hazy effect I desired. I cropped the image into a panoramic format post-capture.
Nikon D200, 18–70mm lens (at 70mm), ISO 100, 1/8sec at f/22, polarizer, tripod.

GONDOLAS
Smearing petroleum jelly on a clear filter – such as a skylight or UV – is a great way to create a makeshift soft-focus effect. In this instance it has added mood and mystery to this view of bobbing gondolas.
Kodak SLR/n, 35mm lens, ISO 160, 1/2sec at f/16, Vaseline (smeared horizontally), tripod.

CHAPTER SEVEN: CLOSE-UP FILTERS

The appeal of photographing the fascinating miniature world underneath our feet is obvious, but many photographers are deterred by the cost of specialized equipment. Macro lenses, which are optimized for close focusing, are expensive and other close-up attachments, such as extension tubes and reversing rings, can disable some of a DSLR's automatic features. Instead, a good introduction to macro photography is to invest in a set of close-up filters – or supplementary close-up lenses, as they are more commonly known. These enable you to capture small subjects by simply adapting the optics in your existing DSLR system – ideally suited for those on a limited budget. Although they do not offer the same image quality as some other close-up accessories, they are lightweight, convenient and a useful addition to anyone's camera bag. Most major filter manufacturers boast a set of close-up filters in their range.

HOW CLOSE-UP FILTERS WORK

Close-up filters screw into the filter mount on the front of the lens and act like a magnifier; reducing the lens's minimum focusing distance. They work by shifting the camera's plane of focus from infinity to the distance corresponding to the focal length of the close-up lens. Their magnification is measured in dioptres, a unit you may be familiar with from an optician's prescription. The lenses are convex meniscus – thicker in the middle than at the edges – and are similar to the optics found in glasses for people who are long-sighted.

Close-up filters do not affect normal camera functions, like TTL metering, or restrict the ambient light entering the lens – useful when working handheld.

STRENGTHS AND TYPES

Typically, supplementary lenses are of a single-element construction and are produced in a range of four strengths: +1, +2, +3 and +4. The higher the number, the nearer it is possible to focus and therefore the greater the magnification. Hoya also produces a more powerful +10 dioptre, which has a two-element construction to help optimize image quality.

Close-up filters can be bought singly or in a set. A set will typically contain a +1, +2 and +4 dioptre. They can be used individually or together to achieve different levels of magnification. For instance, if you combine a +1 and +2 filter together, you will achieve a level of magnification equivalent to a +3 dioptre.

IMAGE QUALITY

Although they do not give the same optical quality as a specific macro lens – especially at the edges of the frame – it is still possible to achieve excellent results using a supplementary close-up lens. However, they are prone to chromatic and spherical aberration. Chromatic aberration is when colour fringing or 'ghosting' occurs around the edges of out-of-focus objects. Filters that employ a two-element construction are designed to minimize this flaw, although they are more expensive to buy. Spherical aberration is softening of the image overall, and this will be further exaggerated if taking pictures using a small aperture. To minimize this effect, it is best to take pictures using a mid-range f/stop of f/8 or f/11 – although, as a result, this will limit depth of field.

It is possible to couple close-up filters together to create a greater level of magnification. If you do this, attach the most powerful one on your lens first and the weakest last. Combining three or more filters together will degrade image quality and exaggerate any optical flaws, so it is recommended that you attach a maximum of two at any one time.

To optimize image sharpness, it is best to combine a close-up lens with a prime focal length lens, as opposed to a zoom lens. A standard 50mm lens is an ideal focal length, but short telephoto lenses, up to 135mm, are also well suited.

GETTING CLOSER
I spotted this curious, lichen-encrusted carving (opposite page) on an old gravestone at a local church. The engraving was approximately 30cm (12in) in width. I used a Nikon D200 with a standard 50mm lens to photograph this sequence, taking the first image without a filter and then using close-up dioptres of progressive strength for the subsequent shots.

CLOSE-UP FILTER
Supplementary close-up filters might be inexpensive, but they are an excellent introduction to the world of macro photography. They are available in a range of filter threads and strengths and can be purchased individually or in a set.

PROGRESSIVELY CLOSER

50MM LENS, NO FILTER

WITH +3 DIOPTRE ATTACHED

WITH +1 DIOPTRE ATTACHED

WITH +4 DIOPTRE ATTACHED

WITH +2 DIOPTRE ATTACHED

WITH +10 DIOPTRE ATTACHED

MAGNIFICATION

To help you select the correct strength filter for the subject, it is useful to understand how to calculate a dioptre's magnification. This will vary depending on the lens it is attached to. If you are using a digital SLR camera with a cropped-type sensor, the reproduction ratio will be further increased, but depth of field will grow narrower as a result. The technical pros and cons need to be weighed up to ensure you make the right choices.

CALCULATING A CLOSE-UP DIOPTRE'S MAGNIFICATION

The strength and effect of a close-up dioptre will vary depending on the focal length of the lens it is combined with. To calculate the magnification possible when you add a close-up filter to a lens focused to infinity, you will need to do a little basic arithmetic – so if maths wasn't your favourite subject at school, I suggest you find a calculator.

First you need to establish what the dioptre's equivalent value would be in millimetres. To do this, divide 1,000 by the strength of the dioptre. For example, to calculate the value of a +3 dioptre:

1000/3 = 333mm

Now, divide the focal length of the lens in millimetres by the equivalent focal length of the dioptre in millimetres. So, for example, if you attach a +3 dioptre to an 80mm prime lens, you will achieve a magnification of:

80/333 = 0.24x – approximately 1:4 life-size

Just remember this simple equation:

Magnification = focal length of lens/focal length of dioptre.

Of course, you do not have to take photographs using the lens focused to infinity. It is possible to adjust focus in the normal way, and by setting the lens to its minimum focusing distance you can achieve an even greater level of magnification in your images.

REPRODUCTION RATIO

The reproduction ratio represents the real life-size of any given subject in relation to a digital camera's image sensor. Therefore, if an object 80mm wide appears 10mm wide on the resulting image, the reproduction ratio is 1:8 (80mm divided by 10mm). An object that appears exactly the same size has a 1:1 life-size reproduction.

BRAMBLE LEAF
It was a chilly winter's morning and everything was glistening with frost. I noticed this attractive leaf and attached a close-up dioptre so I could capture a frame-filling image. To isolate the leaf from its background, I deliberately selected a small f/stop. The narrow depth of field this created reduced the backdrop to an uncluttered and colourful blur.
Nikon D70, 50mm lens, ISO 200, 1/10sec at f/4, +3 dioptre, tripod.

This ratio can also be expressed in terms of magnification, with 1x being life-size, 0.5x half-life-size, and so on.

DEPTH OF FIELD

Depth of field is the zone, in front and behind of the point of focus, which is recorded acceptably sharply in a photograph. Taking pictures at high magnifications will greatly reduce depth of field. When using a close-up dioptre, it can be a matter of just a few millimetres; even at small apertures, like f/11 or f/16. For this reason, careful and precise focusing is vital. It is also important to remember that selecting a small aperture will slow the corresponding shutter speed. Therefore, a tripod is recommended whenever possible.

Although a limited depth of field can prove problematic, it may also be used for creative effect or manipulated to influence how the viewer interprets the subject you are photographing. For example, shallow focusing can be used to emphasize a subject or just a small part of it, drawing attention to your intended point of focus.

Cropped-type sensors

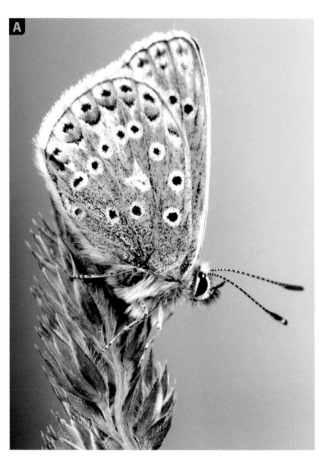

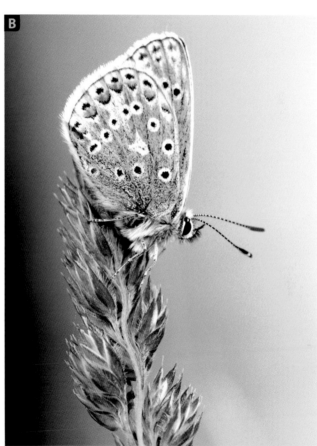

For the sake of economy, the majority of digital SLR cameras are designed with a cropped-type image sensor. As a result, they don't 'see' as much of the scene or subject as a larger full-frame sensor or traditional film camera. In effect, they crop into the image and this creates a degree of magnification. Commonly, this is by a factor of 1.5x, but it will vary depending on the make and model of your digital SLR. This magnification factor can have both a positive and negative effect on the characteristics of the lens attached; it really depends on what you are photographing. For example, a traditional 28mm wide-angle lens attached to a DSLR with a 1.5x focal length magnification will, in effect, be equivalent to a 42mm lens; negating the lens's intended wide angle of view. However, this conversion factor can prove very handy when using a telephoto lens to photograph distant subjects, like timid wildlife or sport. Similarly, cropped-type sensors are useful when using close-up filters, as they effectively increase their level of magnification.

DIGITAL CROP

Digital cameras boasting a cropped-type image sensor increase the effective magnification of close-up filters. This either allows photographers to work from further away (useful when shooting timid or flighty wildlife), or take pictures with the subject even bigger in the frame. These two images of a blue butterfly show the extra magnification of a digital SLR camera boasting a 1.5x crop (A), compared to full-frame model (B).

FLOWERS

Regardless of whether they are wild or cultivated, flowers are perennial favourites among photographers. Their vibrancy, colour and intricate design make them an irresistible subject. Although they can be photographed within a garden setting or maybe bunched together in a vase, often the most eye-catching results are images showing the subject close-up. Frame-filling pictures are only possible with the aid of a close-up attachment and, unless you intend shooting close-ups on a regular basis, it is unlikely you can justify the high price tag of a macro lens. Therefore, a close-up filter is the ideal compromise – allowing you to shoot great floral close-ups at a fraction of the cost.

RED-HOT POKER
I feel simplicity often works best. Although this image is quite striking, it was relatively easy to capture; I simply relied on the subject's colour and form. The key to shooting good floral images is to identify a perfect specimen, as close-up photography will exaggerate even the tiniest flaw or imperfection.

Nikon D70, 50mm lens, ISO 200, 1/60sec at f/11, +4 dioptre, tripod.

tip

It is fine to couple a polarizer with a close-up dioptre. Polarizing filters (page 22) work by reducing glare, so they can be used to eliminate the 'sheen' reflecting from flower petals, leaves and foliage. This will restore colour saturation and give your floral close-ups added punch.

CULTIVATED FLOWERS

The overriding advantage of shooting cut, cultivated flowers is that you have far greater control over light, composition and the subject's background. Visit a local florist and you will be presented with a huge choice of flowers to buy and photograph. Some types are more suitable than others, so examine them closely. Opt for large flowers with interesting detail or symmetry that can be shot comfortably using a close-up dioptre. Remember to consider the maximum magnification that your particular lens and dioptre combination is capable of (page 66). One of the drawbacks of close-up photography is that the high level of magnification will exaggerate even the tiniest imperfection. It is important to personally hand select the flowers, examining them closely to ensure they are pristine. To prevent them wilting, keep the stems in water, and photograph them as quickly as possible.

WATER LILY
To maximize the available depth of field, I had to position my camera directly overhead this water lily. This involved me submerging the bottom section of my tripod legs in the water of the pond. Bright but overcast light provided subtle, even lighting and permitted me to record the subtle shades of the flower. A +3 close-up dioptre allowed me to crop in tight to the flower and fill the frame.
Nikon D70, 50mm lens, ISO 200, 1/10sec at f/14, +3 dioptre, tripod.

FOXGLOVE
Simplicity is the key to good flower close-ups. I positioned myself so a shady bank formed a simple, dark backdrop to this colourful foxglove. A close-up dioptre allowed me to get close enough to capture fine detail and every delicate dewdrop.
Nikon D70, 50mm lens, ISO 200, 1/30sec at f/8, +3 dioptre, tripod.

The joy and convenience of taking pictures indoors is that your subject will be unaffected by wind. Create a mini tabletop studio adjacent to a window, so you can utilize the sunlight – this is often preferable to a burst of fill flash. If you wish to soften the light, hang a piece of muslin or calico over the window to diffuse the incoming sunlight.

Frame-filling close-ups will highlight your flower's shape, form and colour. Alternatively, use your close-up dioptre to isolate a section of the flower, set against a contrasting backdrop. Brightly coloured matte card can be employed as a makeshift background; colour 'clashes' can work surprisingly well.

If you prefer a still-life approach – as opposed to a macro study – the 'props' you employ will be crucial to the image's success. Try placing your flowers in an attractive vase, against a suitable, flattering backdrop. Subtle, soft lighting is often preferable. To create moody, artistic results consider using a soft-focus filter (page 58).

WILD FLOWERS

Close-up filters are also handy should you fancy shooting wild flowers. It is important not to damage wild species, so you have to adapt your approach depending on the plant's position, its surroundings and the direction of light. To produce natural results, shoot from a parallel angle, which often means lying on the ground. Shooting at such a low angle can make it impractical to employ a tripod, so you may need to rely on your elbows for support. Thankfully, a dioptre is perfect as it is lightweight, making it easier to shoot shake-free images handheld with a close-up lens attached to a short, compact standard lens than it would be if you were using a heavier, longer macro lens.

Select a medium aperture of f/8 or f/11 to throw the background out of focus and isolate the flower from its surroundings. Check the background for any distracting blades of grass. If there are any, use scissors to remove them or simply flatten the grass with your hand.

TEXTURES AND NATURAL PATTERNS

Normally, a subject's picture potential is glaringly obvious. A beautiful sweeping vista, sunset or colourful flower will soon have you reaching for your camera. In contrast, the photogenic appeal of many miniature subjects is all too easily overlooked. A good example of this is the huge variety of natural and artificial patterns and textures that can be found all around us – indoors and out. Close-up filters allow photographers to isolate small, key areas of detail and interest; transforming otherwise mundane, everyday subjects into eye-catching results. Let's face it, you would probably never consider photographing objects like electrical circuitry, fabric, bark or moss, but with the aid of a close-up filter, their appearance can be totally altered. Some subjects will become virtually unrecognizable in close-up, creating abstract and unusual results. The opportunities are endless; all you need is a sharp, creative eye.

BACKLIT LEAF
In its entirety, this leaf wouldn't have created a strong image. It had been nibbled by caterpillars and the background was messy and distracting. A +3 close-up filter allowed me to move in much closer, revealing its intricate veins and the pattern they created. Positioning a major vein diagonally helped strengthen the composition.
Nikon D200, 50mm lens, ISO 100, 1/8sec at f/14, +3 dioptre, tripod.

ARTIFICIAL PATTERNS

There is never an excuse for not taking pictures. Even if it is miserable outside, with the aid of a close-up filter you will always be able to find something to shoot indoors. Through a close-up filter, colourful pens and pencils, cutlery, children's toys, a speaker grill or circuitry can be isolated from their surroundings to form interesting, photogenic patterns. Remember that taking pictures indoors under artificial tungsten lighting can cause a warm colour cast unless you adjust your camera's WB setting accordingly (page 34).

The key to creating interesting pattern pictures is to fill the frame. This wouldn't be possible without a dioptre, due to a lens's restrictive minimum focusing distance. But with one it is possible to maximize your image's impact.

Presuming you require edge-to-edge sharpness, position your camera so the sensor plane is parallel with your subject.

NATURAL TEXTURES

Once you begin using close-up filters, you will look upon the miniature world underneath your feet in a completely new light. With so many natural patterns to photograph, it can be difficult to know where to begin. Subjects such as moss, lichen, bark, sand, leaves, interesting geology and water droplets need to be studied through a close-up lens before you can appreciate their form and picture potential. You may have to get down on your hands and knees to photograph these things, but the results will make getting grubby worthwhile.

A support to steady your set-up will prove useful in many picture-taking situations. Some supports, such as the Benbo and Uni-Lock tripods, are designed specifically for close-up work and their legs can be arranged in almost any position. Alternatively, use a beanbag or crumpled-up jumper as a makeshift support.

As a result of using a close-up dioptre, you will be working in close proximity to the subject. Therefore, light is often severely limited. Although it may be tempting to add a burst of flash, this can easily destroy the natural feel of your shot. Instead, try to manipulate the natural light available using a small reflector. Compact, collapsible reflectors are available from manufacturers such as Lastolite – or make your own by stretching tin foil over a large piece of cardboard, then carefully position your reflector to direct light on to your subject.

PENS
A close-up filter, combined with a little imagination, will help transform mundane, everyday objects, like this group of coloured pens, into striking pictures.
Nikon D70, 50mm lens, ISO 200, 1/8sec at f/11, +3 dioptre, tripod.

FEATHERS
From a distance, you simply can't appreciate the beauty of natural textures like the feathers forming a bird's wing. Thanks to a close-up dioptre, I was able to fill the frame, thus maximizing the impact of my composition.
Nikon D200, 50mm lens, ISO 100, 1/6sec at f/14, +3 dioptre, tripod.

PHOTOGRAPHING INSECTS

Nature is one of the most popular but challenging forms of photography. The majority of photographers will, at some point, want to give wildlife photography a go, but many are deterred by the cost of specialized equipment or lack of time. Although it is true that, for some wildlife, you will require a long telephoto lens and need to wait patiently in a hide for hours, there are simpler and cheaper routes into the world of nature photography. Bugs and beasties can be photographed with a basic set-up and sometimes in the comfort of your own back garden. All you need is a supplementary close-up filter and a little patience.

BROOM MOTH
When I found this moth, I knew immediately that a +3 close-up filter wouldn't produce a high enough magnification to achieve a frame-filling result. Instead, I decided to place more emphasis on the background of the old, weathered wooden post, with the moth as a smaller percentage of the frame.
Nikon D200, 50mm lens , ISO 200, 1/8sec at f/11, +3 dioptre, tripod.

Camera shake

Camera shake is a common fault that can occur in pictures when the selected shutter speed isn't fast enough to eliminate our natural movement. When shooting close-ups, any movement is more noticeable and this is exaggerated further as the magnification is increased. A tripod will practically guarantee a shake-free result. Alternatively, a monopod or beanbag will help you to keep the camera still during exposures. If using a camera support is impossible or impractical, select a shutter speed at least double the focal length you are using. For example, if taking close-up pictures using a 50mm lens, ensure you use a shutter speed of 1/100sec or faster. When shooting handheld, it is also important to give yourself a good, steady platform. Stand with your feet shoulder width apart and one foot slightly in advance of the other. Keep your elbows tight to your chest and hold the camera firmly to your face.

ADVANTAGES OF USING CLOSE-UP DIOPTRES

Regardless of what you photograph, a camera support is a welcome aid. Not only will a tripod give your set-up extra stability, but it will also help you to fine-tune your composition. However, a tripod is bulky, fiddly and not always possible to use. When photographing flighty, timid insects, a tripod can be impractical, due to the enhanced risk of disturbance. As a result, it is likely that you will often need to shoot handheld.

This is where close-up filters have a major advantage over some other close-up

attachments. Although a specific macro lens is capable of a higher degree of magnification, it is heavier, making it more difficult to handle. In contrast, a short standard lens coupled with a close-up dioptre is lightweight and compact. In addition to this, close-up filters do not restrict the ambient light entering the lens – unlike a teleconverter – so shutter speeds remain unaffected, which is extremely useful when photographing insects, as you will require a fast shutter speed to help eliminate camera shake when handheld.

DIOPTRE DRAWBACKS

I am a big fan of close-up filters, but it is important not to overlook the drawbacks of using them. They are not capable of the same high level of magnification as a macro lens or reversing ring – unless you combine two or more dioptres together, which isn't recommended. Although this may not present a problem when photographing larger subjects, it can prove more restrictive when shooting small insects. One way to overcome this problem is to place less emphasis on the subject and more on its surroundings.

Too often, photographers will fill the viewfinder with their subject just through habit. However, a more aesthetically pleasing result can be achieved by taking pictures from further away. As a result, the limitations of using close-up filters can sometimes prove a blessing in disguise. It can help you to think more about creating a good, balanced composition and stronger picture overall. Showing a subject within its environment, or contrasting against a striking background, is a good way to create a dynamic wildlife image.

SHOOTING INSECTS

Insects vary tremendously in size, shape and colour, making it impossible to generalize about the best techniques needed to photograph them. However, there are a few basic rules worth remembering.

Insects are normally at their least active first thing in the morning and just before nightfall, so this a good time to photograph them. The light is also more dramatic at either end of the day.

Most insects will fly or scurry away if disturbed, so a slow, careful approach is needed. Do not cast your shadow across the insect, as this will alert it to your presence.

Before taking a picture, it is a good idea to manually pre-focus the lens and then gradually move your set-up nearer to the subject – until in sharp focus. By doing this, you eliminate the risk of your camera's autofocusing disturbing the creature, either through the noise of its motor or via the rotating front element.

To optimize image quality, it is best to combine close-up filters with a medium f/stop of around f/8 or f/11. However, this will limit depth of field, making precise focusing critical. To maximize the depth of field that is available, try to position the camera so that the image sensor is parallel with the subject.

BANDED DEMOISELLE
Close-up dioptres are light and compact. When combined with a short, standard lens they can be used comfortably handheld. The dew on this damselfly's wings was drying quickly in the early morning sunshine and the insect was almost ready to fly. To minimize the chances of disturbance, I decided to shoot handheld, but was still able to achieve a pin-sharp image.
Nikon D200, 50mm lens , ISO 100, 1/80sec at f/5, +4 dioptre, handheld.

BACKLIT BUTTERFLY
The best time to photograph butterflies is during early morning, when they are still asleep or only just emerging. I found this stunning insect just as the first rays of light began to warm its wings. While butterflies are still cold and laden in dew, they are unable to fly, giving you a good window of opportunity to photograph them. In this instance I was able to use a tripod to ensure a pin-sharp image.
Nikon D200, 50mm lens, ISO 100, 1/125sec at f/7.1, +3 dioptre, tripod.

PART TWO:
IN-COMPUTER FILTRATION

While you strive to create 'the perfect picture' in-camera, it is not always possible to produce the image you desire without a little tweaking afterwards. Photographers have been enhancing their images post-capture for generations – only today we use software instead of a darkroom. The methods may be different, but the principle is the same. While many traditional filters remain essential tools, others have been made redundant by digital techniques – saving you money and conserving space in your camera bag. This is because some filter effects can be added with greater precision using Photoshop, allowing you to experiment at home.

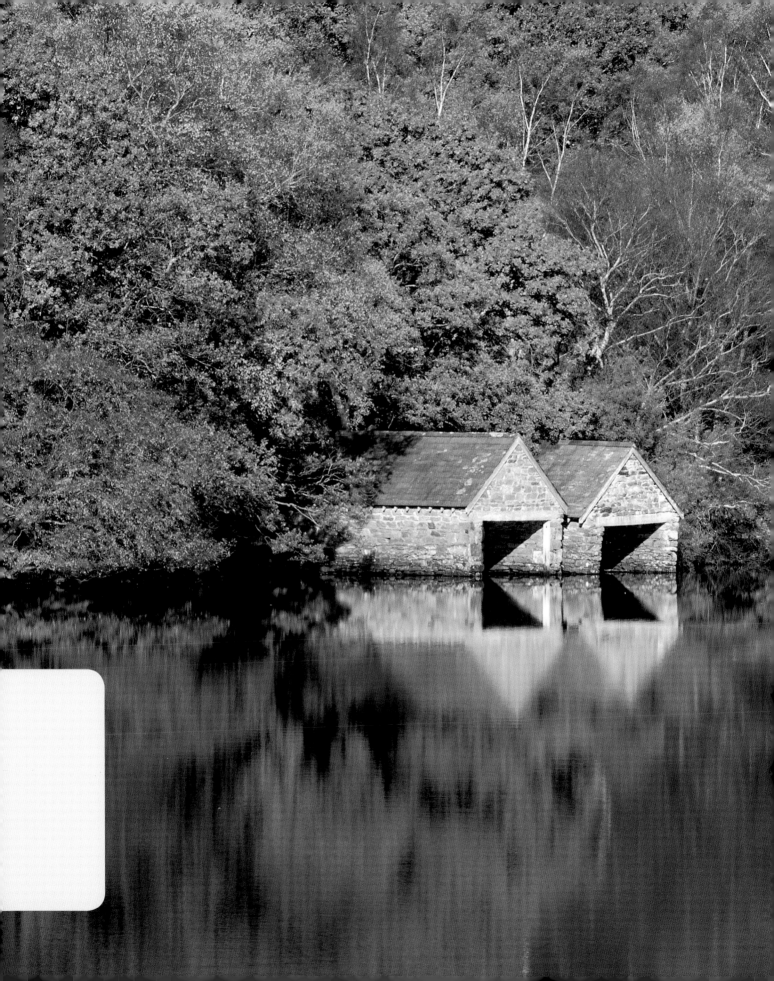

CHAPTER EIGHT:
CORRECTION

When you squeeze your camera's shutter release button to capture a photo, it isn't the end of the picture-making process, but the beginning. Digital capture has greatly altered a photographer's workflow, and post-processing is an essential part of modern photography. Once downloaded on to your PC, your images will normally benefit from some degree of 'tweaking' using image-editing software. This can take many forms. You may only wish to make subtle, discreet changes to enhance an image (page 90). Alternatively, you might decide to completely transform the appearance of your images by applying a special effect (page 118).

CORRECTIVE POSSIBILITIES

Post-capture correction isn't a form of manipulation. You are simply fine-tuning your images to ensure that they accurately resemble the scene or subject as it was viewed through the camera's viewfinder when the picture was originally captured. Once the files have been successfully downloaded from the memory card to your computer, you will normally view and edit the photographs using the software supplied with the camera. This software is especially useful if you shoot in RAW mode, as it will allow you to adjust the image's shooting parameters quickly and simply, including WB and contrast.

Colour casts are a common problem. They can be the result of a combination of things and, while an unnatural hue can enhance a photo,

TO CORRECT
OR NOT TO
CORRECT?

The changes you make to your images post-capture will greatly depend on your outlook. Purists will prefer to keep their alterations to a minimum, while other photographers enthusiastically embrace the vast array of post-processing techniques available to them. However, regardless of your attitude, some degree of correction is normally essential. If this is overlooked, your pictures will often not fulfil their potential.

OUTDOOR PORTRAIT
A degree of post-processing is normally needed before a digital image can fulfil its potential. Only by doing this can the photographer ensure the processed file is exactly as they desire. Colour casts are a common problem. In this instance, the image's colour balance has been tweaked to ensure the colours in the final image are authentic.
Nikon D2x, 70–200mm lens (at 135mm), ISO 100, 1/250sec at f/5.6, handheld.

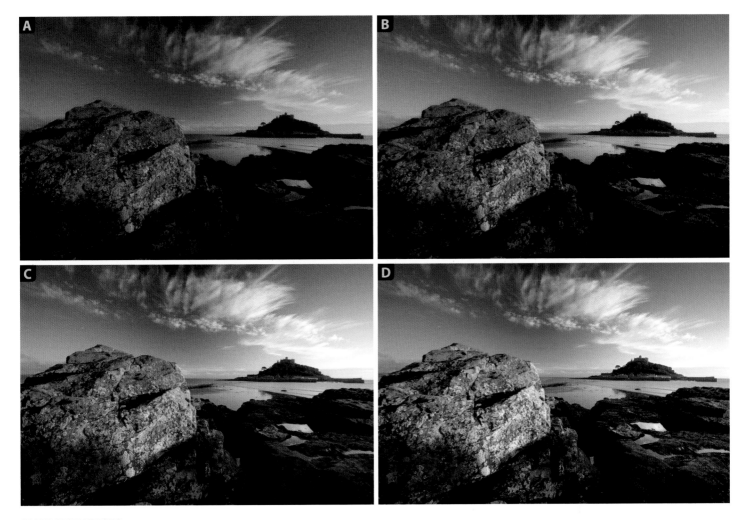

IMAGE CORRECTIONS

When I took this image, I didn't have an ND grad to hand, so I took two images – the first exposed for the sky and the second exposed for the foreground. My intention was to later sandwich them together to create a balanced result. Image (A) shows the image exposed for the sky. As a result, the foreground is underexposed. The image is still unprocessed at this stage, so it lacks contrast and appears dull. The image is also suffering from an overly warm colour cast. The file was then processed with the supplied software, which helped improve contrast and gave the image a little more life (B). I then sandwiched the image with the frame exposed for the foreground. This produced an overall balanced exposure (C). Finally, I adjusted the image's colour balance to neutralize the warm colour cast (D). These few basic corrections have radically transformed the original.

Nikon D200, 10–20mm lens (at 11mm), ISO 100, 1/4sec at f/20, polarizer, tripod.

often it will prove ugly and degrade the image. Film users need to anticipate the strength and type of cast and then correct it in-camera using optical filters. In contrast, digital photographers not only have the luxury of being able to regulate their results via image playback, but can also neutralize a cast during the processing stage. This can be done by either mimicking the effects of traditional colour-balancing and colour-conversion filters (page 39) or by intuitively adjusting the image's colour balance settings to create an accurate-looking result.

One of the biggest challenges for outdoor photographers, regularly dealing with mixed lighting, is correcting uneven exposures. The sky will often need a different level of exposure than the landscape below. Balancing an unevenly lit scene can be done by attaching a graduated ND filter (page 48), but can also be achieved post-capture by 'sandwiching' two images together – one that was correctly exposed for the sky and the other for the darker foreground. This is a useful technique for when you are without an ND grad or when the horizon is broken by key elements that would also be artificially darkened by the use of a graduated filter.

By making just a few basic corrections to your images – as described in this chapter – your pictures will be greatly improved. For some images, these are the only alterations you will want to make. However, other photographs may also benefit from the post-processing techniques outlined in Chapters Nine and Ten.

DOWNLOADING IMAGES

The first step towards making corrections or creative adjustments to your images is to download your digital shots from the camera to your PC. Regardless of whether you decide to shoot in RAW or JPEG (page 81), the latest digital bodies boast such impressively large resolutions that your storage media will soon be bursting full of images. Your camera will link directly to your computer via the USB cable supplied. Alternatively, specific card readers are available to buy.

CAMERA SOFTWARE
While the supplied image-editing software will vary from one camera manufacturer to the next, each will boast the same basic, essential controls, including contrast, brightness, sharpness and colour balance. Software will be updated from time to time, so check your camera manufacturer's website for free downloads of the latest version.

The image-editing software bundled with the camera makes downloading images on to your hard drive a simple, user-friendly process. However, the software supplied by different manufacturers varies tremendously, with some programs boasting more features and capabilities than others. Essentially, though, they are all designed to do a similar job and will each contain certain key features.

MAKING BASIC ADJUSTMENTS

While the software supplied with most cameras is limited compared to Photoshop, they are still useful programs that allow you to make basic adjustments to your images for correction or creative enhancement. Once your images have been successfully downloaded to your PC, they will normally be displayed in a 'browser' or 'viewer' as thumbnails. Images can then be viewed

Converting film to digital

If you are a digital convert, you shouldn't allow your existing library of transparencies or negatives to gather dust. Instead, why not convert them to digital? This would enable you to tweak the original or make creative adjustments. You should try applying some of the filter effect techniques illustrated here to breathe fresh life into your existing shots. You may have a scenic image that you feel would benefit from a coloured sky (page 100), but you didn't have a colour-graduated filter when you took it. By digitizing the shot, and using image-editing software, you can finally achieve the effects you desire.

Most photo labs offer a professional scanning service. However, if you have a large number of images this may prove costly. Instead, consider buying a specific film scanner. Manufacturers such as Nikon, Canon and Konica-Minolta market high-quality, affordable models. They are well worth the cash if you have a large library that needs digitizing – although the process can prove time-consuming. Most scanners boast ICE (Image Correction and Enhancement). However, if your negatives or slides are dirty, it is still wise to clean them carefully beforehand, using a specific microfibre cloth. If you intend to print the scanned image – or even use it commercially – it is best to scan using the maximum resolution and bit depth. However, bear in mind that scans of this size and quality will consume large chunks of your computer's memory.

DIGITIZING FILM
The Nikon Coolscan V is typical of the type of desktop film scanner available for consumers to buy. It boasts a 4,000dpi true optical resolution and 14-bit A/D converter.

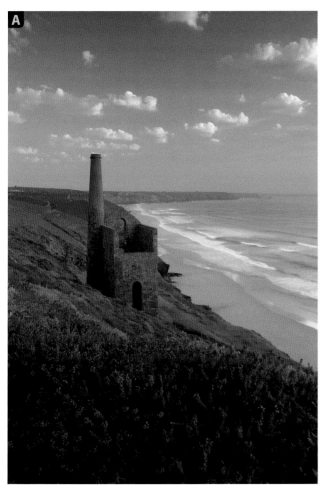

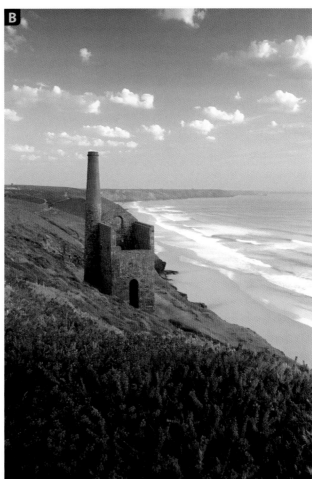

BASIC ALTERATIONS

Just by using your camera's supplied imaging software, you can greatly enhance your digital images. The original shot (A) was captured in RAW, but without any processing the image looks flat and suffers from a cool colour cast. I decided to spend a few moments adjusting contrast and brightness using the supplied software. I also tweaked its colour balance to add a little extra warmth and nullify the blue hue. The result is a much punchier image (B).
Nikon D70, 18–70mm lens (at 18mm), ISO 200, 1sec at f/22, polarizer, 0.9 ND grad, tripod.

quickly and easily, allowing you to identify the images you want to edit and save. By opening an image in the software's 'editor', you will be presented with an array of controls that can be used to make basic image adjustments. Some programs are more sophisticated than others, but even the most basic software will allow you to tweak contrast, sharpness, brightness, colour balance and also flip, rotate and crop your image. While most digital images need a degree of sharpening, this is best applied using Unsharp Mask in Photoshop (page 116). The image's colour balance can be altered, usually via a selection of colour sliders. They can be dragged left or right to either add or subtract a particular colour from the image. These can be used to

CARD READER

Regularly downloading images directly from your camera to a PC can damage your camera's delicate components – due to connecting and disconnecting the USB cable. Instead, use a hardware card reader. They are relatively inexpensive and connect to your computer via a USB or FireWire cable.

correct a colour cast or to add one for creative effect. Large colour shifts can simulate the look of traditional in-camera filters, with the added advantage that they can be fine-tuned to create just the effect you require. Personally I prefer using Colour Balance in Photoshop (page 97), but your camera's software is a viable alterative and can prove a quick fix.

RAW users will have a larger array of image-editing controls available to them. Compared to a JPEG, a RAW image is a much more flexible file type. The shooting parameters of RAW images can be more easily altered post-capture, so you will have the added luxury of being able to adjust the white balance (page 80) and apply exposure compensation if required.

WB ADJUSTMENT OF RAW FILES

Photographers who shoot in RAW have the luxury of knowing that, should they not achieve the correct WB in-camera, it can still be adjusted post-capture. Equally, it can be altered to create a more aesthetically pleasing result than if you remained faithful to the original lighting. Unlike RAW images, the shooting parameters used to capture a JPEG or TIFF are applied in-camera, including WB. If the wrong WB setting is used, the final image will be affected – making it important to achieve the correct setting in the first place. Although RAW images are flexible, it remains important to get as much right as possible at the moment of capture, rather than relying on remedial actions on a computer. However, RAW shooting is advantageous, giving you the opportunity for corrective, or even creative, tweaking on your computer.

LEAF
When I took this image, I forgot to alter my WB setting from 'Shade' – the pre-set that I had been using the day before. The resulting artificial colour cast has given the snow an unsightly warm cast (A). Thankfully, I'd taken the image in RAW and was able to correct my mistake during conversion (B).
Nikon D70, 105mm lens, ISO 200, 1/50sec at f/1, tripod.

USING RAW CONVERSION SOFTWARE

Trying to remove colour anomalies in JPEG or TIFF files can be fraught with difficulty. In contrast, RAW conversion software is designed to make alterations to WB quick and simple.

Although RAW files contain all the information needed to create a picture, in reality they are not actually an image until they have been processed and resaved. They require specific software to do this. Digital cameras are bundled with appropriate RAW conversion programs – or you may prefer to buy independent software such as Capture One, Bibble or RAW Shooter.

Many programmes have batch mode, which is the ability to convert multiple files quickly at the same time. RAW converters work by reading the file and will, at first, apply the camera settings you used when you took the original.

Different effects can be applied via the WB menu and the choice will normally mimic the WB pre-sets available on the camera itself. If faithful colour rendition is required, you will want to match the WB setting closely to the temperature of light that illuminated your scene originally. For a more creative approach, experiment to deliberately mismatch the settings.

WB EXPERIMENTATION

It is well worth experimenting with different WB values during RAW conversion. When I originally took this moody image of trees in the mist, I relied on my camera's 'Daylight' WB setting (A). However – although accurate – the result wasn't very exciting, so I applied WB settings of 'Shade' (B) and 'Fluorescent' (C) post-capture. Although I probably wouldn't have considered using either setting at the time of taking the image, I prefer both effects to the 'correct' original.

Nikon D200, 100–300m lens (at 125mm), ISO 100, 1/8sec at f/11, tripod.

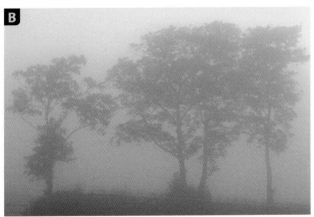

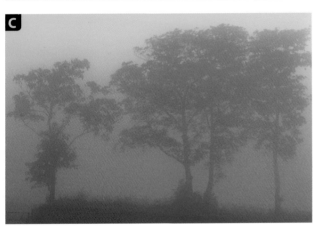

ADJUSTING WB

RAW files cannot be read or processed without specific software. As a Nikon user, I normally rely on the basic RAW conversion software supplied with my camera. However, you may prefer one of the independent programs on the market or a plug-in. Each has its merits and shortcomings, and you should base your choice on speed and ease of use.

File types

Digital images can be captured using different file types; typically JPEG, TIFF and RAW. Each type has its own individual advantages and disadvantages, so a good understanding of these is important.

RAW is the most flexible file format, being undeveloped digital data. RAW files are not normally compressed and the shooting parameters are attached – not applied. As a result, they can be adjusted post-capture using RAW conversion software. The disadvantage of shooting in RAW is that processing images can prove time-consuming; the advantage is that the photographer has far greater control over the appearance of the final image. However, RAW files – produced by high-resolution cameras – will consume large chunks of memory. Therefore, you will require large-capacity storage media or a Portable Storage Device (PSD). Once a RAW file is processed it should be saved as either a TIFF or JPEG.

JPEG – Joint Photographic Experts Group – is the most commonly used file format and can be opened, viewed and printed by any imaging software. It is a compressed file type, so images are smaller – in bytes, not physical size. As a result, they are easier to archive. Your camera will allow you to capture JPEGs in different sizes and qualities; typically, Fine, Normal and Basic. The lower-quality settings are fine for snaps or to send pictures via email, but if picture quality is a priority, employ the highest resolution. However, a JPEG is less flexible. The shooting parameters employed to capture the image are applied in-camera. This is fine if you intend using or printing the shot immediately after download, without further adjustment. However, if you make a technical error – or simply wish to 'tweak' WB creatively – its lack of flexibility can prove frustrating. Being a 'lossy' file, each time you resave a JPEG, some of the original data will be lost.

TIFF – Tagged Image File Format – is a 'lossless' format. Similar to JPEG, shooting parameters are applied in-camera, making it a less flexible format than RAW capture. However, it is not a compressed file type, so image quality is superior to a JPEG – although not significantly. The major drawback of shooting in TIFF is that file sizes are big, and will quickly fill your memory card – as a result, not all digital cameras are designed to capture TIFFs. Instead, TIFFs are popular as a format to edit and archive images and most photographers save processed RAW files in this format.

COLOUR CORRECTION

Colour casts are a common problem. They can be the product of a number of factors, for example coolness under a clear blue sky or the artificial warmth of tungsten lighting. In the past, colour-correction and colour-conversion filters (page 39) would be attached to neutralize the problem in-camera. However, a digital camera's WB setting is designed to replicate their effect. In theory, as long as you correctly match the WB setting to the prevailing lighting conditions, image-degrading colour casts shouldn't ever occur. If only it were this simple. Regardless of how diligent you are, casts will still occur in your images from time to time. Therefore, it is important that you are armed with the knowledge on how best to correct them.

INDOOR PORTRAIT
Portraits captured indoors under tungsten lighting will often have a warm, orangey hue unless corrected. While a degree of warmth will benefit skin tone, too much will look ugly and discolour whites. The warm cast apparent on this image originally was neutralized by making adjustments to Colour Balance.
Canon 5D, 135mm lens, ISO 100, 1/200sec at f/4, reflectors, handheld.

CORRECTING CASTS

There are several ways to correct unsightly casts. Tools such as Curves, Levels and Hue/Saturation can be used. If you are working with Photoshop CS, it is possible to apply the effect of traditional light-balancing filters using the Photo Filter tool. However, if you have an older or limited version of Photoshop, you can replicate their effect closely using specific settings in the program's Colour Balance control.

CORRECTING A COOL COLOUR CAST

A cool blue hue can be neutralized by applying the Photoshop equivalent of an 81- or 85-series warm-up filter. The following adjustments to Colour Balance are designed to mimic their effect, but they are only a guideline and may need refining depending on the image and the apparent hue.

Settings for 81-series colour-correction filters:
81 filter = –7 Yellow
81A filter = –7 Yellow and –4 Magenta
81B filter = –12 Yellow and –4 Magenta
81C filter = –17 Yellow and –7 Magenta
81D filter = –28 Yellow and –9 Magenta

tip

In order to achieve the full benefit of the above settings, it will normally be necessary to apply the settings three times, using the same values for each of the Shadows, Midtones and Highlights under Tone in the Colour Balance dialog box.

Settings for 85-series colour-conversion filters:
85A filter = –55 Yellow and –20 Magenta
85B filter = –65 Yellow and –22 Magenta
85C filter = –35 Yellow and –10 Magenta

CORRECTING A WARM COLOUR CAST

Images with warm colour casts can be easily corrected by applying the equivalent of an 80- or 82-series cooling-down filter. The strength of the effect you require will naturally depend on the cast. The following settings are approximate and will likely need a degree of fine-tuning, depending on the image.

Settings for 82-series colour-correction filters:
82 filter = –12 Cyan and –7 Magenta
82A filter = –17 Cyan and –7 Magenta
82B filter = –22 Cyan and –9 Magenta
82C filter = –27 Cyan and –9 Magenta

Settings for 80-series colour-conversion filters:
80A filter = –90 Cyan and –30 Magenta
80B filter = –80 Cyan and –27 Magenta
80C filter = –55 Cyan and –17 Magenta

OTHER CASTS

Of course, not all colour casts are regular or can be corrected by applying the effect of traditional balancing filters. If an image has an excessive level of, say, green, magenta or cyan, it will be necessary to manually reduce this colour channel using Colour Balance – or if you prefer, Levels, Hue/Saturation or Curves. The degree of alteration will be dictated by the strength of the cast. The adjustment will need to be intuitive to a great extent.

Photo Filter

The Photo Filter is a handy tool, offering automated colour-correction filters, simulating the effect of a range of traditional filters. It is found in Photoshop CS, so users of older versions will need to rely on adjusting Colour Balance settings manually.

Using Photo Filter, you can quickly add a filter effect of your choice to balance a colour cast – or for creative effect. While this option is less suited to neutralizing unusual colour casts that require the adjustment of more than one colour channel, it is a quick and simple method for warming up and cooling down your images.

Click Image > Adjustments > Photo Filter to open the Photo Filter dialog box. There are two main controls. First select the filter effect you wish to apply from the dropdown filter menu, or alternatively select any colour you like using the Colour Picker. The Density slider can reduce the intensity of the filter. Ensure that the Preserve Luminosity box is checked. This stops the exposure of the image from altering because of the changes you've made. Preview allows you to gauge the effect.

BASIC CORRECTION OF A COLOUR CAST

I took this photograph in bright sunshine under a near-cloudless blue sky. In conditions like this, pictures will often exhibit a slight coolness. I had selected my camera's 'Daylight' WB setting to match the prevailing lighting, but a subtle blue hue was obvious in the resulting image. I decided to correct this in Photoshop.

Nikon D70, 18–70mm lens (at 18mm), ISO 200, 1/2sec at f/22, polarizer, tripod.

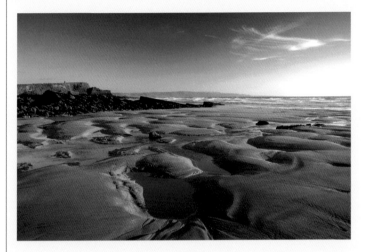

1 I opened the image in Photoshop and clicked Image > Adjustments > Colour Balance to open the Colour Balance dialog box. In this instance, I felt the equivalent of an 81B warm-up filter would correct the cool hue apparent in the image. Using the default Midtones setting, I dragged the Yellow slider to –2 and Magenta to –4. I then repeated this process to adjust the settings for the Shadows and Highlights too.

2 By mimicking the effect of a traditional 81B warm-up filter, the natural warmth of the image is restored. In this instance, it wasn't necessary to make any further Colour Balance adjustments, but sometimes you will need to refine the settings to correct the prevailing cast.

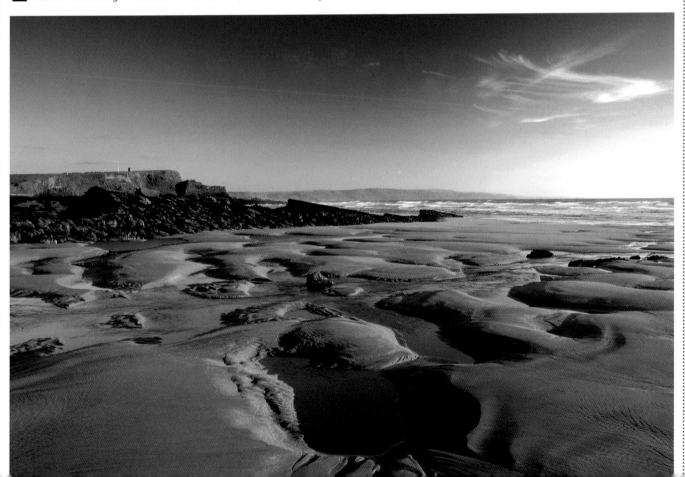

CORRECTING UNEVENLY LIT IMAGES

A well-balanced exposure – retaining detail in both the shadow and highlight areas – is one of the keys to capturing successful scenic images. However, this is often far from simple to achieve, particularly in high-contrast, mixed lighting conditions. Compared to the human eye, which can distinguish between bright and dark areas well, a digital camera has a limited dynamic range. When there is a large level of contrast within a scene, the image sensor cannot faithfully record detail throughout. As a result, photographing scenes with a high degree of contrast can prove challenging. For example, there is often a difference of 1–3 stops of light between the sky and darker foreground. If you decide to meter for the sky, the landscape will be underexposed; correctly meter for the foreground and the sky will be overexposed and look washed-out.

Traditionally, the best method to correct this type of unevenly lit scene is to position a graduated neutral density filter (page 48) over the lens prior to releasing the shutter. An ND grad has a coated graduation designed to hold back the exposure on the sky, thereby lowering overall contrast. While these filters remain essential, there will be times when a digital form of correction is required or better suited to solve the problem.

SIMULATING AN ND GRAD

There are several ways to digitally simulate the effect of an ND grad. One method is to take a picture that is correctly exposed for the sky/highlights and then use Photoshop to lighten the foreground. However, just like using a traditional filter, this method is better combined with landscape images boasting relatively simple, unbroken horizons. It is not so useful when a scene is lit by irregular light or when key

BEACH HUTS
The ability to blend images together is especially useful in circumstances where the natural light is quickly changing or fading. In situations like this, it can prove far quicker to bracket your camera settings, rather than fiddle about attaching and aligning optical filters.
Nikon D2x, 35mm lens, ISO 100, 1/8sec at f/16, polarizer, tripod.

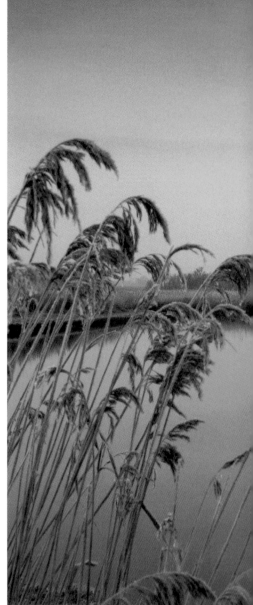

elements break the skyline – trees, buildings or rocky outcrops, for example – as they will also be artificially darkened by the graduation effect. Instead, a better method is to take two individual photographs of the original scene, one correctly metered for the sky and the other for the foreground. The simplest way to do this is to use your camera's auto-bracketing sequence; alternatively you can alter the exposure manually. The images can then be combined in Photoshop to create an apparently evenly lit result.

This technique relies on the use of a tripod to ensure the two images are truly identical. It is also important that there are no moving elements within the frame. By merging the two differently exposed images, detail in the sky and foreground brightness can be retained. It is also wise to shoot

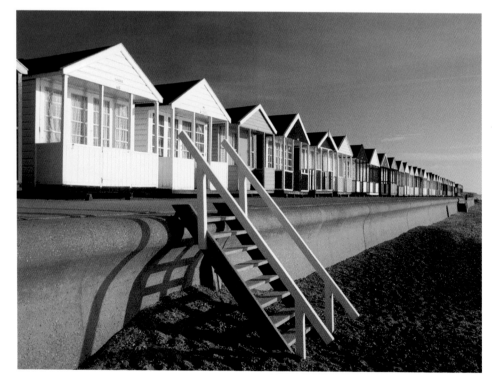

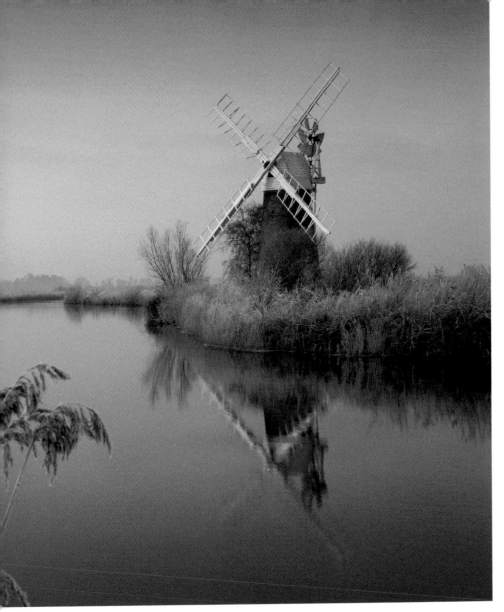

in RAW format, as opposed to JPEG. In-camera JPEG conversion can discard as much as 1–2 stops of dynamic range. Therefore, shooting in RAW is the only way to take advantage of the camera's full colour gamut and dynamic range.

BLENDING

When taking pictures that include bright sky – especially early or late in the day – the contrast range will frequently exceed the capabilities of your camera's chip. Therefore you need to identify a way to reduce contrast to within a range your camera can handle, to ensure highlights don't wash out and regions of shade don't appear black. While an ND graduated filter can provide the answer, sometimes a better method is to blend two images together, taken using different exposure settings. There are many ways to do this using image-editing software and if you search the Internet you will find a variety of options. However, there is only room to demonstrate one blending technique here.

The one I have opted for is less complex than many other methods, but it is a technique I have found effective and useful. It involves the use of a Layer Mask, which controls the transparency of the associated image. By making the black mask areas transparent and white areas opaque, the two images are blended to produce an image with details in both highlights and shadows. To prevent any artefacts arising during the blending process – along sharp edges between shadows and highlights – the Layer Mask is softened using a small amount of Gaussian Blur (page 127). This technique is demonstrated overleaf.

WINDMILL
ND grads have their limitations. For example, buildings and trees that break the horizon will be artificially darkened if a grad is correctly aligned with the skyline. This can look odd and degrade the resulting image. The alternative is to take two frames – using different exposure settings – and blend them using software.
Nikon D2x, 50mm lens, 1sec at f/16, polarizer, tripod.

GRADUATED FILTER PLUG-INS

Plug-ins (page 134) are available that allow you to quickly and seamlessly merge two identical compositions captured using different exposures. There are many available for download on the Internet, with the DRI Pro Plug-in by Fred Miranda being one of the best-known and most widely used. DRI (Dynamic Range Increase) is available for download from www.fredmiranda.com at a small cost. This professional tool is a simple but efficient solution to widen dynamic range, doing so by blending two images shot at different exposures. With just a few clicks of a mouse, the images are combined with great precision. This type of software is especially handy when photographing landscapes with horizons interrupted with key foreground elements. DRI Pro works with all digital camera files and scanned film.

tip

Blending can prove useful when speed is a priority. Deciding which ND gradient and density to use – and then correctly aligning the transitional zone with the skyline – can take several minutes. This is time you can ill afford if the light is changing or disappearing quickly, so for the benefit of speed, take two exposures and merge them later.

MERGING EXPOSURES

The conditions for photography were perfect. The evening light was soft and warm and the tide gently lapped the rocky shore. I knew the contrast in light between the sky and foreground would be beyond my camera's dynamic range. The steep, sloping horizon made the use of an ND grad less practical. Therefore, I decided to take two separate images; one exposed for the sky/highlights and another for the foreground/shadows. I knew I could later merge them using Photoshop. A tripod was essential to ensure the images were identical. *Nikon D200, 10–20mm lens (at 12mm), ISO 100, 1sec at f/22 (sky), 2sec at f/22 (foreground), polarizer, tripod.*

Exposed for sky/highlights.

Exposed for foreground/shadows.

1 The images were originally shot in RAW, so before I could merge them, they needed to be processed in the camera's editing software. Shooting in RAW is preferable to JPEG, as RAW images have a wider colour gamut and dynamic range. For the sake of the demonstration, I named one image SKY and the other FOREGROUND – to indicate their correct exposure.

2 Import the two images into Photoshop and place them alongside each other. Now, select SKY and press CTRL + A to select the whole image. This will be indicated by a segmented line running along the edges of the image. Press CTRL + C to copy the selected file.

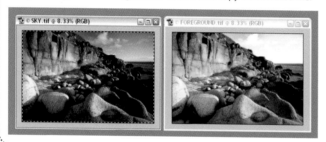

3 Select your FOREGROUND image and, by pressing CTRL + V, paste/overlay SKY on to it. The SKY image is no longer needed, so close this file. In the Layers palette, you will notice that your FOREGROUND image is indicated as the Background Layer and your pasted shot as Layer 1.

4 Having overlaid the dark image on to the lighter frame, add a Layer Mask. Do this by clicking on the Add Layer Mask icon at the bottom of the Layers palette – a white circle within a grey rectangle. A white rectangle will appear next to Layer 1 in the Layers palette.

5 Select the Background Layer by clicking on it in the Layers palette. Press CTRL + A to select the whole image, followed by CTRL + C to copy it to the clipboard. Finally, hold down the ALT key and click on the white Layer Mask thumbnail alongside Layer 1 in the Layers palette. The image will turn white.

6 Next, press CTRL + V. This will paste the contents of the clipboard on to the white Layer Mask. The image will transform into a black and white mask. Don't worry – the image's colour is still retained within the Layers.

7 With the black and white mask displayed, click Filter > Blur > Gaussian Blur. This will open the Gaussian Blur dialog box. Set the Radius in the region of 30–40 pixels. Click OK to apply the blur. This provides a gradual transitional zone.

8 Finally, click on the Background Layer. As if by magic, the two images are now blended together. Finally, flatten the layers and, if desired, fine-tune contrast using Curves or Levels. The resulting image gives the impression of being accurately exposed for both highlights and shadows.

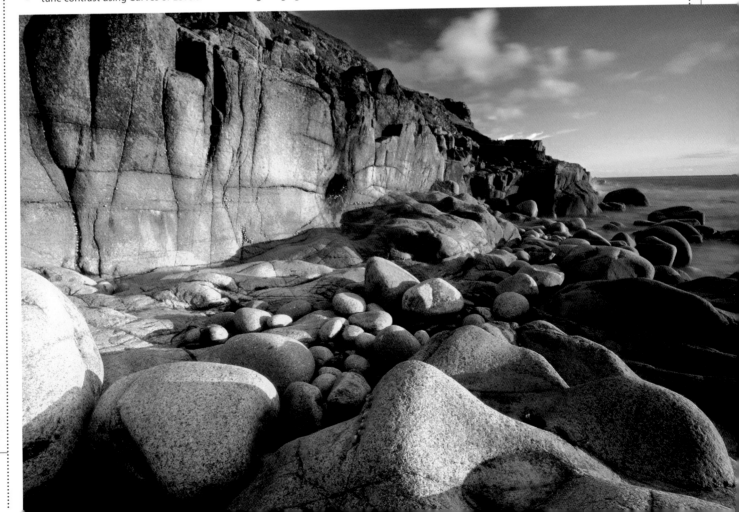

CORRECTING AN UNDEREXPOSED FOREGROUND

Gradual neutral density filters (page 48) continue to play an integral role in scenic photography; reducing the contrast between the sky and foreground. However, from time to time you might find that you are without a suitable filter for the scene you're photographing. This might be due to you accidentally leaving your filter pouch at home or, maybe because you are new to using filters – or on a tight budget and don't own an ND grad of a suitable density. In situations like this, it is important to be armed with the knowledge and Photoshop expertise to correct the problem during post-processing.

SCOTTISH LOCH
Mimicking the effect of an ND grad, by metering for the sky and later brightening the foreground in Photoshop, is a basic technique most suited to scenic images boasting a relatively flat horizon. This is also a useful method to restore detail in the foreground of poorly exposed images originally shot on film, but digitized through scanning.
Nikon F100, 28mm lens, ISO 100, 1sec at f/22, polarizer, tripod.

tip

When using this technique to correct a high-contrast scene, take a spot meter reading from a bright area of the sky (page 49). By doing this, and then employing the recommended settings, the sky will be correctly exposed. The foreground will be rendered underexposed, but can be lightened later.

GRADUATED FILTER EFFECT

The merging or 'stitching' technique, outlined on pages 85–87, is most suited to images with awkward light and/or a broken skyline. However, if you are photographing a landscape with a relatively simple, straight horizon there is a quicker, easier method. It relies on you correctly metering for the sky/highlights when the original was captured. Then, in Photoshop, it is possible to lighten the foreground to create the look of an overall, correctly exposed image, using the Gradient Tool to maintain detail in the sky. This method is preferable to metering correctly for the foreground and later darkening the sky in Photoshop. If you try to do this, you risk burning out the highlights to such a degree that no detail is retained. In contrast, underexposure is unlikely to destroy detail, and it can be revealed if lightened in Photoshop. Depending on your personal preference and experience, either Curves or Levels can be used to lighten the underexposed foreground.

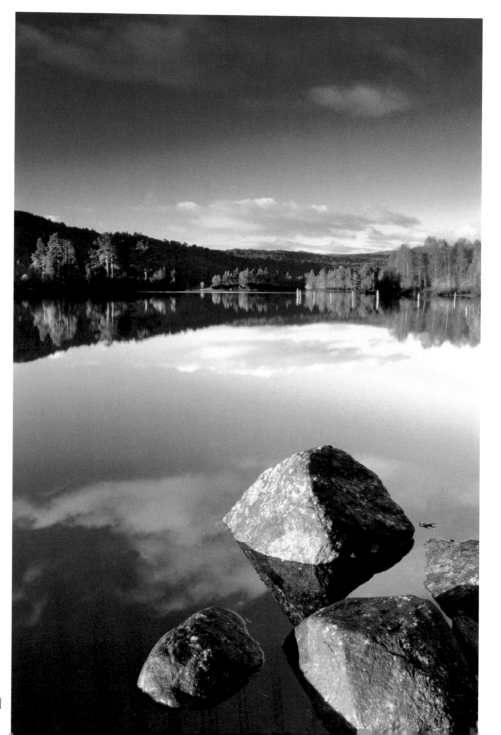

CORRECTING AN UNDEREXPOSED FOREGROUND USING THE GRADIENT TOOL

I took this shot of the rugged Cornish coastline one spring evening. I attached a polarizer to saturate the clear blue sky and decided to employ a 0.6 ND grad to balance the contrast between the sky and foreground. However, I couldn't find my wallet of slot-in filters. It then dawned on me that I had removed them from my camera backpack for cleaning and forgot to return them. To compensate, I decided to take a picture correctly exposed for the sky and then later lighten the underexposed foreground in Photoshop.
Nikon D200, 10–20mm lens (at 12mm), ISO 100, 1/6sec at f/18, polarizer, tripod.

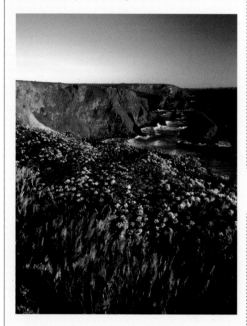

2 By altering Levels in this way, you adjust the overall brightness of the image. Therefore, the sky will now appear too light. To correct this, click on the Gradient Tool in the Tool palette. Open the Gradient Editor dialog box by clicking on the gradient bar – top left of your screen. Select Foreground to Transparent.

3 Ensure the Levels adjustment layer is active and then, using the mouse, place the cursor at the top of the image and drag the gradient line down to the skyline. This creates a black to transparent gradient – similar in principle to an ND grad. The effect of the Levels adjustment layer is cancelled where you position the gradient.

tip

It is also possible to make corrections to an underexposed foreground by selecting the sky, using the Magic Wand or Lasso Tool. Feather your selection (Select > Feather), to ensure a smooth, natural transition, and then invert the selection (Select > Inverse). Finally, use Levels or Curves (Image > Adjustments > Levels, or Image > Adjustments > Curves) to adjust the brightness of the foreground.

4 It may be necessary to draw several gradient lines until the sky is restored to the way you want it to look. In this instance I repeated the process a couple of times before I achieved the effect I desired. I then tweaked contrast and merged the layers. In stark contrast to the original frame, the final image looks evenly exposed throughout.

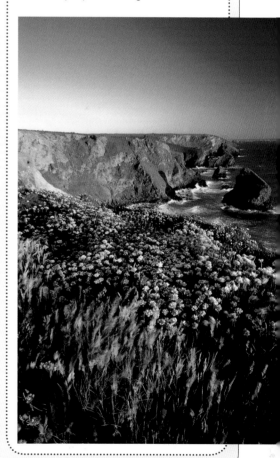

1 Open the image in Photoshop. In this instance, I decided to use Levels to lighten the underexposed area, so I created a Levels adjustment layer by clicking Layer > New Adjustment Layer > Levels. Click on OK to open the Levels dialog box. Now, drag the highlight and mid-tones sliders to the left until you are happy with the brightness of the foreground.

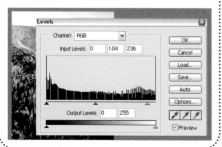

CHAPTER NINE:
ENHANCEMENT

Even in the digital age, filters continue to play a major role in creative photography. The majority of filters are designed with a single purpose in mind: to enhance. While many photographers still remain wary or sceptical of using software to improve or 'manipulate' their images, the principle is actually no different to using hardware filtration. I am quite a traditionalist in my approach to picture-taking, but for more than a century photographers have been using all types of in-camera and wet darkroom techniques to enhance their images. We are fortunate that today, instead of having to work in a darkroom, using smelly chemicals, it is possible to enhance our images with a few clicks of a mouse.

Several of the effects in this chapter closely mimic traditional filters. Warming up, cooling down, soft-focus and colour graduation can all be achieved in-camera. However, there are certain advantages to applying the filter effect post-capture. For instance, it can be applied with greater control and precision – and quickly undone if no improvement is obvious. Also, sometimes in our haste to take a picture we will overlook using filters altogether. Today, this can be easily remedied by applying the relevant filter effects post-capture.

Black and white photography continues to be a popular medium, and digital capture has made it more accessible than ever before, negating the need to buy specific black and white film and

USING
PHOTOSHOP

Image-editing programs such as Photoshop are powerful and sophisticated tools – the creative possibilities are endless. However, software like this can prove intimidating at first glance, especially as many photographers feel far more comfortable behind a camera than in front of a computer. The temptation can be to shy away from post-processing techniques altogether. This would be a mistake though, and your digital images will never fulfil their full potential as a result. In reality, many of the most relevant and useful effects are surprisingly simple to apply, so don't worry if you have a limited knowledge of using Photoshop. The effects in this chapter are explained in a language that is simple to understand, so the techniques should prove easy to later replicate using your own images.

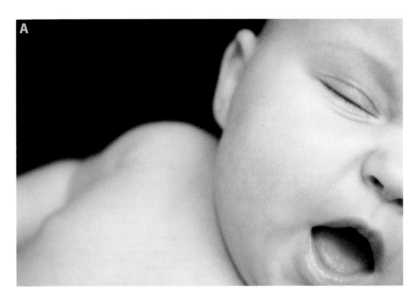

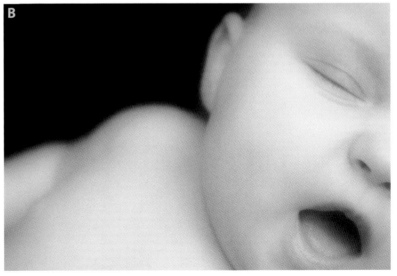

allowing photographers who would normally only ever shoot colour also to dabble in mono. Filters have long played a significant role in black and white photography and, having first converted your images into mono (page 106), their effect can be simulated to enhance contrast and create far more dramatic results.

You will notice that one or two of the post-processing methods that are included in this chapter do not actually simulate the effect of any traditional form of photographic filtration. However, when combined with the right image, they will help to enhance your images. Therefore, they are techniques that should prove of interest to the creative filter user. All enhancements are subjective, so experiment to see what you like.

AUTUMN WOODLAND
I don't like the term 'manipulation', the improvements you make to your images are subtle and sensitive and 'enhancement' is a far more accurate way to describe the type of techniques outlined in this chapter. For instance, after I scanned this image I decided it would benefit from a little extra warmth (page 94) and also a soft-focus effect (page 102).
Nikon F100, 28mm lens, ISO 100, 1/4sec at f/22, polarizer, 81c warm-up, tripod. �

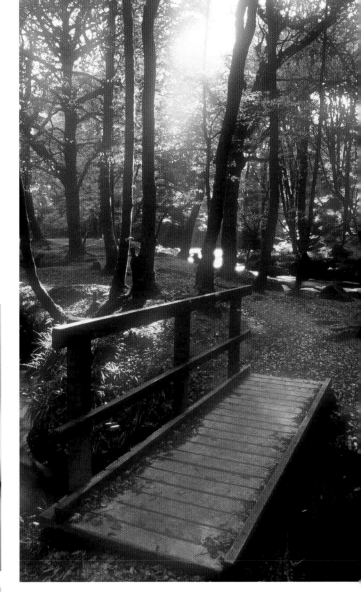

◀ FILTER EFFECTS
An image can be completely transformed by applying different filter effects using image-editing software. The advantage of enhancing images post-capture is that you carefully regulate the strength of the effect and undo any results that you don't feel improve the final image. You can also compare and combine the results before deciding which to save and which to discard. In this instance, I began with an unaltered colour photograph (A). I then added a subtle soft-focus effect (page 102) to smoothen skin tone (B), before deciding the image might also work well in mono (page 106) (C). Finally, I applied grain (page 114) to create an arty, moody result (D).
Samsung GX10, 18–55mm lens (at 55mm), ISO 400, 1/60sec at f/8, handheld.

HUE AND SATURATION

Hue, Saturation and Brightness (HSB) are all aspects of colour in the red, green, and blue (RGB) scheme. The Hue/Saturation dialog box in Photoshop allows you to adjust the hue, intensity and lightness of the colours found within your image. You can decide to enhance just one colour or choose to adjust them together. The principle of using Hue/Saturation isn't dissimilar to attaching a red enhancer (page 29). However, while this filter is only capable of enriching warm colours, HSB can be used to enhance any colour or colours of your choosing.

HUE/SATURATION CONTROL

Sometimes the colours within your shot just don't appear as vibrant and colourful as you remember them. Used correctly, Hue/Saturation will give your photographs far greater impact.

To open the dialog box, click Image > Adjustments > Hue/Saturation. You will be presented with three sliders: Hue, Saturation and Lightness – Lightness and Brightness are considered the same thing in Photoshop. By adjusting Hue, you are selecting a pure colour; by altering Saturation you are either diluting or intensifying the colour; while changing Lightness will simply add black or white to either lighten or darken the image.

By clicking on the Edit dropdown colour menu bar, you can select Master – to alter all pixels – or Reds, Yellows, Greens, Cyans, Blues or Magentas individually, for tighter control.

By checking the Preview box, all alterations you make to the image's dynamic range will be displayed.

Adjusting Hue/Saturation is an effect best judged by eye rather than entering a specific value, so the Preview is essential and makes it easy for you to regulate the effect you are achieving before committing to it.

MAPLE LEAF

The principle of the Hue/Saturation control can be compared to that of a traditional red-enhancing filter. However, Hue/Saturation offers far more control and versatility and can be used to alter any colour – not just warm shades. In the original shot of these autumnal maple leaves, the colours were not as intense as I would have liked (A), so I used the Saturation control to subtly intensify the reds (B).
Nikon D70, 150mm lens, ISO 200, 1/80sec at f/4, tripod.

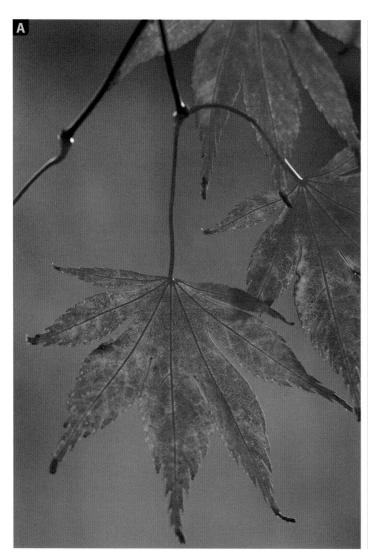

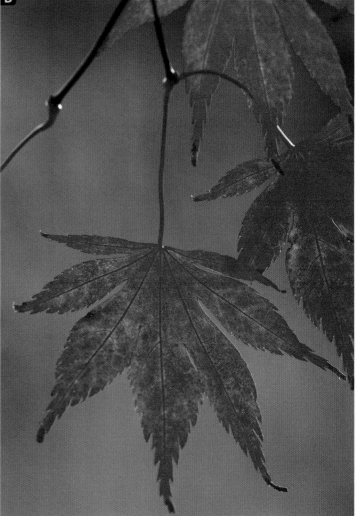

A

HUE

By dragging the Hue slider left or right, you are able to alter the colour of the entire image, or a selected part of it. Although this can be employed to create bizarre, surreal-looking results – altering the appearance of the image completely – subtle adjustments can enhance the natural look of the image's colours. Basically, by moving the Hue slider, you are cycling through the spectrum and re-mapping colour. This is illustrated via the two bars at the bottom of the dialog box. The top bar represents the colours of the original and never changes, while the one below moves in relation to it, displaying the new arrangement. The original colours, shown on the top bar, are replaced by the colours immediately beneath them.

SATURATION

Saturation reflects the depth of colour. Moving the slider to the right will intensify the colour, while dragging it to the left will weaken the colour. In fact, push the slider fully to the left and the image will appear black and white; drag it too far to the right, and colour will be too enriched and look completely unnatural. The Saturation slider is useful for emphasizing certain colours – or parts of the image.

LIGHTNESS

This is the least useful of the three options. Altering the Lightness slider will not alter the image's Hue or Saturation. Therefore, colours remain identifiable. Instead, moving the slider left will darken the image, while pushing it right will lighten it.

◄ **KEYHOLE**
My eye was drawn to the peeling blue paint on this ageing door. I included the keyhole as a compositional tool. Although I liked the composition, the blue paint was old and faded, so the resulting image lacked impact (A). Therefore, I decided to boost colour using Hue/Saturation. In this instance, it was only the colour of the paintwork that I wanted to enrich. Therefore, I selected Blues from the Edit box. Hue only needed a slight adjustment of +10, while Saturation was increased to +40 (B). This created a far more vivid, eye-catching result (C). Hue/Saturation is a very visual tool. Ensure Preview is checked, so that you can monitor the effect you are making while adjusting the sliders. Play with the different colour channels until you achieve the result you desire. *Nikon D200, 150mm lens, ISO 100, 1/20sec at f/14, tripod.*

C

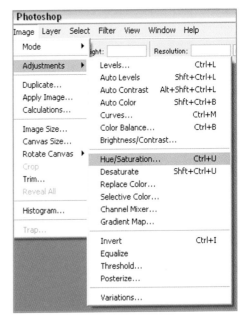

DIALOG BOX

The Hue/Saturation dialog box is easy to navigate. The best way to grow intimate with its effects is simply to 'play' with the sliders and watch how they affect the image.

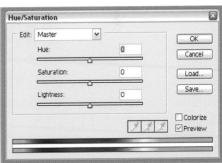

WARMING UP

Photography would be boring if we only ever captured colour exactly how our eyes perceived it. For many years, filters have proved the only reliable method to introduce a false hue to our images. Today, you also have the luxury of being able to alter the feel and appearance of your images with a simple click of a mouse. The most popular and useful colour shift is adding warmth to an image. Warm hues are renowned for their ability to flatter and they can greatly enhance an image's appeal.

Today, the 81- and 85-series warm-up filters (page 39) have been largely superseded by white balance (page 34). However, the right effect isn't always achieved in-camera. You may forget to alter your camera's WB setting or inadvertently select the wrong colour temperature. If so, it will be necessary to adjust the image's colour balance at the post-processing stage instead.

CREATIVE WARMTH

The best results will not always be the product of colour being rendered technically 'correct'. Subconsciously, enhanced shades of red, orange and yellow create a cosy feeling of warmth, which appeals to the human eye.

Similar to traditional 81-series warm-up filters, a slight warming effect will correct any blue colour cast present in shade. It will also give the image greater appeal overall. Warmth is especially well suited to portraits, enhancing skin's texture and tone. It is also common practice to add extra warmth to scenics, exaggerating the colour of a setting sun or adding warmth to soft early morning or evening light. Often, the best effect will be subtle, but it will depend on the image. Treat every image individually, experimenting until you achieve the best result.

There are several ways to add a warm colour cast to your images in Photoshop, but Curves is one of the most useful and versatile.

CURVES

Curves is a powerful tool, allowing you to exercise a large degree of control over tonal and colour adjustments. It is similar in principle to Levels (page 111). Both tools are able to compress and stretch the tonal values across the image, achieving an overall colour shift in the shadows, mid-tones and highlights. Although more complex, Curves is a more sophisticated control.

Curves adopts the form of a grid, with vertical and horizontal scales representing input and output brightness. A line cuts diagonally at a 45-degree angle. The bottom of the line (0) represents shadow tones, the middle (128) mid-tones and the top (255) highlights. The line can be pushed and pulled up or down, and up to 16 anchor points can be created to form your 'curve'.

To adjust Curves confidently, you need to understand the relationship between the additive and subtractive colour schemes. For example, subtracting Red will result in more Cyan, subtracting Green will result in more Magenta and subtracting Blue will achieve more Yellow… and vice versa. To warm up an image, it is necessary to add more Yellow, Magenta or Red – or in other words, less Blue, Green and Cyan. Using Curves, it is possible to adjust each individual channel, allowing you to tweak colour with precision. To realize the full potential and power of Curves takes time and experience, but basic colour shifts are quick and simple to apply.

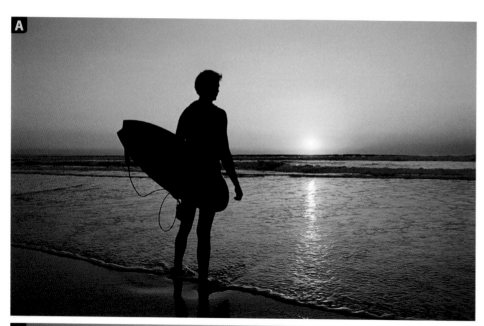

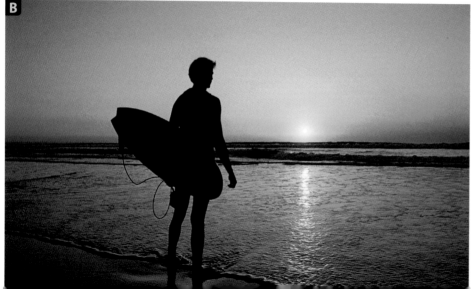

SURFER AND SUNSET
I photographed this surfer on a clear, summer's evening as the sun was setting. When I took the photo I didn't have time to adjust WB and, although happy with the original shot (A), the sun was too weak to radiate natural warmth. I decided to artificially warm up the image (B) by increasing the levels of Red and Yellow via the Colour Balance control (page 96).
Nikon D70, 18–70mm lens (at 20mm), ISO 200, 1/30sec at f/11, tripod.

WARMING UP AN IMAGE USING CURVES

An early start was rewarded with this sunrise. The sunlight streaking through the tree's branches created fingers of light and a wonderful glow. However, I felt the image would benefit from a little extra colour and warmth, so I decided to make a few simple adjustments using Curves.
Nikon D70, 18–70mm lens (at 42mm), ISO 200, 1/100sec at f/11, polarizer, tripod.

2 By dragging the curve line downwards, the level of Blue in the image is decreased. As a result, the shot appears warmer. Pulling the line upwards would have the opposite effect, adding a cool cast (page 96). With the Preview box checked, you can view the effect your adjustment is having. Finely adjust your Curve until satisfied with the result. Repeat the process with the other colour channels if required.

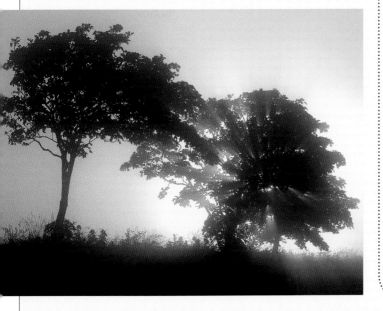

1 I opened the image in Photoshop and created an adjustment layer by clicking Layer > New Adjustment Layer > Curves. A New Layer box will pop up. Click OK. The Curves dialog box will open. Now select the colour Channel you wish to alter from the dropdown menu. In this instance I began by selecting the Blue Channel.

3 In this example, I also decreased the level of Green to add Magenta. Finally, I merged the layers by clicking Layer > Merge Down and resaved the image. Despite the complicated nature of Curves, creating this basic colour shift proved quick and easy. The added warmth dramatically alters the look and feel of the shot.

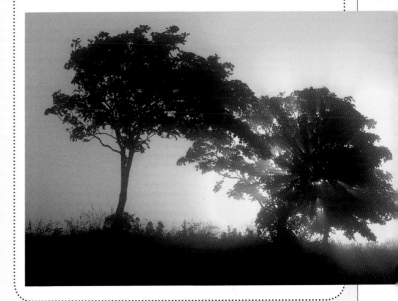

COOLING DOWN

Colour has a dramatic effect on the look, feel and mood of your images. It can detract or enhance. Colour casts have the ability and power to alter your perception of a scene or subject. For example, a blue hue will naturally create a feeling of coolness. Visually, this can prove a very striking effect and, while it is less useful on a day-to-day basis than warming up images, combined with a suitable shot it can prove an equally powerful tool.

For many years, filter users have used an 80- or 82-series colour-balancing filter to create the feeling of coldness in-camera. Today, it is an effect more commonly applied using WB (page 34). However, it can also be achieved by adjusting the image's colour balance using software. Arguably, this gives you far more control over the look of the final image.

SUITABLE SUBJECTS

While a blue colour cast isn't always desirable – and can be easily corrected (page 36) – combined with a suitable image or subject, it will actually enhance your images. A blue cast, if already present, can quickly and easily be exaggerated – or one can be introduced if you feel the shot would benefit from a cool hue. Sometimes it is glaringly obvious which images will suit this effect. A waterfall or rising tide – blurred creatively using an ND filter (page 42) – can look eerie and magical with a blue cast. Equally it can work well combined with early morning mist or even fog. A subtle blue hue will greatly enhance the icy-cold look of frost or snow or a wintry landscape.

COLOUR BALANCE

There are several ways to adjust an image's colour balance and, as a result, create a colour cast. Curves and Levels are both good methods, although using the specific Colour Balance setting is possibly better suited to novice users of Photoshop. The Colour Balance setting (Image > Adjust > Colour Balance) is a very straightforward but useful tool. It can be used to add or remove a colour cast. It is quite flexible in the adjustment choices it gives. The Colour Balance dialog box consists of three slider bars for adding or subtracting colour from the image. The colour sliders are: Cyan and Red, Magenta and Green, and Yellow and Blue. The colours work in tandem, adding from one colour while subtracting from the other. The values for the subtractive colours – Cyan, Magenta and Yellow – are expressed in negative numbers in the dialog box. Another set of controls are located under Tone Balance. They allow you to select which area of the image your settings will affect – Shadows, Mid-tones or Highlights.

Colour Balance can be adjusted to add a colour cast of any type. To create a blue cast, set a negative value for Cyan and Magenta and/or a positive value for Blue. Ensure that the Preserve Luminosity box is checked to maintain the original's brightness.

Colour Balance is a very visual, intuitive tool and the combination of settings and level of adjustment will depend on the strength and look of the effect you desire.

ICE
I photographed this ice pattern without using any filtration. I selected a WB setting of 'Cloudy' to suit the conditions, but the resulting image didn't feel cool enough (A). I opened the image in Photoshop and, using Colour Balance, increased the Blue setting to give the image a cool hue (B).
Nikon D70, 105mm lens, ISO 200, 1/4sec at f/16, tripod.

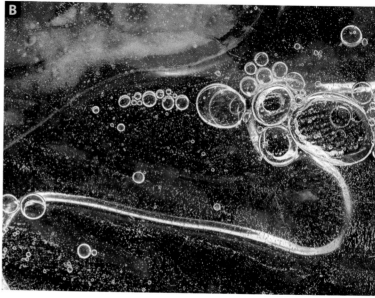

COOLING DOWN AN IMAGE USING COLOUR BALANCE

It was a dull, overcast day when I shot these distant mountain peaks. The resulting image looked flat and boring. I was just about to delete the image, when I decided that the shot might benefit from an artificial, icy-cool blue cast.

Nikon D200, 100–300mm lens (at 300mm), ISO 100, 1/13sec at f/16, tripod.

1 I opened the image in Photoshop and decided to alter the Colour Balance via an adjustment layer, so clicked Layer > Adjustment Layer > Colour Balance. A New Layer box will pop up. Click OK. The Colour Balance dialog box will open.

2 To create a blue cast, drag the Cyan and Magenta sliders to the left and Blue one to the right. In this example, I employed a setting of –90 Cyan, –30 Magenta and +75 Blue. This created the strong cast I desired. I only adjusted Mid-tones, although – depending on the image and effect you require – it may be necessary to individually adjust Shadows and Highlights too.

3 Being happy with the effect, in this instance I didn't adjust the Blending Mode or Opacity. I merged the layers by clicking Layer > Merge Down before saving the image. While the blue cast looks obviously artificial, the final image is far more striking than the original.

SIMULATING A COLOUR-GRADUATED FILTER USING THE GRADIENT TOOL

When I'm out shooting landscape images, I find nothing more frustrating than having a beautiful scene before me, only to be let down be an insipid, lifeless sky. I'm sure that you are also familiar with this scenario. Of course, it is possible to attach a colour-graduated filter (page 54) to boost skies, but this will necessitate buying a variety of different filters. Not only can this prove costly and add bulk to your camera bag, but it can also prove more restrictive than applying a colour-graduated effect via Photoshop.

THE GRADIENT TOOL

Not only can the Gradient Tool be used to mimic a graduated neutral density filter (page 89), but it can also be employed to apply more obvious graduated effects – from subtle casts to strong artificial colouring.

The Gradient Tool is grouped with the Paint Bucket Tool in the Tool palette. There are five different patterns to choose from: Linear, Radial, Angle, Reflected and Diamond. Each gives a different shape of gradient and is designed to create a smooth blend from one colour to another. However, it is the (default) Linear setting that is best suited to adding a natural-looking tint to skies.

Having created the gradient colour and fine-tuned the settings using the Gradient Editor, colour is applied by simply pressing the mouse button at the top of the image and dragging the line across the photograph in a straight line. The longer the line, the smoother the gradient transition will be. The direction of the gradient is determined by the angle of the line direction.

ACHIEVING THE RIGHT EFFECT

Adding a colour gradient to an image is a delicate balancing act. If the effect is too subtle, it won't be noticeable, but if the cast is too strong it will look grossly artificial – which, unless intentional, is normally undesirable. Achieving just the right effect is often the result of trial and error, as the colour tint you require will vary depending on the individual image. However, before you can begin to apply gradients to your photographs, you first need to learn how to create one.

REED BEDS

While I liked the composition of the original, the bright, washed-out sky drew the eye. To remedy this, I decided to apply a subtle, powder-blue gradient to the sky. I dragged the gradient line from the top of the image to the silhouetted reeds, using an Opacity setting of 70%. Finally, I tweaked image contrast using Levels.
Nikon D200, 10–20mm lens (at 11mm), ISO 100, 1sec at f/20, polarizer, tripod.

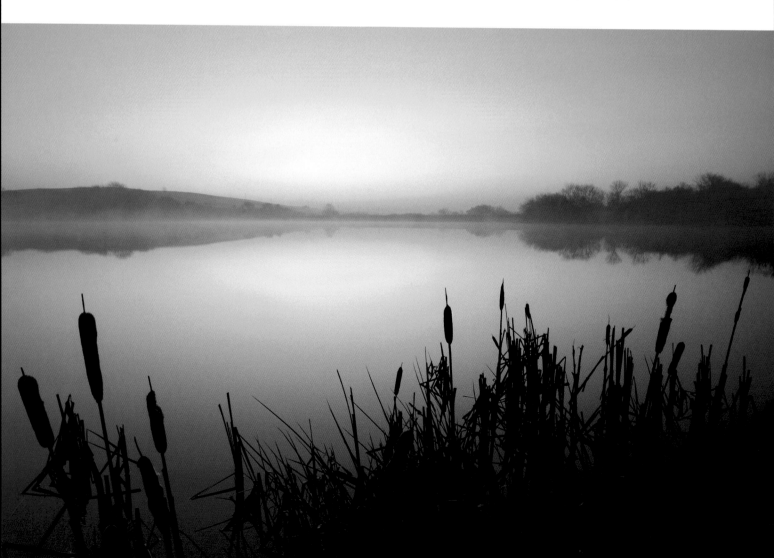

GRADIENT OPTIONS

Using the Gradient Tool in Photoshop, it is possible to add a variety of different effects to the same image – from flattering, subtle shadings to shocking artificial casts. The only restriction is your creativity. However, while it is important to experiment, natural-looking hues normally prove the most beneficial to your photography. Varying shades of blue and also warm tones will enhance your original shot, while also retaining an authentic feeling to your image.

The Gradient Tool in the Tool palette.

PINK GRADIENT: A pink gradient looks very obviously artificial, but its effect is not as bad as you might imagine.

ORIGINAL IMAGE: The original is fine, although the sky has a slightly cold feel to it.

DARK RED GRADIENT: A dark red gradient warms up the image, giving the shot more of a sunset feel.

BLUE GRADIENT: A blue tint has further enhanced the cool feel of the sky, but the effect isn't unpleasant.

LIGHT ORANGE: A light orange gradient gives warmth to the sky, although the effect is beginning to look more artificial.

CREATING AND APPLYING CUSTOMIZED GRADIENTS

One of the most appealing aspects of digital capture is the ability to revisit images and, if necessary, enhance them. While the effects you apply might only be very subtle, they can prove the difference between a good and great image. Applying a colour gradient to an otherwise dull, subdued sky is relatively simple to do. However, it will help give your original far more punch and impact.

I took this shot using a ND filter. This created a long 10sec exposure, which blurred the rising tide gently lapping the breakwater. Although I was happy with the composition, the late evening sky was cloudless and looked bland. To add interest to any lifeless sky, you can apply a colour gradient in Photoshop. Here's how it is done.
Nikon D200, 10–20mm lens (at 12mm), ISO 100, 10sec at f/22, 0.9 ND filter, tripod.

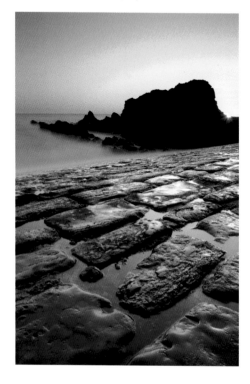

CREATING A SIMPLE CUSTOMIZED GRADIENT

1 To create a colour gradient, half-colour and half-transparent, first select the Gradient Tool from the Toolbox. An option bar appears below the menu, displaying the current gradient settings.

2 Click on the gradient bar to display the Gradient Editor dialog box and selected the Foreground to Transparent pre-set – second right. A checkerboard pattern is displayed in the bar to indicate that it will change to transparent when applied.

3 There are house-shaped boxes at the four points of the gradient display bar – known as stops. The two above the bar alter opacity from either side; the bottom two stops adjust colour. Here, I only wanted to create a simple colour gradient. To do this click on the first colour stop – bottom left.

4 There are two ways to select the gradient's colour: the Swatches palette, or for extra precision, the Photoshop colour picker. To do this, double-click the colour square at the bottom of the Gradient Editor dialog box. Here, I selected a moody, dark blue.

5 The colour is displayed in the left side of the gradient bar. The diamond icon in the centre is the colour midpoint and it can be adjusted. Moving it to the left will reduce the amount of colour used, while adjusting it to the right will add more colour.

6 To save a gradient to the pre-set list, enter a name and click New. To save a gradient so it can be used again, click Save. Finally, select the customized gradient by clicking on it.

APPLYING THE GRADIENT TO YOUR IMAGE

1 Open your image. Although you can apply the gradient directly to the image, it is best to create a new layer first. By applying all the gradient information to a layer of its own, it is completely non-destructive to the original photograph. Create the layer by clicking on the New Layer icon at the bottom of the Layers palette.

2 Ensure that your new layer is selected by clicking on it in the Layers dialog box. On the option bar, check the Dither box, to help prevent any banding in the gradation. It is also a good idea to check the Transparency box, which helps retain a natural, not so painted-on look. By reducing the level of Opacity, the gradient becomes more transparent. Here, I reduced Opacity to 65%.

3 Click and drag the Gradient Tool from the top of the frame downwards. Here, the sky filled less than half of the frame, so I didn't need the gradient to be applied to the full length of the shot. Therefore I dragged the line to a point around halfway. You can also draw the line at a slight angle, as I did here – this helps create a more natural look. The gradient floods over the area when the mouse button is released.

4 Finally, merge the two layers together by going to Layer > Flatten Image. Be careful to save the image using a different file name, therefore retaining the original, unaltered file to experiment with different coloured gradients.

In contrast to the original image, the edited result boasts a subtle but attractive cool blue sky. The gradient took no longer than a few minutes to create and apply. The biggest benefit of applying a colour gradient in this way is that the effect on the original isn't permanent – unlike a traditional colour-graduated filter. Therefore, if you don't like the result, just try again.

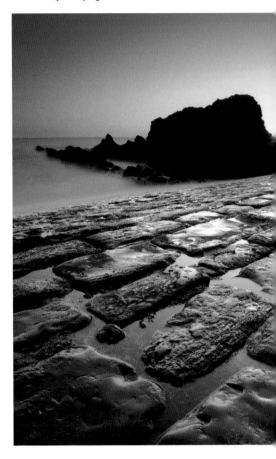

tip
If the effect of the gradient is too strong or weak, simply Edit > Undo, adjust the level of Opacity and repeat until the desired effect is achieved.

SOFT-FOCUS EFFECT

Soft-focus filters (page 58) continue to play a significant role in creative photography. By softening hard edges and adding a dreamy, ethereal glow to images, they can help create mood and atmosphere. However, it can be tricky to achieve just the right look. If diffusion is too subtle, the effect won't look intentional; too strong and detail will become totally unrecognizable and the image will look badly distorted. It is a fine balancing act, which is why today many photographers prefer to mimic the effect during post-processing.

There are several advantages to doing it this way round. First, softening can be applied with greater precision on a computer, and the result can be easily tweaked until you achieve just the effect you desire. If you decide you don't like the results, you can simply return to the unaltered original. In contrast, a picture softened in-camera cannot be restored – you are stuck with its effect. There is no need to go out and buy a specific filter – a welcome saving for photographers on a budget. It is also an opportunity to revisit existing shots that, in hindsight, you feel would benefit from a soft-focus effect.

DIGITAL DIFFUSION

In a similar way to if you were using a traditional diffuser, the key to creating a successful 'soft' image post-capture is to match the effect with a suitable shot. If you fail to do this, you may degrade the image, as opposed to enhancing it. Once again, people and portraits are the genre that will benefit most, but this effect is also capable of enhancing the mood and mystery of atmospheric scenics and still-life images. If unsure, simply opt for trial and error. The effect is relatively easy to create using the Blur filters in Photoshop, so it is well worth spending time experimenting with a variety of images and subjects. However, remember this particular effect works by disguising fine detail. Therefore, opt for simple images that don't rely on intricate detail for their success.

Although there are several ways of creating a soft-focus effect using the Blur filters in Photoshop, Gaussian Blur is many users' preferred choice, being both versatile and quick and simple to use.

FAMILY PORTRAIT
Great family portraits are often the result of opportunism – spotting an intimate moment and quickly grabbing an instinctive shot. In situations like this, there is no time to waste fiddling around with filters. Instead, why not apply a soft-focus effect post-capture?
Canon 5D, 200mm lens, ISO 100, 1/500sec at f/8, handheld.

CREATING DIFFUSION USING GAUSSIAN BLUR

I took this photograph of wild garlic among bluebells in dappled woodland light. I liked the result, but felt it lacked something. Backlit subjects are ideally suited to a soft-focus effect, as this type of light creates a 'halo' glow. Therefore, I decided to enhance the original using Gaussian Blur.
Nikon D200, 150mm lens, ISO 200, 1/25sec at f/5.6, polarizer, tripod.

1 First make a duplicate layer of the original image, so you can easily discard the effect if you don't like it. Click Layer > Duplicate Layer. Alternatively, click on the New Layer icon in the Layers palette.

2 Ensure the duplicate layer is selected and click Filter > Blur > Gaussian Blur. A preview box with Radius slider will appear. The further you pull the slider to the right, the more blurred the image becomes.

3 At this stage, the result simply appears out of focus. To create the soft-focus effect, your blurred layer needs to be combined with the sharp original. To do this, change the Blending Mode of the duplicate layer from Normal to Lighten, using the dropdown menu in the Layers palette.

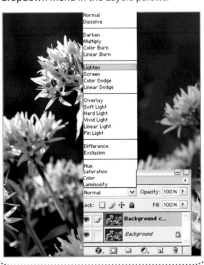

4 The resulting effect was good, but a little too strong. It is quick and simple to reduce the effect of the blurred layer, by clicking Opacity in the Layers palette and dragging the slider to the left. In this instance, I decided an Opacity of 80% created the moody effect I desired. Finally, merge the layers by clicking Layer > Merge Down and save the image using a different file name to the original.

5 By subtly softening this photograph, it now has far greater impact and appeal. By altering the level of blur, Blending Mode and Opacity, it is possible to create contrasting effects. The choice is yours and the best effect will greatly depend on the original image.

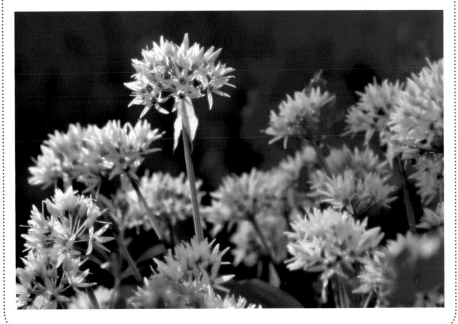

DISTORTION FILTERS

As their name suggests, Distortion filters are a collection of Photoshop filters designed to distort your images. They can be used to add image-destroying twirls, waves or zigzags – among other strange and crazy-looking results. Although it can be fun playing with their varying effects, in truth they are generally best avoided. That said, not all distortion filters are designed to truly distort.

Although found under the Distort filter menu, the effect of Diffuse Glow can be far more subtle. This filter effect adds a gentle haze of the background colour over the lighter regions of the picture. This creates an attractive glow, which pleasantly blends into the image. Although the effect is not dissimilar to that of a traditional diffusion or soft-focus filter (page 58), it is sufficiently different to be considered a genuine alternative.

DIFFUSE GLOW FILTER

This digital filter is ideally suited for enhancing images with high contrast, for example a woodland view with dappled sunlight. Diffuse Glow creates a gauzy, ethereal look that is very appealing when applied to a suitable scene or subject. It can prove flattering to skin tones in portrait images and also be used to simulate infrared film effects.

Diffuse Glow lightens the entire image by intensifying the brightness of its highlights. Three sliders control the effect and strength of the filter:

Graininess, Glow Amount and Clear Amount. The effect works by adding transparent noise to the image and a glow fading from the centre of the selection. The highlight colour depends on the background colour selected in the Tool palette. For natural-looking results, ensure the background colour is default white before you apply the filter – anything other than this will tint the highlights. To create a subtle glow, keep the level of Graininess at 5 or below, as higher settings can prove too pronounced.

VILLAGE SCENE
The effect of Diffuse Glow may not be to everyone's taste, but it can transform otherwise ordinary shots – like this village scene – into striking, ethereal-looking images. Be creative with your combination of the Diffuse Glow controls, Blending Mode and Opacity until you feel satisfied. Diffuse Glow is a great alternative for filters users who find the effect of soft-focus filters too clichéd.
Nikon D70, 18–70mm lens, ISO 200, 1/20sec at f/20, polarizer, tripod.

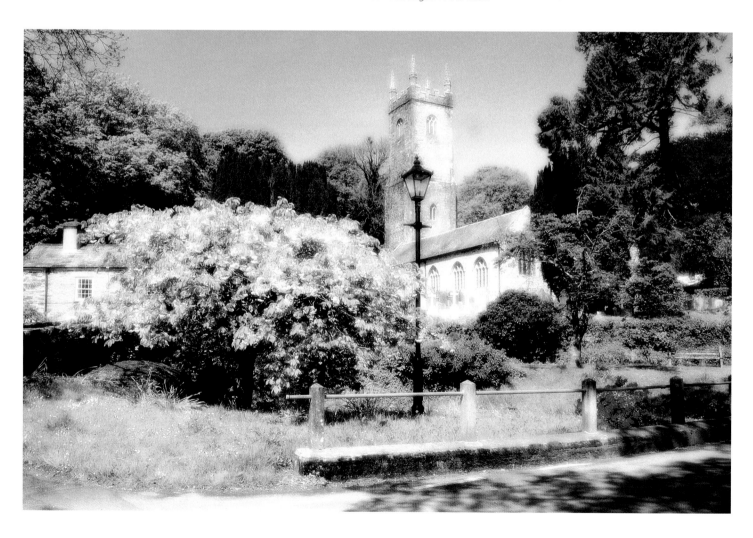

APPLYING THE DIFFUSE GLOW FILTER

When I took this I didn't have a soft-focus filter, so instead breathed on the lens. The effect isn't obvious. The Diffuse Glow filter is ideal for extending the 'high-key' look of images and the dappled morning light here benefits from the effect. *Nikon D70, 18–70mm lens (at 18mm), ISO 200, 1/8sec at f/22, polarizer, tripod.*

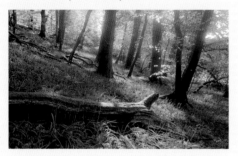

1 The image was opened in Photoshop and a duplicate layer created by clicking Layer > Duplicate Layer. Alternatively, click on the New Layer icon in the Layers palette. By using a duplicate layer, it is easier to discard any effects you don't like later.

2 Ensure that the duplicate layer is highlighted and then click Filter > Distort > Diffuse Glow. The Diffuse Glow dialog box will appear. The level of Graininess, Glow Amount and Clear Amount can be adjusted by dragging the sliders left or right.

3 A wide variety of results can be achieved by simply altering the combination of the three sliders. The large preview box will help you fine-tune the effect you desire. In this instance, settings of Graininess 5, Glow Amount 10 and Clear Amount 10 were selected.

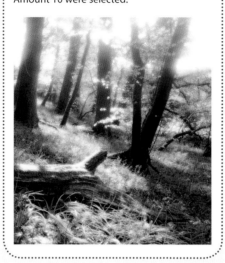

4 The result was a little too pronounced for this image. Thankfully, the effect can be easily altered by adjusting the Blending Mode and Opacity in the Layers palette. In this instance, I reduced Opacity to 75% and selected Luminosity as the Blending Mode. This restored the colour vibrancy of the original. Finally the layers were merged by clicking Layer > Merge Down and the image saved using a different file name to the original.

5 The final image boasts a surreal, dreamy glow that wouldn't have been achievable using a traditional filter.

BLACK AND WHITE

With the advent of digital capture, some people were predicting the demise of mono photography. They were wrong. In reality, DSLRs have made black and white photography more accessible than ever before. Photographers no longer need to worry about loading up with black and white film and going out intentionally to shoot mono images. Instead, digital photographers can enjoy the best of both worlds, by continuing to shoot in colour, but converting suitable images at the post-processing stage. As a result, digital is introducing a new generation of photographers to this powerful and dramatic medium.

WHY CONVERT COLOUR?

Combined with a suitable scene or subject, a mono image can arguably convey more drama and mood than its colour equivalent. It is for this reason that digital photographers must not overlook the potential of converting their images to black and white.

Although some digital bodies allow you to capture grayscale images in-camera, I wouldn't recommend doing this. Digital cameras record more detail and information in colour than they do in black and white, thus maximizing image quality. Also, tonal banding – known as posterization – can occur when grayscale images are enlarged or printed. Without doubt, shooting in colour originally – and converting later – is the best and most flexible option; after all, you can convert a colour image to black and white, but not vice versa.

SELECTING A SUITABLE IMAGE TO CONVERT

It is important to remember that some images do not suit conversion to black and white and by removing their colour you can completely destroy a photo's impact. Therefore, the trick is to select images with care and consideration. Traditionally, portrait and scenic images look most dramatic in mono, but practically any subject matter can convert well.

DESATURATE

This is the quickest, but not the best method. Some hues don't convert well when desaturated and this can affect the image's contrast. However, colour information is retained, which can be helpful if you wish to tone the image at a later stage.

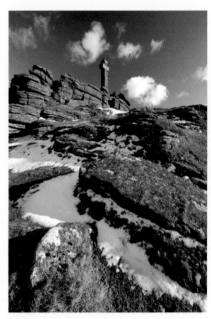

1: Open a suitable image and click Image > Adjustments > Desaturate.

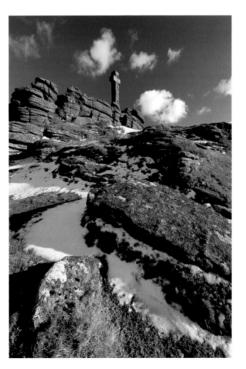

STONE CROSS
It was a cold, wintry day when I took this image. I used a polarizing filter to saturate the sky and define the cloud. Although I liked the colour version, I felt its composition lent itself to mono conversion. I knew the deep blue sky, punctuated with white, fluffy cloud, would look far more dramatic in black and white. I also felt the simplicity of mono would help lead the viewer's eye to the cross more quickly. I find black and white suits granite outcrops, stone and brickwork well, helping to emphasize their rough texture.
Nikon D200, 10–20mm lens (at 11mm), ISO 100, 1/6sec at f/22, polarizer, tripod.

GRAYSCALE

This method produces slightly better results, with increased contrast and better tonal rending – it is also quick and easy to do.

1: Open a suitable image and click Image > Mode > Grayscale.

2: A dialog box will appear with the following message: Discard Colour Information? Click OK.

Without colour contrast to enhance a picture's impact, good composition is vital. Strong lighting is an important ingredient, creating drama, bold shadows and defining shapes. It is also important to convert images with good contrast.

Trying to visualize a colour image in black and white is not an easy thing to do. Thankfully, converting colour images is quick and simple. Therefore, if you are struggling to identify suitable shots, you may find it easier to open potential images in your editing software and Desaturate them (see above). This is what I do to any shots that I'm unsure about. It is immediately obvious which images work in mono and which don't. I then close the files that aren't suitable and continue working on the ones that are.

CONVERTING COLOUR TO MONO
Using Photoshop, there are numerous ways to convert colour files into black and white images. Some are better than others, as shown here.

CHANNEL MIXER

This is the most sophisticated method. The advantage of using the Channel Mixer is that you are able to mix up the colour channels to vary the image's tonal range and contrast. This can be done by adjusting the Red, Green and Blue sliders. Try to keep the combined total of the three Mixer settings to 100%.

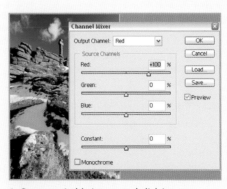

1: Open a suitable image and click Image > Adjustments > Channel Mixer.

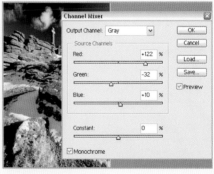

2: The Channel Mixer box will appear. Tick the Monochrome box to convert to grayscale, which changes the Output Channel to Gray.

SIMULATING COLOUR FILTERS FOR BLACK AND WHITE

If you are new to black and white photography, you are probably wondering why you would wish to mimic the effect of a colour filter when shooting mono. After all, what is the point of adding colour to a file that will ultimately be viewed in black and white? While this concept might appear to defy logic, colour filters play an integral role in traditional mono film photography.

Colour filters work by absorbing wavelengths of colour different to their own hue. As a result, they greatly enhance tonal contrast, which is what a black and white image relies upon for its mood and impact. To give an example, a red filter obstructs blues and greens, therefore darkening skies and enriching foliage. The contrasty results can look striking, with white clouds standing out dramatically against inky-black skies.

Tonal contrast remains just as relevant to digitally captured shots that are later converted into mono, and it is possible to simulate the effect of traditional black and white contrast filters during post-processing.

CONTRAST

The difficulty with mono photography is trying to imagine what the final image will look like when reduced to a series of grey tones. While film photographers would have to make this decision at the time of exposure, digital converts have the

COMPLEMENTARY COLOURS
This colour wheel graphically illustrates the relationship of complementary colours to one another. The colour on the opposite side of the wheel is its complement. When attaching traditional colour filters, a green filter for instance, will absorb shades of red – its complementary colour.

MONO PORTRAIT
Even in this age of technology, mono remains a powerful medium, often conveying mood with greater sensitivity then a colour image. Black and white is especially well suited to portrait images, emphasizing texture and tone.
Nikon D2x, 85mm lens, ISO 100, 1/500sec at f/4, handheld.

luxury of being able to make the final decision in front of their computer.

If you are struggling to identify suitable colour shots to convert, use trial and error – opening up a wide selection of images in Photoshop and then desaturating them (Image > Adjustments > Desaturate) to view how they appear in black and white.

While the impact of many colour images is the result of colour contrast, mono photographs simply rely on tonal contrast. Film photographers employ a combination of in-camera filtration and processing techniques to achieve this. Digital photographers can adjust tonal contrast quickly and easily using image-editing software, without having to spend hours in a darkroom. It is only by tweaking contrast in this way that your black and white images will really come to life. There are several ways to do this using Photoshop. The Channel Mixer (page 106) is one – adjusting the Red, Green and Blue sliders to vary the image's tonal range. However, arguably a more versatile method is a technique utilizing two Hue/Saturation (page 92) adjustment layers. One layer is desaturated and treated like a piece of black and white film; the other mimics the effect of using traditional contrast filters. This is regarded as the 'Film and Filter' method, and is demonstrated overleaf.

TRADITIONAL BLACK AND WHITE CONTRAST FILTERS

Despite the basic nature of mono photography, some of the most striking images ever captured are black and white. For years, photographers have been using strong coloured filters to refine and enhance tonal range in black and white photography. Coloured filters are able to weaken or intensify the density of the grey tones that represent the individual colours within a black and white photograph – providing greater contrast. Visually, this creates more striking results.

Traditionally, there are five main coloured filters used for mono

photography: yellow, green, orange, red and blue. Each filter is designed to lighten its own colour, while darkening its complementary colour.

To understand the effect that a colour filter will have on the final image, you need to appreciate that a complementary relationship exists between the Red, Green, Blue (RGB) additive primaries and Cyan, Magenta, Yellow (CMY) subtractive primaries. As a result, a black and white contrast filter will absorb the light that is complementary to that particular colour the most – while allowing similar colours of light to pass largely unaffected. Therefore, if a black and white film photographer wishes to block a particular colour to increase tonal range, he needs to attach a filter that is its complement. Blue is complementary of orange, which is why an orange filter will obstruct blue light, causing clear skies to receive less exposure and thus appear darker in black and white.

SIMULATING BLACK AND WHITE CONTRAST FILTERS DIGITALLY

When I photographed this derelict pier on a cold, blowy afternoon in winter, it didn't occur to me that the scene would also work well in mono. But when I processed the image and opened it in Photoshop, I desaturated the image and liked the result. However, the tones looked flat and the image lacked impact, due to a lack of contrast. I decided to remedy this by using the 'Film and Filter' technique, designed to mimic the effect of traditional black and white contrast filters.

Nikon F90x, 28mm lens, 8sec at f/22, 0.9 ND grad, polarizer, tripod.

LEVELS HISTOGRAM
Although it might resemble a mountain range, the Levels histogram is an important tool for tweaking contrast.

1 With the original colour image open in Photoshop, create a Hue/Saturation adjustment layer by clicking Layer > New Adjustment Layer > Hue/Saturation. Rename this layer 'Filter' and change the Blending Mode to Color. The Hue/Saturation dialog box will pop up, but no adjustment is needed at this stage, so click OK to remove it.

2 It is now necessary to create a second Hue/Saturation adjustment layer. Click Layer > New Adjustment Layer > Hue/Saturation, but name this layer 'Film' for easy identification. The Hue/Saturation dialog box will again pop up. Drag the Saturation slider left to –100. This removes all colour from the image. Click OK.

3 Select the Filter layer. Double-click on the layer thumbnail in the Layers palette to open the Hue/Saturation dialog box. By adjusting the Hue and Saturation sliders it is possible to alter the tonal balance of the image, enhancing its mood and impact. Although every image will need different treatment, in this instance I found a positive setting for Saturation and a negative one for Hue proved the best combination.

4 For even greater control over tonal contrast, it is possible to adjust the Hue and Saturation of each colour individually, as opposed to altering them collectively using the default Master option. Click on the Edit window in the Hue/Saturation dialog box and select from Reds, Yellows, Greens, Cyans, Blues and Magentas. Adjust the Hue and Saturation sliders to either weaken or intensify the tones of that particular colour. Repeat with other colours until you achieve the effect you desire. Finally, save the image using a different file name. In this instance, I clicked Image > Adjustment > Levels and made a few final tweaks using Levels (see box above right).

Levels

The Levels command (Image > Adjustment > Levels) is one of the most essential tools in Photoshop. It allows you to adjust the brightness, contrast and tonal range of your images. The Levels dialog box shows a graph or histogram (see opposite, bottom left) specifying the tonal value of every pixel within the image. The darkest pixels, with a low numerical value, are to the left of the graph, while lighter values and highlights are to the right. The scale used runs from 0 (pure black) to 255 (pure white). Mid-grey is around 128, but represented by a value of 1.00. Underneath the graph are three sliders that represent black, white and mid-tone. Dragging the left-hand slider right will darken the image; pulling the right-hand slider left will lighten the shot; adjusting the central slider will lighten or darken tonal range without significantly altering highlights or shadows. By adjusting Levels, it is possible to alter the tonal range and contrast of the image greatly.

 Every image's histogram is unique, so the amount of adjustment required will vary from one picture to the next. Most shots will benefit from some Levels adjustment. However, be careful not to exaggerate contrast too much.

5 The final image boasts far more impact and mood than the unaltered desaturated image. The moody dark sky mimics the effect of using a traditional red black and white contrast filter.

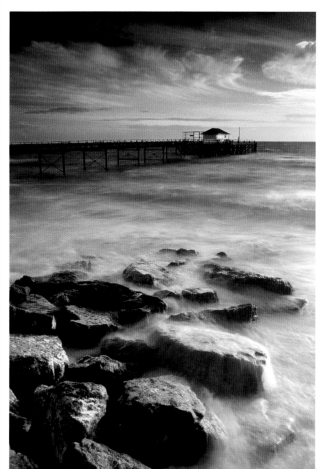

TONING BLACK AND WHITE IMAGES

Once you have achieved the correct contrast and tonality in your mono images, you may wish to add a colour tint for creative effect. Adding a tone to a black and white photograph can greatly alter the mood and look of your shot. By applying an overall colour to your image, you can create a feeling of age or perhaps even romance. Toning has long played an important role in mono photography.

ABANDONED CAR
Sepia remains the most popular colour tint for toning black and white images. It creates a feeling of age, and is especially well suited to scenes that look old-fashioned. While this image of an abandoned car in California suits conversion to black and white, it has even greater appeal when a sepia tint is added.
Wista 5x4, 75mm lens, ISO 100, 1/8sec at f/22, polarizer, tripod.

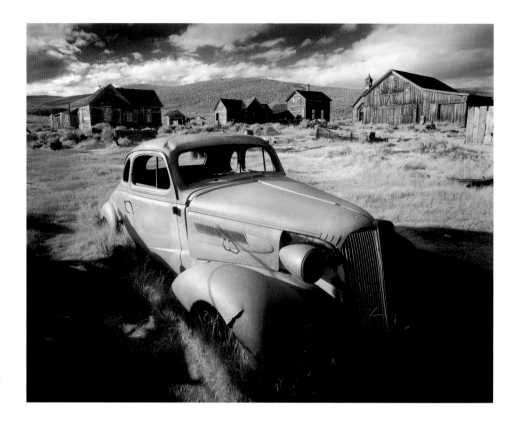

Without doubt, sepia is the most popular hue and is an effect that has been commonly applied for over 100 years. It is a reddish-brown tone that creates a historical, dated feel, which can greatly enhance an image. Other popular toners are blue, copper and brown. While there are sepia-coloured filters available to buy, it is an effect far better applied during post-processing. Traditional photographic prints were toned using chemical kits, but this was a costly, fiddly and time-consuming process. Thankfully, like so many other photographic techniques, toning is a technique that can now be applied digitally.

DIGITAL TONING
Digital toning allows photographers to achieve effects with precision and control to an extent that could never be achieved chemically. A wide variety of hues can be applied with just a few simple adjustments in Photoshop. Errors can be quickly reversed, promoting experimentation.

Toning will only work on images desaturated of colour. If you have converted a colour original to mono via grayscale, all colour information is removed, preventing toning unless you decide to apply Duotone – a Photoshop technique that subtly combines two colours; usually black and one other.

There are three or four techniques that can be used to add a hue to your black and white images. Curves (page 94) and Colour Balance (page 96) are both popular methods. However, Hue/Saturation is the preferred option for many Photoshop users.

TONING USING HUE/SATURATION
Using the Hue/Saturation command is arguably the most straightforward and quick method to tone a desaturated image. Click Image > New Adjustment Layer > Hue/Saturation to open an adjustment layer to work on. By doing this, the colour tints you apply will be to the new layer and not the original. In the Hue/Saturation dialog box, click on the Colorize window. Now, by simply adjusting the Hue and Saturation sliders, you can tint your black and white image with the colour of your choice. Ensure the Preview box is checked so you can view your adjustments as you make them. Adjusting Hue will change the colour, while altering Saturation will weaken or strengthen the tone. Using this technique, you can intuitively add any colour tint you wish. The approximate settings in the panel opposite are likely to need a degree of fine-tuning to achieve just the effect you are after, but they will act as a good starting point.

APPLYING TONE

Certain images will suit toning in particular ways. The best way to find out is to experiment with different settings until you find the effect that works best for the image. Often the same image will look good toned in several different ways.

FISHING BOATS: I converted this colour original into black and white, but the image lacked impact in mono. I decided to experiment with different colour tints.
Nikon F100, 28mm lens, 4sec at f/22, polarizer, tripod.

HUE/SATURATION CONTROLS
To tone a black and white image, open the Hue/Saturation dialog box and check the Colorize box. Now, by sliding the Hue and Saturation sliders, you can carefully and precisely apply a colour tint of your choice.

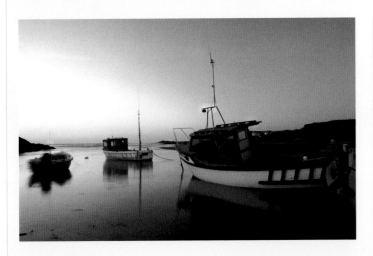

SEPIA: Hue 30, Saturation 40.

RED: Hue 0, Saturation 25.

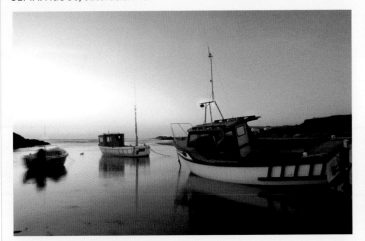

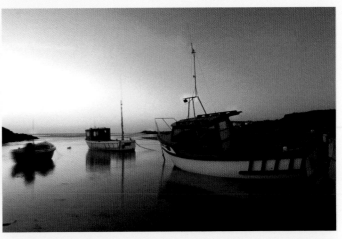

BLUE: Hue 200, Saturation 25.

GREEN: Hue 100, Saturation 20.

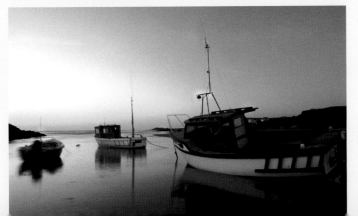

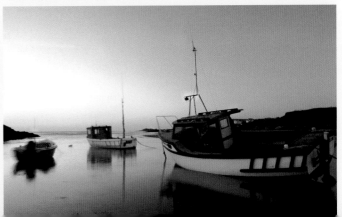

GRAIN

Grain is a term more commonly associated with film photography. It is the speckled pattern created by exposed and processed silver halide crystals on film emulsion or paper. Faster ISO film is more responsive to light because the silver halide 'clumps' are larger, but film is grainier as a result. Slower film generally has finer grain.

The equivalent effect in digital photography is image 'noise', caused by stray electrical signals. Similar to grain, noise is more pronounced at higher ISO sensitivities. However, today's digital cameras are so sophisticated that picture quality remains remarkably fine even at sensitivities of ISO 800 or faster.

While in normal day-to-day photography, the image-degrading effect of grain or noise is considered undesirable, its appearance has long been used to enhance a picture's texture and feel – especially mono images. However, it is an effect now best applied during post-processing, rather than in-camera.

FILTERING FOR GRAIN

Grain is something you either love or loathe. Personally, I think a grainy image, oozing with atmosphere and grit, can look far more striking than the unaltered original. However, grain should be applied with care. It isn't an effect that will suit just any image, so make your picture selection with thought and care. It also needs to be applied well. Too much grain and the results will look too impressionistic; too little grain and the effect won't seem intentional. Thankfully, it is relatively straightforward to achieve the correct balance using Photoshop filters.

ONIONS AND GARLIC
This image was captured using the digital camera's lowest ISO setting. As you expect from today's high-resolution image sensors, the result was bitingly sharp. However, the original didn't have any great appeal. By adding grain using the Grain filter in Photoshop, the shot boasts far more mood – looking softer, textured and impressionistic.
Nikon D200, 18–70mm lens (at 70mm), ISO 100, 1/2sec at f/22, tripod.

APPLYING GRAIN

Your images might be recorded silky smooth thanks to the latest digital technology, but grain can be applied creatively using Photoshop. There are several methods of applying it – each with varying levels of control and producing subtly different results. The only way to discover which one you prefer is to try each individually and then compare the results.

ADDING NOISE

This is the simplest way to create a grainy appearance. However, a lack of control over the end result restricts its versatility and usefulness. You can select either Uniform or Gaussian distribution. Uniform produces results in a completely random manner and is best used for full-colour images, while Gaussian employs a special curve to produce a wider range of light and dark pixels.

1: Open a suitable image and click Filter > Noise > Add Noise.

2: A dialog box will pop up. Drag the Amount slider to the right to increase the degree of noise. The effect on the image is previewed instantly.

THE GRAIN FILTER

The Grain filter offers more control. It works by adding random pixels to give the effect of high ISO film. The pop-up dialog box gives you access to ten types of grain structure and the adjustable Contrast and Intensity sliders allow you to fine-tune graininess. For added control, it is worth creating a duplicate layer (Layer > Duplicate Layer). This way, if the effect of the grain is too coarse, it can be easily adjusting by moving the Opacity slider in the Layers palette.

1: Open a suitable image and click Filter > Texture > Grain.

2: In the Grain dialog box, click on the Grain Type pull-down menu and select from the options. Presuming you wish to create a natural-looking result, opt for either Regular or Soft. Vary the strength of the effect by experimenting with the Intensity and Contrast sliders.

FILM GRAIN FILTER

This filter is designed to replicate the even, coarse grain pattern that faster ISO film produces. Arguably, this is the best filter for applying grain to your images. You can alter the size of the grain, in addition to Highlight Area and Intensity. If applying a high level of grain, you may find the results look a little flat. However, this can be remedied by adjusting contrast, using Levels (page 111). Again, it is advisable to create a duplicate layer to work on.

I converted this photograph into black and white (page 106), as I felt it looked stronger in mono. Grain can prove very flattering to skin tone, as it helps to soften the image overall. Therefore, I decided to enhance the image by applying grain using the Film Grain filter in Photoshop.
Nikon D200, 105mm lens, ISO 100, 1/400sec at f/3.5, handheld.

2: The pop-up dialog box displays a preview area of the image. Control over the effect is via three sliders: Grain, Highlight Area and Intensity. If you desire a pronounced effect, drag the Grain slider right, using a setting of 8–14. This will give your image a gritty feel. Should the effect be too strong, alter Opacity in the Layers palette. In this instance, I applied a setting of Grain 8, Highlight Area 2 and Intensity 2.

1: The image was opened in Photoshop. It is advisable to apply filter effects to a duplicate layer, as this will allow you to discard or finely adjust the effect. Therefore, I clicked Layer > Duplicate Layer. With the duplicate layer selected, I clicked Filter > Artistic > Film Grain.

3: The effect was a little too strong, so I adjusted Opacity to 88% in the Layers palette. As is often the way when applying grain, the image looked a little dull and lifeless. Therefore, contrast was adjusted using Levels.

Although grain isn't to everyone's taste, personally I much prefer the filtered image to the original. Try it for yourself…

SHARPENING

Digital photographs – particularly RAW files – will often require some degree of sharpening during post-processing. The effect of sharpening is created by an increase of edge contrast between groups of pixels. Therefore, over-sharpening can prove destructive to image quality, creating noticeable artefacts at edges.

It is important to remember that sharpening will not improve an out-of-focus shot. However, it will enhance an in-focus image.

SHARPEN FILTERS

Click Filter > Sharpen and you will be presented with a menu of four Sharpen filters: Sharpen, Sharpen More, Sharpen Edges and Unsharp Mask. Photoshop CS2 users will have the option of a fifth – Smart Sharpen. The most useful of these is Unsharp Mask, which is arguably the most important and regularly used 'filter' in Photoshop.

Sharpen and Sharpen More – Increases the contrast between pixels. Photoshop will compare the values either side of edges and then darken the darkest value and lighten the lighter one. However, you have no control over the level of adjustment. Sharpen More operates in a similar way, but its effect is even stronger. In truth, both filters are normally best avoided.

Sharpen Edges – A slightly more sophisticated filter. Often, the perception of a lack of sharpness is concentrated along distinct edges in the image. This filter identifies the areas where significant colour changes occur. It then sharpens only these, preserving the overall smoothness of the image. Again the effect is left to the discretion of the software and cannot be altered.

Unsharp Mask (USM) – This the most useful Sharpen filter available. It allows precise control over sharpening, enabling you to carefully alter the effect. Despite the name, no actual mask is applied. Unsharp Mask relies on three sliders:

 Amount: Adjusts the apparent level of sharpness by increasing the contrast of adjacent pixels. To maintain image quality, it is best to keep the value below 175%.

 Radius: Gives the illusion of enhanced sharpness by increasing the number of adjacent pixels that are affected by the filter. It is best to keep settings between 1.0 and 3.0.

 Threshold: Determines which pixels will be affected. At lower settings, more pixels are sharpened and the effect is more pronounced. At the default of 0, all pixels are sharpened. Typically, a value between 2 and 20 will be sufficient.

Smart Sharpen – New to Photoshop CS2, and developed to improve sharpening of edge details, shadows and highlights. In addition to Amount and Radius controls it offers fine control over sharpening in shadow and highlight areas. You can also choose from different types of blur to remove: Gaussian Blur, Motion Blur, and Lens Blur. Settings can be saved as pre-sets for later use.

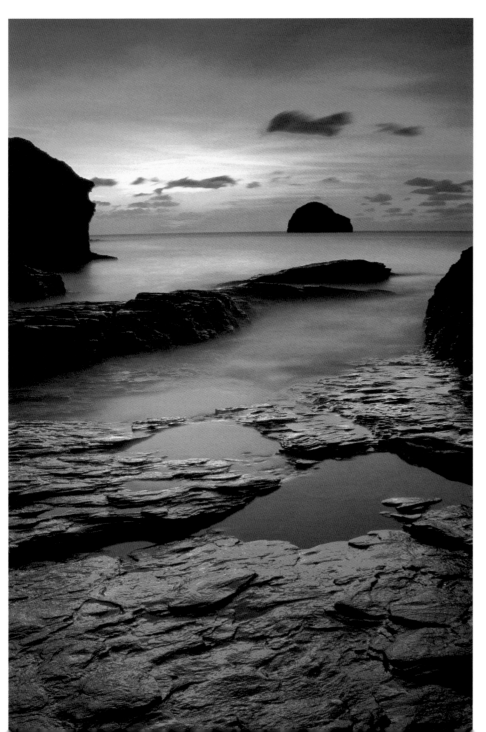

SUNSET
I added extra warmth to this image by adjusting its Colour Balance and also tweaked contrast using Levels. Before finally resaving the shot, I applied a small degree of USM to improve sharpness. In this instance, a setting of Amount 120, Radius 1.4 and Threshold 10 proved sufficient.
Nikon D70, 18–70mm lens (at 50mm), ISO 200, 30sec at f/22, polarizer, 0.9 ND grad, tripod.

SHARPENING AN IMAGE USING UNSHARP MASK

I photographed this mallard duck along a canal and the resulting image was nicely in focus. However, like many digital images, it needed a subtle amount of sharpening to counteract any softness in the image.
Nikon D70, 100–300mm lens (at 300mm), ISO 200, 1/400sec at f/4, tripod.

2 Click Filter > Sharpen > Unsharp Mask to open the USM dialog box. In this instance, a medium setting of Amount 140, Radius 1.0 and Threshold 12 was selected. As the sliders are adjusted, the Preview box shows the resulting effect.

3 Click OK to apply sharpening. Normally, the effect of the filter is best viewed with the image at 100%. This enlarged section of the sharpened image shows the improved edge contrast, when compared with the original image (see step 1). If the effect is too strong, click Edit > Undo.

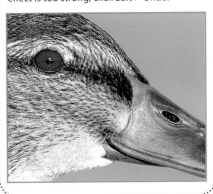

1 The image was opened in Photoshop. This enlarged section shows the original sharpness of the image. Although in focus, I felt that some extra sharpness would help to define the texture of the bird's feathers.

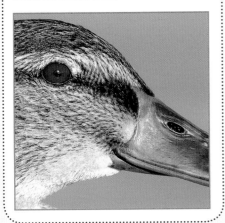

4 The setting you select for each slider will greatly depend on the image being sharpened, but always err on the side of under-sharpening; overdo the effect and the image can look unnatural. However, correctly applied, you will enhance the impact of your shot.

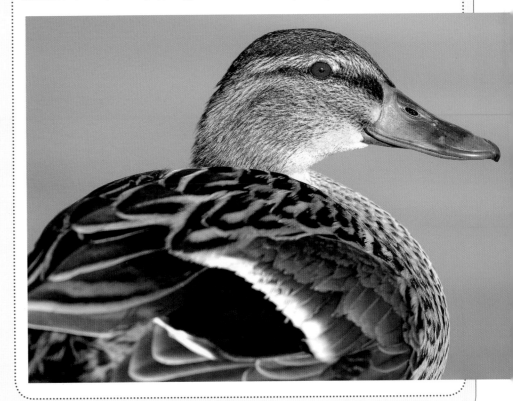

tip
Sharpening a digital file should be the last action you take before resaving the image. So, only apply Unsharp Mask once you have completed all other alterations that you intend making.

CHAPTER TEN:
SPECIAL EFFECTS

Software filters have made it easier than ever before for you to add special effects to your shots. With just one or two clicks of a mouse, your images can morph into a colourful or surreal variation of the original. However, despite what you might think, applying this type of effect isn't a new trend. While software might offer a host of creative possibilities far beyond that of a conventional, wet darkroom, photographers have been creating weird and wonderful results ever since the advent of photography.

DOING IT DIGITALLY

Optical special-effect filters are also available, proving very popular until digital capture revolutionized photography. Cokin is among the filter brands that continue to offer a range of special-effect filters. Starburst, diffraction and multiple-image filters are just some of the types available. They are designed to add an extra, eye-catching element to the resulting photo. However, today their effect is relatively simple to replicate post-capture and for this reason, their appeal has diminished. After all, why add this type of effect in-camera, when you can experiment with a much larger, more varied range of software filters and apply them at no harm to the original? If you don't like the effect, you can simply undo it and try again. In contrast, apply a special effect in-camera and – like it or not – you are stuck with the result.

TEMPTED TO SKIP THIS CHAPTER?

I appreciate that some photographers will be tempted to skip this chapter altogether. The manipulation of images is a very thorny issue and the debate on which filter effects are, and aren't, acceptable will continue to rage on. It is subjective, and you will have your own personal view. The following pages may not immediately appeal to the purists among you, but combined with a suitable photo, even the biggest sceptic cannot deny that this type of filter can help images stand out. While their usefulness is more limited than the corrective and enhancing techniques outlined previously, special-effect filters more than justify their inclusion in this book. Applied with thought and care, they are creative tools of huge potential.

SPECIAL-EFFECT FILTERS

Virtually all image-editing software is integrated with a filter library – split into general categories. Blurring, colour changes, artistic effects and

distortions can be achieved with a few clicks. The majority of Photoshop filters have a set of variable controls, where you can manually adjust the strength and nature of the effect. Experimentation is important, giving you a better understanding of how each filter works. This, in turn, will help you decide when and how best to use it. Multiple effects can be applied to the same image, meaning that there are literally millions of different combinations and effects possible.

This chapter begins by looking at the filter categories in general. It then progresses to take a more detailed look at a few of the most useful special effects – worth having in your repertoire of Photoshop skills. If the array of native Photoshop filters isn't sufficient to satisfy your creative juices, you may wish to download plug-ins (page 134) to further expand your software's functionality.

While I am promoting the application of creative filters, it is also important to reiterate that, if used carelessly, they can prove destructive and potentially ruin a perfectly good original. Special-effect filters shouldn't be overused, or relied upon to add interest to your shots. Don't get carried away and apply a filter just for the sake of doing so, or you risk your images looking clichéd. Finally, remember some special-effect filters are best avoided altogether. If you need proof, turn to page 136 for a handful of examples.

plug-ins (page 134)

tip

When applying any Photoshop filter, it is wise to apply the effect to a duplicate layer, by clicking Layer > Duplicate Layer. By doing this, you can fine-tune the strength and look of the effect by adjusting the Blending Mode and Opacity in the Layers palette.

ONE IMAGE – A THOUSAND POSSIBILITIES

Although special-effect filters can be memory-hungry, presuming you have a relatively up-to-date computer system, they are quick to apply. Not only are they powerful, creative tools, but this type of filter can also prove great fun to play with. It only took me a few moments to create this eye-catching sequence. First, I opened the original flower image (A) in Photoshop, and created a Bas Relief effect (B). Returning to the original image, I created a solarized effect using Curves (C), before finally applying the surreal effect of the Cutout filter, from the Artistic filter group (D). These are just four of the practically endless possibilities.
Nikon D70, 70–300mm lens (at 300mm), ISO 200, 1/300sec at f/8, handheld.

BUILT-IN PHOTOSHOP FILTERS

Photoshop filters are designed to correct an image, enhance it or create a special effect of some variety. Therefore, it is hardly surprising that they adopted the name of their optical namesake. In principle, their role is similar. However Photoshop filters offer far greater variety.

Photoshop is installed with dozens of built-in filters. Click on the Filter menu, and you will be presented with a list of general filter categories, each home to a submenu of powerful and varied effects. Few Photoshop effects are designed to replicate the look of a traditional filter. Instead, they introduce you to a whole new world of possibilities. With a just a few clicks, your photograph can resemble practically anything from a stained glass window to a watercolour painting – the possibilities are endless. However, the effect of some filters is so strong and artificial that they distort the original image to a degree where it is unrecognizable. For this reason, it is useful to be familiar with the filter categories, so that you can then quickly and easily access the effect you feel will benefit your shots.

FILTER OVERVIEW

Filters are pre-programmed effects grouped under the Filter menu in Photoshop. They work using algorithms (mathematical formulas/ instructions) that can 'read' the colour values of individual pixels. This allows a filter to define the edges of individual shapes and manipulate them. They can be applied either to the entire image or to a selection.

FILTER MENU
By clicking the Filter menu, you will be presented with a list of filter categories to explore.

Artistic – These filters are used to achieve artistic-looking results such as fine-art effects, resembling traditional techniques. This is possible by utilizing different filters and types of brushes and strokes. See page 122.

Blur – Important filters for retouching images. They can be used to add a soft-focus effect (page 102), or to soften all or part of an image. These are especially useful for smoothing the transition between hard edges.

Brush Strokes – Not dissimilar to the Artistic filters. However, they rely more heavily on brush strokes and ink effects to generate their arty look.

Distort – Used to distort images and create reshaping effects. Among the effects are Ripples, Twirls, Waves and Zig Zags. The effects are entertaining and fun, but generally not suited to serious photography.

Noise – Add Noise is popular for creating texture and adding grain, creating gritty, moody images. Other filters such as Median, Dust & Scratches and Despeckle can be used for photo retouching.

Pixelate – This filter group works by creating small cells in an image, based on similar colours. A Mosaic and Crystallize look are among the effects that can be applied.

Render – Lens flare is among the effects you can apply. You can also add different lighting effects and clouds.

Sharpen – Filters to sharpen an image's appearance, by increasing pixel contrast. See page 116.

Sketch – Simulates a variety of arty and abstract results. You can quickly transform your picture so, among other effects, it appears to be Chrome, Plaster or created on Water Paper.

Some Photoshop filters require you to be working with an 8-Bit RGB file. If you are working with a 16-Bit image, these filters will be disabled. To convert an image to 8-Bits, click Image > Mode and select the 8 Bits/Channel option. You can now apply all filters to your image.

Filter Gallery

A new addition to Photoshop CS and CS2 is the Filter Gallery – found under the Filter menu. By clicking Filter > Filter Gallery you open a gallery featuring thumbnails, illustrating various filter effects. This feature not only gives users a more visual way of selecting filters, but it also allows you to 'stack' filter effects and apply them in one simple step. You also get a much larger window to work within, with a big preview area.

By default the Filter Gallery window is divided into three sections, with the preview on the left, the filter thumbnails in the middle and the variable filter settings on the right. Below the settings

area is the stack – a list of all the filters applied. Here you can change the order in which the filters are applied, or hide or delete an effect. To apply multiple filters to an image, click the New Effect Layer icon at the foot of the gallery.

Not all the filters in the Photoshop repertoire are included in the Gallery, but there are nearly 50 to select from. By making it easier to apply multiple effects and toggle filters on and off, the Filter Gallery is a welcome tool – encouraging filter users to improvise and experiment with different effects. However, it is tempting to go over the top sometimes, so try to exercise restraint.

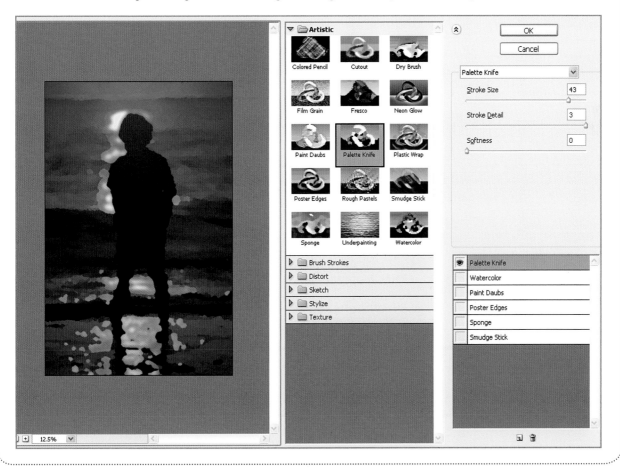

Stylize – These filters can be used to create impressionistic effects, including Diffuse, Emboss and Solarize (page 130).

Texture – As the name suggests, this group will help give images a textural feel, including effects such as Mosaic Tiles, Patchwork and Stained Glass. In truth these are all rather gimmicky and are not suitable for serious photography.

Video – Smoothes the appearance of images captured from video.

Other – Used to create your own filters. High-pass is also another form of sharpening.

Digimarc – This option can be used to embed a digital watermark to an image – essential for copyright information.

ARTISTIC FILTERS

Look under the Artistic filters menu in Photoshop, and you will find a range of 15 'painterly' effects that can be applied – alone or in combination – to transform your images into potential masterpieces. With just a few clicks, your photo can resemble a watercolour or appear to have been painted using a palette knife or dry brush. Admittedly, some filters, such as Neon Glow and Plastic Wrap, are gimmicky, destructive and normally best avoided. However, when you begin using Artistic filters, you quickly learn which effects are useful and also the subjects to which they're best suited.

A GENERAL OVERVIEW

By clicking Filters > Artistic you will be presented with a submenu of 15 filters, ranging alphabetically from Coloured Pencil to Watercolour. While there are additional 'painterly' effects hidden in other categories – for example, among the Sketch filter menu – it is this group of filters that prove best at simulating the look of traditional artistic techniques.

Artistic filters apply a certain degree of abstraction to your images. To what extent will greatly depend on the type of filter and the settings you select. The majority of the Artistic filters are equipped with three sliders, which can be dragged left or right to weaken or strengthen their effect. The sliders alter such things as Brush Size, Detail, Texture, Softness, Smoothness and Intensity. All the Artistic filters have a preview window, where you can monitor the changing effects of the filter as you adjust the settings. Applying an Artistic filter is simple and, to a great extent, intuitive. There are no set rules – simply experiment with the settings until you feel the effect enhances your original. Once satisfied, click OK. If you decide you don't like the filter when applied to the image overall, click Edit > Undo and try again, perhaps using a different filter.

ARTISTIC FILTERS FOR PORTRAITS

People have long provided the greatest inspiration among painters. A great portrait might take days to complete, but Photoshop users can mimic the look of a pastel, oil or watercolour painting in just a few moments. When applied correctly, the filter will add an extra dimension to family portraits or wedding photographs.

COUNTRY COTTAGE
When using the Artistic filters, you will quickly learn which effects are worth utilizing and with which subjects. Any subject traditionally popular among artists will work well. I felt this 'chocolate box' image of a quaint cottage (A) would prove suitable, so I applied the Palette Knife filter. In this instance, a setting of Stroke Size 11, Stroke Detail 2 and Softness 2 created the effect I required (B).
Nikon D70, 18–70mm lens (at 20mm), ISO 200, 1/40sec at f/18, polarizer, tripod.

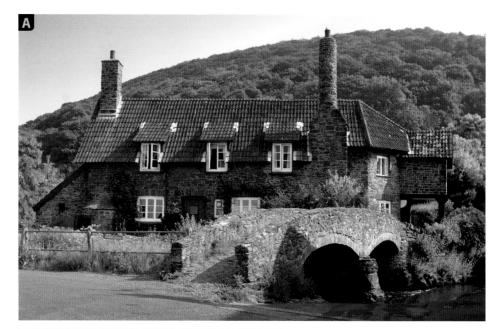

PORTRAIT EFFECTS

CONTEMPORARY PORTRAIT: Artistic filters can't make a good image from a bad one, so when applying this type of effect, remember you still need a strong, technically good original in the first place. This bright, modern portrait is a good example of the kind of image that will work well with the artistic filters available.

Nikon D2x, 85mm lens, ISO 100, 1/125sec at f/4, handheld.

CUTOUT FILTER: Using the Cutout filter, your image will resemble a cut paper collage or silk-screen print. It does this by taking an average of all the shades and colours and then converting them to just a handful. You can alter the look by adjusting Levels (2–8), Edge Simplicity (0–10) and Edge Fidelity (1–3). In this instance, a setting of Levels 8, Edge Simplicity 9 and Edge Fidelity 3 was applied.

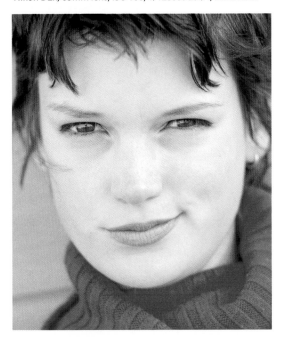

DRY BRUSH FILTER: Dry brush is a term used by artists to signify a particular technique that appears midway between an oil and watercolour effect. The filter looks at nearby pixels and blends them into areas of common colour to simplify the image. The effect can be adjusted by altering Brush Size (0–10), Brush Detail (0–10) and Texture (1–3). Here, I set Brush Size to 9, Brush Detail to 7 and Texture to 3.

POSTER EDGES FILTER: The Poster Edges filter locates the edges in your image – judging by the amount of contrast between adjacent pixels – and posterizes them, placing a dark line around the edges. The effect is a little surreal, but not unpleasant. The effect can be varied by altering Edge Thickness (0–10), Edge Intensity (0–3) and Posterization (0–6). To create this effect, I set Edge Thickness to 8, Edge Intensity to 2 and Posterization to 1.

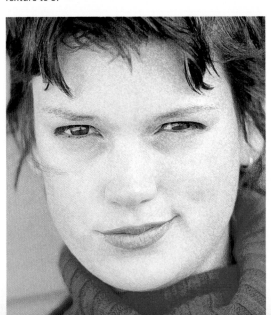

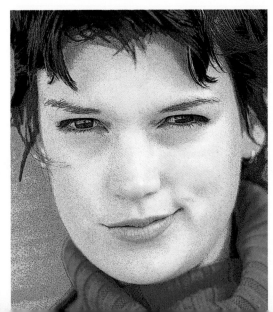

BAS RELIEF

Like the majority of Photoshop filters, Bas Relief is a special effect that doesn't actually mimic an optical filter. However, it is a creative effect that will prove appealing to many filter users. Bas Relief is a form of carving or etching, boasting a three-dimensional feel. The word is derived from the Italian *basso rilievo* – meaning 'low contrast'. In basic terms, Bas Relief is a sculpture portrayed as a picture.

Although fiddly and time-consuming, the effect can be created using traditional wet darkroom methods. This involves sandwiching positive and negative copies of the same image together, but slightly out of register. When printed, this creates the embossed look of Bas Relief. Today, digital photographers can create similar effects, quickly and easily, using Photoshop.

USING THE FILTER

Bas Relief is the first filter found under the Sketch Filters submenu in Photoshop (Filter > Sketch > Bas Relief). Like many filters in this category, the look of the effect you create will be greatly dictated by the foreground and background colours set in the Photoshop Tool palette. This is because the program employs them to create a low-relief rendering of your picture. Dark regions of the image will adopt the foreground colour, while light areas will utilize that of the background hue. Depending on the colours you select, the resulting effect can look like copper foil, hammered metal or carved stone.

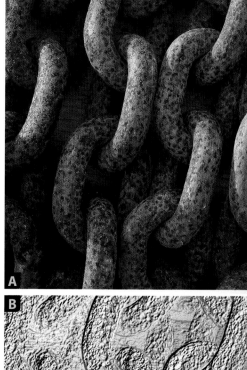

A

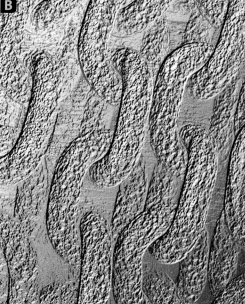

B

DIALOG BOX
You can alter the strength and effect of Bas Relief via three controls in the dialog box. The Preview box will help you regulate the effect.

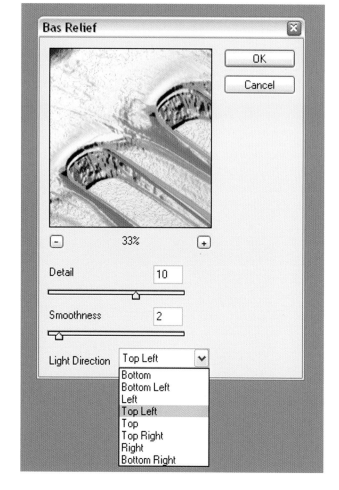

The Bas Relief filter is best combined with simple images boasting good contrast, or a textured subject against a flat background. Colour or black and white images work equally well, although often a dark background will create the most pleasing result. The effect is often too strong on its own, so it is advisable to apply the filter to a duplicate layer and then alter the Blending Mode and Opacity to tune the result.

The Bas Relief filter dialog box presents you with three controls: Detail, Smoothness and Light Direction. The best results are normally achieved with Detail set high and the Smoothness slider kept low – or the resulting image can appear overly blurred. Personally, I prefer Light Direction set to Top Left, as this gives a traditional three-dimensional gloss to the image.

RUSTY CHAIN
While it is possible to create the look of Bas Relief using Layers and inverting a copy of the original to form a negative, the Bas Relief filter is by far the quickest and easiest option. By adjusting the combination of controls in the dialog box, you greatly influence the look of the final effect. This shot of a rusty chain (A) was completely transformed using a setting of Detail 9, Smoothness 2 and Lighting direction of Top Left (B).
Nikon D70, 18–70mm lens (at 70mm), ISO 200, 1/15sec at f/13, tripod.

BAS RELIEF EFFECTS

FORKS: I photographed this still life image of two forks and then decided such a simple composition might work well in Bas Relief, so I decided to have a little fun experimenting with different settings.
Nikon D200, 150mm lens, ISO 100, 1/80sec at f/2.8, tripod.

DETAIL 1; Smoothness 15; Light Direction Top; Foreground Colour Black; Background Colour White.

DETAIL 10; Smoothness 3; Light Direction Bottom; Foreground Colour Blue; Background Colour Red.

DETAIL 12; Smoothness 1; Light Direction Top Left; Foreground Colour White; Background Colour Black.

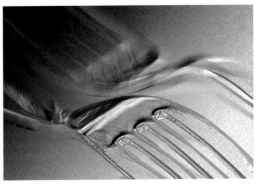

DETAIL 12; Smoothness 2; Light Direction Top; Foreground Colour White; Background Colour Black.

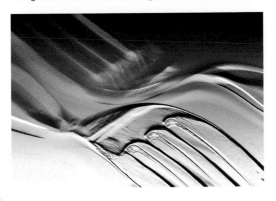

DETAIL 13, Smoothness 3; Light Direction Bottom; Foreground Colour Light Blue; Background Colour Yellow.

tip
When you are happy with your settings and apply the Bas Relief effect by clicking OK in the dialog box, the image will often appear quite light in tone. This can be easily fixed by adjusting contrast using Levels or Curves.

BLUR FILTERS

At first glance, the Blur filter group might seem to be one of the least useful categories in the Photoshop filter submenu. Why would you possibly wish to distort your images in this way, when image sharpness is normally such a high priority? Well, you may want to use one of the blur filters for several different reasons. For example, you might wish to blur the background of a picture to draw attention to a foreground subject, create a soft, dreamy looking portrait, or maybe add the impression of movement to your photo. In reality, blur filters have many useful applications that can be used for picture correction, enhancement and also to create special effects.

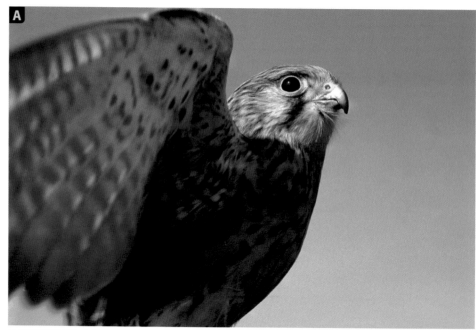

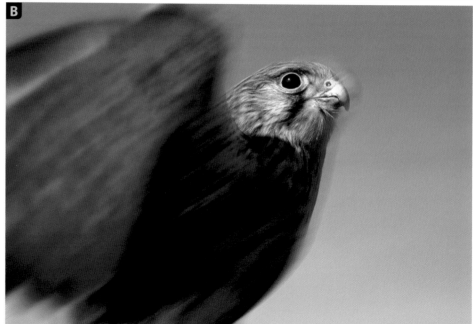

KESTREL
The original of this image (A), was shot on film and lacked interest, so I decided to bring the shot to life by scanning it and then applying a degree of Motion Blur. Using the Lasso Tool, I traced round the bird's head and feathered the selection by 75 pixels to create a natural transition. I inverted my selection and then applied Motion Blur. In this instance, an Angle of 32 degrees and Distance of 200 pixels created the look of motion I desired (B). *Nikon F100, 300mm lens, 1/300sec at f/8, handheld.*

BLUR FILTER MENU

The list of Blur filters available to you will depend on the version of Photoshop you have. Users of CS2 will have 11 Blur filters to select from, while older versions have a slightly more modest list.

Regardless of the version you are using, you will not be short of options. Below is a brief introduction to all the filters.

Average – Calculates the degree of each colour in the original photo and creates a one-colour visual with the result. No controls are given. Use on a duplicate layer to reduce the appearance of noise.

Blur – Works by averaging pixel colours wherever it identifies distinct edges. Very simple to apply, but without controls or a preview.

Blur More – Works in a similar way to Blur, but three or four times stronger. Lack of control greatly limits its appeal and usefulness.

Box Blur – CS2 filter. Changes the colour of pixels based on the ones adjacent. Only one slider gives control over the Radius of the effect. In principle, a basic, quicker form of Gaussian Blur.

Gaussian Blur – The most useful blur filter, allowing precise control. Quickly blurs a selection by an adjustable amount, adding low-frequency detail.

Lens Blur – CS filter. Adds selective focus to an image. Similar to traditional in-camera techniques, it can be used to create depth of field. Filter palette lets you experiment with different settings and preview the results before committing to an effect.

Motion Blur – Most commonly used to create the impression of movement. Blurs in a specified direction and at an intensity of 1–999.

Radial Blur – Adds creative flare to your images, creating a zoom or rotational motion effect. See page 128.

Shape Blur – Blurs your image based on the shape you specify. There are a variety of pre-set shapes to select from.

Smart Blur – A very precise filter that blurs areas of a similar hue. Colour, sharpness and important detail are retained, while image noise and grain are reduced.

Surface Blur – Attempts to blur only the flat surface areas within the image. This helps retain the edges and detail that make the photo crisp. Good for reducing marks and blemishes on skin, for example.

WILD PONY
Gaussian Blur can be used to remove unwanted focus from distracting or ugly background objects – not dissimilar to employing a large f/stop to create a shallow depth of field. In the original image (A), I felt the background was distracting, so I selected it and applied Gaussian Blur, using a Radius of 60 pixels. The resulting image (B) places far more emphasis on the wild pony in the foreground.
Nikon D70, 300mm lens, ISO 200, 1/180sec at f/11, tripod.

tip

Often, you will only wish to apply blur to a selected area of your image. Therefore, before using the filter you need to select the area you wish to apply it to. This can be done using the Pen, Lasso or Magic Wand Tools, depending on which is best suited. Remember to feather your selection for a smooth blend.

RADIAL BLUR

While the Radial Blur filter is probably not an effect you will find useful on a day-to-day basis, it is great for creating powerful special effects. Not only is this type of filter fun to play with, but it can be used to add energy and movement to your images. This can be especially handy if action photography isn't one of your strengths.

MILL SAILS
The deep polarized sky provided a great backdrop to the white sails of this windmill. Unfortunately, they weren't turning when the shot was taken (A). To create the look of motion, Radial Blur was applied to the selected sails, using Spin as the blur Method (B). The effect only needed to be subtle, so in this instance Amount was set to 8.
Nikon D2x, 35mm lens, ISO 100, 1/30sec at f/11, polarizer, tripod.

Quick reflexes and fast, pricey optics are normally required to capture subjects that are moving – it can be a real challenge to capture just the right look in-camera. Only after considerable practice will you consistently be able to achieve the results you crave. If you can't wait that long to produce this type of effect, the Radial Blur filter is a good alternative. It works by manipulating the pixels around the specified centre point. This can create a swirled, zoomed or panned effect, giving the impression of motion.

FILTER OPTIONS

By clicking Filter > Blur > Radial Blur, you will open the Radial Blur dialog box. You will be presented with options to alter the look and strength of the effect. Select from either Spin or Zoom as the Blur Method. Choosing Spin will create blur along concentric, circular lines, while the Zoom option will blur along radial lines – as if zooming in or out during exposure. Depending on the effect you desire, specify the blur strength by adjusting the Amount slider from 1 to 100. There are three Blur Quality settings. This is available because the Radial Blur filter is very memory-intensive, and can take several minutes to render if your computer system is aging. Select the Draft option to apply the effect in the shortest amount of time, although results can look grainy. It is normally better to opt for either the Good or Best settings, producing smoother, higher-quality results. Finally, specify the origin of the blur by simply dragging the pattern in the Blur Center box to suit your image.

tip
Although you can adjust the Blur Center in the Radial Blur dialog box, it can prove tricky to judge exactly where the centre is on your image – unless it is square. Often it is easier to leave it at its default setting and, if necessary, move the image itself to position the blur.

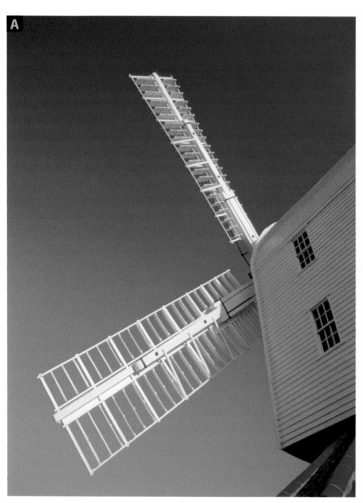

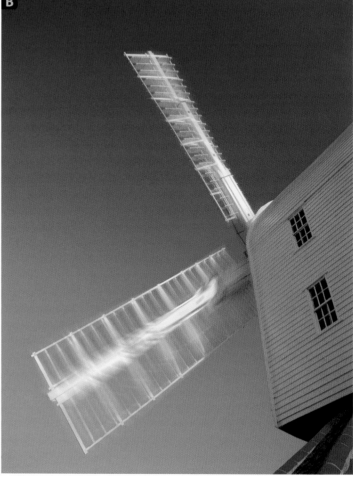

APPLYING THE RADIAL BLUR FILTER

While this is a bright, fun image, it looks a little static. This can be easily remedied in Photoshop using Blur filters. To create a feeling of motion, I added Radial Blur to the image's background. Motion Blur can also be used to create this effect, so it is worth experimenting and comparing the effects to see which you prefer.
Nikon D2x, 85mm lens, ISO 100, 1/30sec at f/11, fill flash, handheld.

1 Open the image in Photoshop and create a duplicate layer to work on by clicking Layer > Duplicate Layer. In this instance, I decided to use the Lasso Tool to make my selection. Feathering was set to 50 pixels.

2 Using the Lasso Tool, manually trace around the edges of your main subject. When applying this type of effect, you don't need to be that precise with your selection. However, if you prefer, you could use the Polygonal or Magnetic Lasso Tools instead.

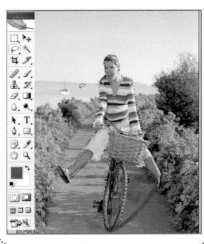

3 You need to invert the selection so that the Radial Blur is applied to everything but your selection. Do this by clicking Select > Inverse.

4 Now click Filter > Blur > Radial Blur to open the filter's dialog box. In this instance, I wanted to create the impression that the cyclist was moving towards the viewer, so I selected Zoom as the Blur Method. I opted for Best as the Quality setting. I also dragged the Amount slider to 50 to create a pronounced effect. Click OK and wait for the effect to be applied.

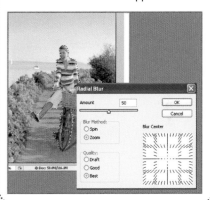

5 Remember; this is a memory-hungry application, so remain patient while it is processing the filter. If the effect is too strong, alter Opacity in the Layers palette or Undo and try again. In this instance, I fine-tuned the result by setting Opacity to 90%. The final image is bursting with more life and energy than the original.

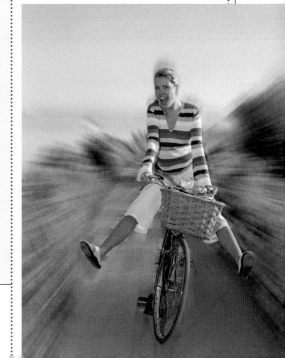

SOLARIZATION

Solarization is a traditional wet darkroom technique. It was discovered by mistake in the 1920s and brought to prominence through the work of pioneering American photographer Man Ray. Also known as the 'Sabatier effect', solarization occurs when a partially developed photographic print or film is exposed to light – thus becoming partly fogged. Development is then resumed. As a result, undeveloped areas of the print go dark, while other colours or tones are inverted.

The effect solarization creates is quite surreal, as parts of the resulting image look positive while other areas appear to be negative. Fine lines occur at the borders between the light and dark areas, known as 'Mackie lines'.

Today, creating the look of a solarized image is far easier to achieve using Photoshop. There is even a specific Solarize filter, allowing photographers to sample the effect with a simple click of the mouse.

SOLARIZE FILTER

While solarization won't be to everyone's taste, it is an effect that, when matched to a suitable image, can create eye-catching results. The results achieved will vary greatly depending on the subject matter and colours most affected. Like any special effect, experimentation is the key. It is an effect that can suit both colour and mono images. However, detail is lost by applying solarization, so normally it is best to combine the effect with simple images that boast bold shapes and strong outlines.

The Solarize filter is found under the Stylize filter submenu. Note that, while it is deemed a Photoshop filter, it does not actually mimic the effect of any traditional in-camera filter. Although it is a quick and easy way to sample the effect of solarization, the drawback of using this method is that it is automatic and you have no control over the final effect, thus limiting its usefulness. While this filter is quite capable of producing acceptable results, the effect can be more precisely applied using Curves.

CURVES

The effect of solarization can also be simulated using Curves. The advantage of using this method, as opposed to the Solarize filter, is that you will have far greater control over the final result. The effect can be approximated by inverting Curves in a certain way and then fine-tuning the effect as desired.

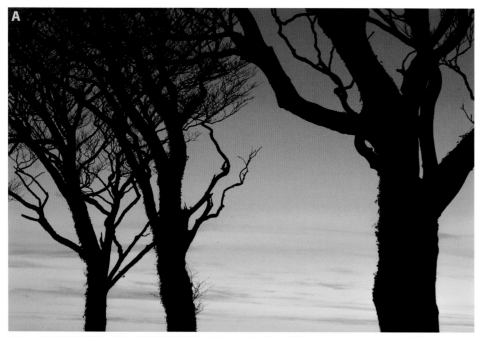

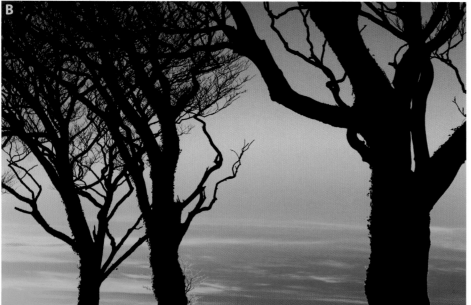

SILHOUETTED TREES
I took this photograph late one winter's evening (A). To transform the sunset into a more abstract shot, boasting surreal, unnatural colours, I decided to apply solarization using the Solarize filter in Photoshop. Click Filter > Stylize > Solarize to apply the filter. Solarization is automatic, so the user cannot alter the strength of the effect. In this instance, I liked the result achieved (B).
Nikon D200, 18–70mm lens (at 70mm), ISO 100, 1/8sec at f/8, tripod.

SOLARIZATION USING CURVES

This simple, yet colourful image of a small fishing boat bobbing in a harbour was pleasant enough, but to create a more memorable result, I decided to apply solarization using Curves.
Nikon D70, 150mm lens, ISO 200, 1/320sec at f/10, tripod.

2 Drag the bottom left point (0, 0) to the top of the box (0, 255) so the image goes white. Next, click on the centre of the line and pull the curve downwards. This inverts the tones of the image so it appears similar to a film negative.

3 To create the solarized effect, pull down the curve on the left and right of the centre point. Then drag the centre point back upwards. This should shape the curve into the form of a 'W', which will give you an effective level of solarization.

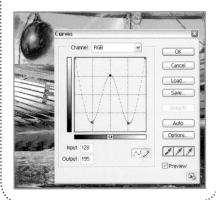

1 The image was opened in Photoshop and a new adjustment layer was created to work on by clicking Layer > New Adjustment Layer > Curves. A New Layer dialog box will appear. Click OK to open the Curves controls.

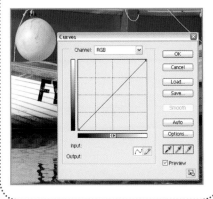

4 In this instance, I altered each point slightly until fully satisfied with the effect. Finally, merge the Layers by clicking Layer > Merge Down. The end result is striking and colourful, boasting far more impact than the unadjusted original.

tip

The contrast and colour of digitally solarized images will often benefit from a small degree of tweaking in Levels. If you aren't completely satisfied with the surreal colours created by the Solarize filter, adjust the Hue slider in Hue/Saturation (page 92).

LIQUIFY FILTER

Liquify is a powerful tool, capable of both subtle and drastic results. Liquify allows you to twist, stretch and warp an image, by enabling you to push, pull, rotate, reflect, pucker and bloat groups of pixels. It therefore has the potential to create all types of weird and wonderful results.

The Liquify filter is an extremely powerful manipulation tool, which allows you to adjust areas of an image without losing image quality. While this filter can be employed to create ugly or fun distortions, it is also a practical tool for retouching images – especially within the fashion industry. Applied correctly, it can be used to reshape facial features or be used to 'thin' faces, tummies, legs and arms. In fact, this technique is sometimes referred to as the 'Photoshop diet'.

LIQUIFY COMMANDS

By clicking Filter > Liquify, you open a new, full-page interface, where you dictate the look of the effect before actually applying the filter to the image. There are three main components in the dialog box: top left is the Tool palette, in the centre is the large Preview area and on the far right are the Tool Options.

MANIPULATION TOOLS

The Tool palette consists of 12 controls, of which the first eight are varying forms of distortion and reconstruction: Forward Warp, Reconstruction, Clockwise Twirl, Pucker, Bloat, Push Left, Mirror and Turbulence. They are applied to the image using brushes. The Tool Options panel on the right side defines the brush settings: Brush Size, Density, Pressure, Rate, Turbulent Jitter and Reconstruct Mode. However, not all options are available for every tool.

Returning to the Tool palette, beneath the eight manipulation tools are two mask controls.

CHANGING FACES

The Liquify command is a powerful and sophisticated tool, best employed to make subtle image enhancements. In this instance, the model's ear stuck out slightly (A), so using the Pucker Tool, I carefully reshaped it. I also made fine adjustments to his jaw line. While these changes are subtle, they have helped reduce the length of the model's face, enhancing his looks (B). If required, it is possible to completely transform the look and shape of a person's face, using this filter.

Canon 5D, 85mm lens, ISO 100, 1/200sec at f/8, softbox, handheld.

In most instances, you will not want to apply the Liquify effect over the entire image. Using the Freeze Mask Tool, you can protect critical areas – in a similar way to a Quick Mask. Simply select the Mask Tool from the Tool palette, adjust the brush options as required, and 'paint' over the areas you wish to protect. Thaw Mask can be used to restore 'frozen' areas. If you don't apply a mask and accidentally affect an area of the image that you didn't intend to, you can use the Reconstruct Tool to paint the original image data back on to the frame.

PRESERVATION TOOLS

In the Liquify Options panel to the side of the Preview area are the Reconstruct Options. Here, you can quickly reconstruct your image by clicking Restore All. Alternatively, you are able to apply lesser degrees of reconstruction by choosing a setting from the Mode pull-down menu and clicking Reconstruct. The Mode can be selected from Revert, Rigid, Stiff, Loose and Smooth. The results you will achieve can be pretty variable, so you may need to do some experimenting before you get the result you are after. Once you are finally content with the effect displayed in the Preview window, click OK to apply the filter.

LIQUIFY MESH

At the top of the Options panel are the Load Mesh and Save Mesh buttons. Basically, a mesh is a matrix of points used to describe a distortion. It is a pre-defined Liquify operation. When you activate the mesh option, a fine mesh or grid is placed over the image and then, as you apply the Liquify tools, it will bend and distort. After applying considerable time and work to a particular image, it is possible that you may want to used the exact same distortion on another image. That is where the Load Mesh and Save Mesh options become relevant. With a click of a button you can create a mesh and save it to use again and again.

LIQUIFY EFFECTS

Here I applied the most popular tools to the same image. I selected a large Brush Size of 400, then applied the tool to each flower. The distortion is concentrated at the centre of the brush area and is intensified if you hold down the mouse button.

LIQUIFY DIALOG BOX: At first it may seem complex, but by experimenting with the different tools and options, you will soon learn how best to utilize its strange and varied effects.

WARP: This tool allows you to move the pixels around on the canvas.

TWIRL: Creates the effect of a miniature tornado within the brush area.

PUCKER: Gives the impression that the pixels are being sucked in towards the centre of the brush area.

BLOAT: This causes the pixels to expand outwards towards the edges of the brush area.

PLUG-INS

A plug-in is a computer program that integrates into another, adding new features and increasing functionality. They can take many different forms – image-processing, text, file formats and automation, for example. However, the most abundant type for graphics are Photoshop-compatible plug-ins for image editing. Plug-ins are almost always developed by a third party. This is because the purpose of the plug-in is to add functionality that is not inherent in the original software.

In relation to graphics software, the term 'filter' generally refers to a plug-in capable of a special effect. The type of effect can vary from something relatively simple, such as applying blur, to complex image distortions or psychedelic patterns.

The terms 'filter' and 'plug-in' are often used interchangeably. However, there is a distinction. The term plug-in refers to the entire third-party module. This plugs into the host application and may actually consist of several individual filters, which can then be accessed through a common user interface.

If the standard, native filter menu in your image-editing software isn't sufficient to quench your thirst for special effects, you need to get online and download filters that will.

WHERE TO BEGIN?

Type in the term 'plug-in' into an Internet search engine, and you will be presented with a seemingly endless list of sites to visit and filters to download. The huge choice can be mind-boggling and it can be tricky to know just where to begin. New third-party plug-ins are created and being made available online every day. The type of plug-in you wish to download will greatly depend on the effect you personally desire, so visit a variety of different plug-in websites and study the filtered example images. It won't be long before you stumble upon effects you deem useful and that you want to add to your repertoire of filters. Many good sites will offer downloadable demo plug-ins, on a 10–30-day trial, which can prove useful. Don't waste your time – and money – downloading dozens of weird and wonderful filters that, in reality, you will rarely – if ever – use.

Not all Photoshop-compatible plug-ins will work as intended in other image editors. Therefore, if you plan to use a plug-in with software other than Photoshop – Paint Shop Pro, for example – try a trial version first or check with the publisher of the software that the plug-in is indeed compatible.

FILTER FACTORY

The Filter Factory is one of the major culprits for why there is such a huge abundance of plug-in filters available online. The Filter Factory is a plug-in for Photoshop, allowing users to compile their very own custom-made filters. There are quite

LET THERE BE LIGHT!
Avoid gimmicky effects and only opt for filters that will enhance your images, for instance the Light! filter, from Digital Film Tools. This plug-in will add light to a scene where none existed before (A) – just as if you were adding light at the time of shooting (B). Realistic lighting and shadow is introduced using the entire pattern/gobo library created by Gamproducts Inc.

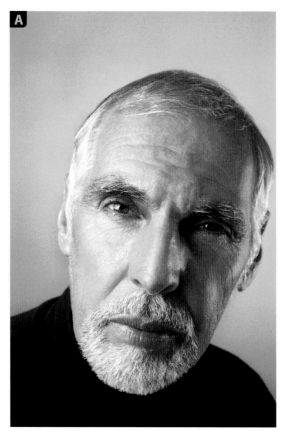

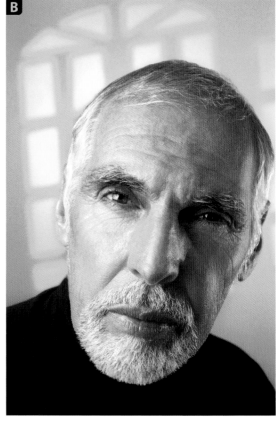

literally thousands of filters created with Filter Factory that have been made freely available on the Internet.

While, in truth, the majority of this type of plug-in produce abstract, arty effects that photographers will rarely find useful, some Filter Factory plug-ins create nice results. Unfortunately, they do not commonly support any sophisticated form of interpolation or anti-aliasing, so their application will often create hard, obvious edges. However, they can prove an inspiration to creativity and are fun to experiment with.

Installing plug-ins

Having successfully downloaded a plug-in, you need to install the software before you are able to use the filter. Fortunately, the majority have in-built installation software. This will guide you through the process with the minimum of fuss. It will also check your PC for earlier copies of the plug-in and for host application support. If an installer is not required or provided, the plug-in developer should provide instructions for what to do. If not, you will need to install the software manually. Although it is impossible to provide a universal step-by-step, normally it is possible to copy or 'drag' the file into the 'Plug-Ins' subfolder of the Photoshop folder. For instance, Photoshop CS2 is typically located at: C:\Program Files\Adobe\Adobe Photoshop CS2\Plug-Ins (for Windows) or Library\Applications\ Adobe Photoshop CS2\Plug-Ins (for Mac OS). When copying the plug-in folder to its new destination, ensure Photoshop is closed first. When you next open Photoshop, your new plug-in will be listed in the Filter menu and be ready to apply.

PRACTICAL PLUG-INS

Although third-party plug-ins are best known for creating all types of wonderful and surreal special effects, some have a more practical role. For example, the EZ Mask from Digital Film Tools is an interactive image masking tool capable of extracting almost any object from an image – even if it includes fine detail, such as hair, smoke or reflections. This extraction process creates a mask. Once a mask is extracted, the foreground object can be seamlessly composed on to a background of your choice. Using this plug-in, the dog in the original image (A) is dropped into the new background (B) with a perfect result (C).

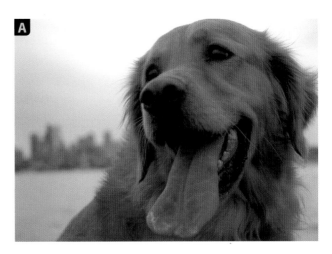

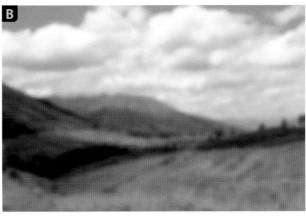

PHOTOSHOP FILTERS TO AVOID

Software filtration is designed to enhance your photography. While Photoshop filters should not be considered a substitute for in-camera creativity and skill, they have the potential to make a good shot even better. They are an essential tool for photographers in the 21st century and shouldn't be ignored.

Applying creative filtration, hardware or software, is a very intuitive skill; after all, not every effect will appeal to everyone. The effect of some Photoshop filters and plug-ins can be overwhelming and they can 'drown' your original image rather than complement it. What is and what isn't acceptable is a contentious issue, but you should instinctively know where to draw the line.

You will find many Photoshop effects useful and beneficial to your photography. However, even their biggest advocate could not deny that some filters are, in fact, best avoided altogether. Among the filter submenus are an array of weird, wacky and – dare I say it – gimmicky applications. While it might be fun playing with the bizarre effects of Plastic Wrap, Stained Glass and Neon Glow, this type of filter has no relevance or relationship to serious photography. If applied, the effect will only degrade and undermine your image. My advice is to give them a wide berth. Instead, concentrate on the many filters that you know will benefit and strengthen your images.

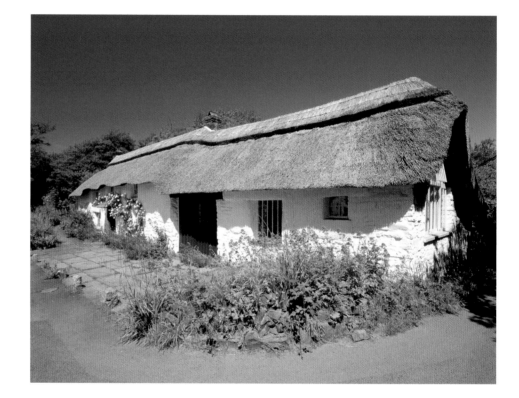

THATCHED COTTAGE
Not all filters and plug-ins will benefit your shots. Some are destructive and are normally best avoided. To give you an example, I spent a few moments in Photoshop applying a handful of its weird and wacky effects to this photograph of a quaint cottage. I'm sure you'll agree that none of the effects actually improve the original.
Nikon D200, 10–20mm lens (at 11mm), ISO 100, 1/30sec at f/18, polarizer, tripod.

ARTISTIC > NEON GLOW

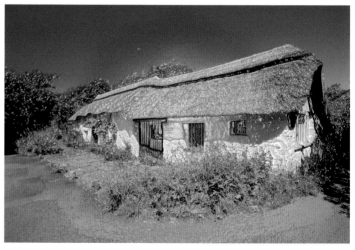

ARTISTIC > PLASTIC WRAP

DISTORT > GLASS

DISTORT > ZIGZAG

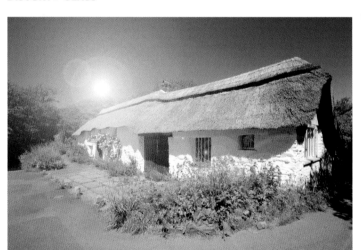

RENDER > LENS FLARE

SKETCH > PHOTOCOPY

STYLIZE > FIND EDGES

STYLIZE > GLOWING EDGES

GLOSSARY

Algorithm A predetermined series of instructions or steps, such as a sequence of instructions in a computer program.

Anti-aliasing Smoothing the jagged edges (aliasing) of digital images.

Aperture The hole in a camera lens through which light passes to expose the image sensor. The relative size of the aperture is denoted by f/numbers.

Artefact A flaw, usually ugly blocks, in a digital file.

AWB (Automatic White Balance) A digital camera adjusts white balance value automatically.

Blending Mode A setting in the Photoshop Layers palette, which determines how the pixels in one layer affect those in the layer below.

Byte A unit of computer storage equivalent to (nearly always) 8 bits.

Channel Part of an image as stored in the computer; similar to a layer. Typically, a colour image will have a channel dedicated to each primary colour.

CMYK Cyan, Magenta, Yellow and Key (black).

Colour balance Accuracy of colour ratios in a recorded image, often related to colour temperature.

Colour cast A pronounced tint or colour tinge to a photo, which may or may not be desirable.

Colour temperature Description of the colour of light source by comparing it with the colour of light emitted by a theoretical perfect radiator at a particular temperature expressed in Kelvin (K).

Compression The way in which a digital file, particularly JPEGs, are reduced in size.

Contrast The difference in brightness between light and dark regions (highlights and shadows) within an image.

Depth of field The amount of the image that is acceptably sharp. Depth of field extends one-third in front of and two-thirds behind the point of focus.

Dialog box An on-screen window in an application, used to enter or adjust settings, or complete a procedure.

Diffusion Lighting that is low or moderate in contrast, such as that which occurs on overcast days.

Drag Moving an icon, selected image or altering a control by moving the mouse while keeping its button depressed.

DSLR (Digital Single-Lens Reflex) A type of camera that allows you to see through the camera's lens via the viewfinder. Compatible with interchangeable lenses.

Duotone A process in which two identical copies of an image are printed on a page using two different colours – typically black and another colour. The effect can be simulated digitally.

Dynamic range The range of contrast intensities, between highlights and shadows, which can be captured by the image sensor. Also referred to as contrast range.

Exposure The process of light hitting the surface of light-sensitive material, such as a digital image sensor. Exposure is determined by two variable settings: shutter speed and lens aperture.

F/stop A fraction that indicates the actual diameter of the aperture. The 'f' represents the lens focal length. The higher the number the smaller the aperture.

Feathering The fading of the edge of a digital image or selection.

File format The internal structure of a computer file. TIFF and JPEG are popular image file formats.

Filter (A) A sheet of transparent material – typically optical glass or resin – placed over the camera lens to modify the quality or colour of light reaching the sensor.

Filter (B) A feature in image-editing software that alters selected pixels for some types of visual effect.

Filter factor Some optical filters work by absorbing light. The result is a general decrease in the total amount of light that reaches the image sensor. This decrease in light transmission is regarded as the 'filter factor'.

Flare Scattered light, often caused by reflections inside the lens barrel or the camera body interior. This scattering causes bright, ugly shapes and patches on the resulting image.

Focal length A numerical value in millimetres, indicating the field of view of a camera lens. The larger the number, the narrower the field of view.

Gamut The full range of colours that can be produced by a camera, monitor, etc. Often presented visually in the form of a two-dimensional colour space for comparison.

Graduation The smooth blending of a tone or colour into another.

Highlights The brightest parts of a photograph.

Histogram A two-dimensional graph showing the brightness range of an image.

Hue Colour information associated with certain wavelengths of light.

Interpolation The estimation of data, used to create new pixels by estimating their data from adjacent ones.

ISO (International Standards Organization) The international standard for representing film sensitivity. In digital cameras the ISO setting represents the sensitivity of the image sensor to light.

JPEG A standard compressed image file developed by the Joint Photographic Experts Group.

Kelvin (K) A scale used to measure colour temperature.

Layer One level of an image file to which objects can be assigned or copied, allowing them to be altered or manipulated, without affecting the image overall.

Megapixel One million pixels – a measure of camera resolution.

Menu An on-screen list of choices used to access certain features or adjust settings.

Metering Using a camera or light meter to determine the value of light coming from a scene or subject and calculate the required exposure.

Mid-tone The regions of an image that are approximately average in tone, falling midway between the highlights and shadows.

Moiré An optical illusion. The interference patterns that appear when two similarly spaced grids overlap.

ND (Neutral Density) Attenuates all wavelengths of light equally without adding a colour cast.

Noise The digital equivalent of grain, caused by stray electrical signals.

Overexposure A condition in which too much light reaches the sensor. Detail is lost in highlights.

Photoshop The industry-standard image-editing software – produced by Adobe.

Pixel Picture element. In digital imaging 'pixel' normally refers to the smallest complete element that makes up an image. Also sometimes (incorrectly) called a dot.

Plug-in A computer program that integrates into another, adding new features and increasing functionality.

Polarized light Light waves vibrating in one plane only, opposed to the multi-directional vibrations of normal rays. This occurs when light reflects off some surfaces.

Post-processing The use of software to make adjustments to a digital file on a computer.

RAW A digital file format used by many digital cameras, with shooting parameters attached, not applied. RAW is an uncompressed file format.

Reciprocity law/failure Image sensors grow less sensitive to light during long exposures. This is reciprocity failure or, more accurately, failure of the law of reciprocity.

Reproduction ratio The ratio of the size of the real-life subject to its image in the focal plane.

RGB Red, Green and Blue.

Saturation The intensity or purity of colour. Low saturated colours appear washed-out because they have high quantities of white light. Completely unsaturated colour is grey. Saturated colour is intense and contains no white light.

Sensor A digital chip in a camera that detects incoming light and records the information as digital data. They are usually either CCD or CMOS types. The resolution of the image sensor is usually expressed in megapixels.

Shadows Dark or poorly illuminated areas of a scene.

Shooting parameters User-defined actions, either in-camera or during post-processing, such as white balance, saturation, contrast and sharpening.

Shutter speed The length of time the shutter is open and the sensor is exposed. Measured in seconds or a fraction of a second.

Spot metering A metering mode that takes a light reading from a small percentage of the scene – typically 1–3 per cent.

TIFF (Tagged Image File Format) An uncompressed digital image file.

Tool A program designed to produce a particular effect on-screen, activated by choosing an icon and then using it as the cursor.

Toolbar The area of an image-editing program used to provide immediate access to the most frequently used tools, settings and commands.

TTL (Through The Lens) Any metering system – ambient exposure metering or flash metering – that works through the lens.

Tungsten Incandescent light bulb that employs tungsten as a filament.

Underexposed A condition where too little light reaches the sensor. Detail is lost in shadows.

Unsharp Mask A software feature that selectively sharpens a digital image in areas of high contrast, while having little effect on areas of solid colour.

Vignetting Darkening of an image around the edges and corners. Most commonly caused by stacking two or more filters together.

White Balance A function on a digital camera that allows the correct colour balance to be recorded for any given lighting condition.

WEBSITES

Before investing in a filter system it is essential to do a little research. This will help ensure you buy one that best suits your needs and budget. Listed here are links to all the major filter brands. This should prove a useful and comprehensive resource for comparing the pros and cons of different filter systems. Also included below are a number of other useful links that you may find a source of inspiration.

FILTER MANUFACTURERS

B+W
www.schneider-kreuznach.com

COKIN
www.cokin.com

CROMATEK
www.spaphoto.co.uk

EXPODISC
www.expodisc.com

FORMATT/HITECH
www.formatt.co.uk

HELIOPAN
www.heliopan.de

HOYA
www.intro2020.co.uk

JESSOPS
www.jessops.com

KOOD
www.koodinternational.com

LEE FILTERS
www.leefilters.com

SIGMA
www.sigma-imaging-uk.com

SINGH-RAY
www.singh-ray.com

SRB FILTERS
www.srb-griturn.com

TIFFEN
www.tiffen.com

SOFTWARE

ADOBE
www.adobe.com

DIGITAL FILM TOOLS
www.digitalfilmtools.com

FRED MIRANDA
www.fredmiranda.com

PHOTOGRAPHERS

ROSS HODDINOTT
www.rosshoddinott.co.uk

ROD EDWARDS
www.rodedwards.co.uk

BOOKS AND MAGAZINES

DAVID & CHARLES
www.davidandcharles.co.uk

DIGITAL SLR PHOTOGRAPHY
www.digitalslrphoto.com

F&W PUBLICATIONS
www.fwpublications.com

PRACTICAL PHOTOGRAPHY
www.practicalphotography.co.uk

ACKNOWLEDGMENTS

Thank you to Neil Baber, Freya Dangerfield, Marieclare Mayne, Demelza Hookway and everyone at D&C for their help, hard work and for giving me the opportunity to write this title. I would like to thank Graham Merritt and Lee Filters for all their kind assistance; Jane Nicholson at Intro2020 who represent Hoya and Cokin; Tiffen and Cromatek; and Marco Paolini at Digital Film Tools. Also, thank you Dan Lezano for your recommendation and Rod Edwards for allowing me to include a selection of your wonderful images in this guide.

I only pursued a career in photography due to the support and love of my Mum and Dad. Thank you for your unfailing belief in me and for making the huge, unselfish decision to educate me at home. I love you both more than you will ever know. I'd also like to thank my beautiful baby daughter Evie, for all her encouraging giggles and smiles.

Finally, a huge thank you to Ame Verso – my editor for this project. Your help and friendly, professional manner has made writing this book far less stressful.

ABOUT THE AUTHOR

Ross Hoddinott began his career by winning the BBC Young Wildlife Photographer of the Year as a teenager. He has since built a steady reputation as a leading landscape, wildlife and close-up photographer. He regularly contributes to a wide variety of publications, such as *Outdoor Photography*, *Digital SLR Photography* and *Practical Photography*, and is contracted to five top picture agencies, including NaturePL and Alamy. He lives with his wife and daughter in Cornwall, England.

INDEX

Note: page numbers in **bold** refer to photographs.